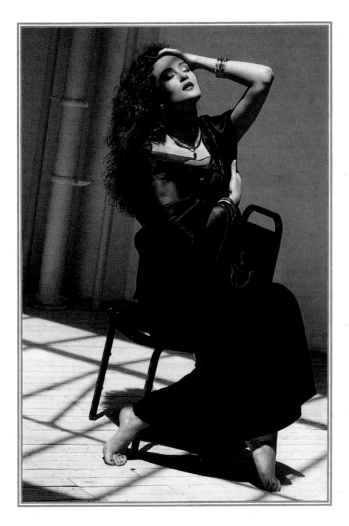

FASHION
PHOTOGRAPHY

FASHION
PHOTOGRAPHY

LUCILLE KHORNAK

AMPHOTO
An Imprint of Watson-Guptill Publications, Inc./New York

Lucille Khornak is a former fashion model who moved to the other side of the camera eleven years ago and became a successful fashion photographer who owns and operates her own studio. Her clients include: Emanuel Ungaro, Yves St. Laurent, Bon Jour, Pierre Cardin, Givenchy, Helena Rubinstein, and Coty Cosmetics. Her photographs have appeared in many major publications, *Vogue, Newsweek, The New York Times Sunday Magazine*, and *New York* magazine among them. She is also the author of *FASHION: 2001*, a photographic preview of fashions for the future.

I would like to thank the following: Randee Benedict, for her devotion to this project, for her creative ideas, and for being a friend; Susan Hall and Liz Harvey, for their endless energy and editing; Sabino Caputo and Frank Murphy, for their support and special attention at odd hours; Nita Barnett, Alistair Gillett, Joe Hunter, Barbara Lance, Frank Maresca, Monique Pillard, and Olga Zaferatos, for their ideas and opinions; Nancy Alusick, Peter Brown, Barbara Laga, Grant LeDuc, Abby MacFadden, Arthur Marks, Scott Taylor, Adrienne Weinfeld, and Nancy Wolfson, for their special expertise; Charles Broderson and Cynthia Altoriso of Charles Broderson Backdrops, Mordechai Cyngiel of Tekno/Balcar Studios, Charles Tarzian of The Columns, and Ernst Wildi of Hasselblad, for the use of their equipment and/or locations; and Click, Elite, Faces, Flaunt, Ford, HV Models, Idols, L'Exclusive Influence, Margaret Models, Pauline's, Select, Wilhelmina, and Zoli, for providing the world's best models and for their "never-say-die" scheduling attempts.

I would also like to express my gratitude to the fine models and artists who contribute their time, energy, and creative talents to make this business possible.

Edited by Liz Harvey
Graphic Production by Andrew Hoffer

First published 1989 in New York by AMPHOTO, an imprint of Watson-Guptill Publications, a division of Billboard Publications, Inc., 1515 Broadway, New York, NY 10036

Library of Congress Cataloging-in-Publication Data

Khornak, Lucille.
 Fashion photography / Lucille Khornak.
 Includes index.
 ISBN 0-8174-3848-3 ISBN 0-8174-3849-1 (pbk.)
 1. Fashion photography. I. Title.
TR679.K48 1989
778.9'9391—dc20 89-33214
 CIP

Manufactured in Hong Kong

1 2 3 4 5 6 7 8 9 / 97 96 95 94 93 92 91 90 89

*To my husband, Robert,
for his understanding,
encouragement, and love*

*In memory of Ron Heck and
Andrew Leit, my friends*

CONTENTS

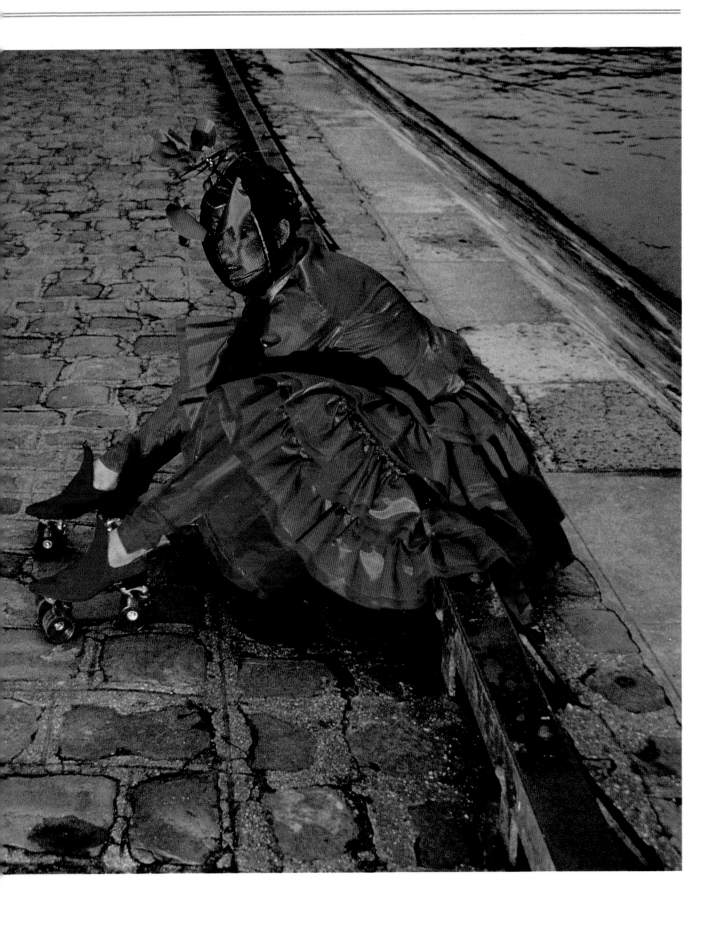

INTRODUCTION

Fashion is an expression of individual taste and a form of communication. Our wardrobes can define our age, status, taste, and profession. They reveal to others how we see ourselves. While our wardrobes are, to a certain extent, a reflection of our tastes, the clothing we choose is, to a much larger extent, predetermined by designers. Fashion dictates; we follow closely. ✿ Throughout the centuries, both women and men of sufficient means have dressed according to the "style" of the moment. Historically, style was restricted by religion, custom, and even law. Until the beginning of the twentieth century, fashion was created exclusively for the wealthy. It separated the upper class from the less fortunate who by necessity spent most of their time trying to survive. The poor could not afford to be fashionable. The Industrial Revolution changed this. With the invention of the sewing machine, the general public was able to afford to dress fashionably. The market for "fashion" grew, and with it came the demand for fashion innovators. ✿ Fashion trends became more visible as the camera glamorized them. Affluent women were photographed at social events, and newspapers used photographs to illustrate stories about the lives of the rich and famous. Soon, designers began using photography to document their collections. As technological advances increased in number and complexity, fashion magazines replaced illustrations with photographs. The rise of fashion photography brought about many changes in the fashion industry. A person no longer had to be part of society to know what was fashionable. Thanks to magazines, women could visualize themselves wearing the latest styles. ✿

The twentieth century has seen dozens of fashion trends come and go: the mini, the midi, full skirts, cinched waists, narrow lines, padded shoulders, the oversized look, the unisex look, wide ties, narrow lapels, and zoot suits. All of these, needless to say, have been meticulously documented by the fashion photographer.

A relatively small group of designers decide what is fashionable and dictate trends. They guide the public from season to season, researching fabrics, defining a mood, and creating themes.

Then, each season, the press is invited, along with the buyers, to view the designers' new collections. Fashion editors choose which styles they will present to the public. These garments are photographed for the editorial sections of major magazines, including *Vogue*, *Harper's Bazaar*, *Gentlemen's Quarterly*, *Town & Country*, *Elle*, and *Mademoiselle*. As undeniably powerful as these forces are, it is still the consumers—the women and men who buy the fashions—who determine whether a trend will succeed or fail.

Women turn to monthly fashion magazines to discover the fashions for the upcoming season. True, many women can be influenced by the photographs they see, but invariably some styles will succeed while others will be rejected.

Like many other women, I am attracted to the beauty of fashion. I also enjoy the endless evolutions that keep my work interesting. Even though I have been involved in the day-to-day operation of fashion photography for eleven busy years, there is still magic in it for me. Every day brings with it different opportunities—and responsibilities. Many times, I am faced with the challenge of taking a fairly ordinary garment and transforming it in a beautiful photograph. I am never bored.

I also have a commitment to beauty. While the news media focus on harsh realities—the tragedies and brutalities of human behavior—I choose to focus on beauty. Fashion photography presents an idealized world. I love fantasy: the idea of beautiful people dressed in elegant clothing in sumptuous surroundings. I expect people to want to "live" in my photographs— or at least fantasize about being in them.

But fashion photography is not portraiture. The true portrait photographer attempts to capture the personality and essence of the subject. I have found, however, that the truth is not necessarily what a person is looking for when he or she commissions a portrait. I can create

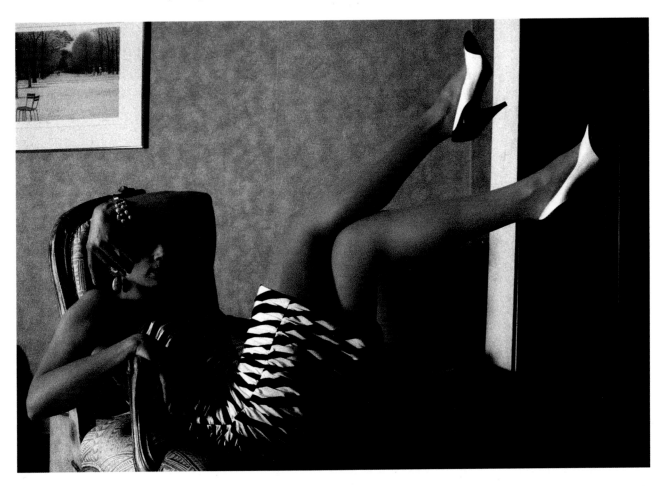

a realistic, artistic portrait—but if it does not show the subject off to best advantage, it may not delight my client. After all, everyone wants to look attractive.

For these reasons, I embrace the idealization that is the essence of fashion photography. I prefer to present my subjects in the best of all possible lights and to photograph a sensitive moment that will capture their beauty forever. I also like to make order out of chaos. Striking models, glamorous clothes, strong colors, different fabrics, exotic shapes, and perfect accessories . . . these are the elements I bring together into an unexpected unity: the finished photograph. I transfer my own instinctual taste into a visible reality on film.

I also love the energy that happens on a shoot. The creative exchanges among the art director, model, hair and makeup artist, stylist, and photographer make fashion photography, like the theater, a richly collaborative art. Fashion goes a step beyond clothing. Hair, makeup, the right jewelry, and a certain look contribute to a good fashion photograph. And, some subtle element—the choice of a lip color, an accessory, a hairstyle, or particularly expressive eyes—can make the difference between ordinary and special. An advertisement can depict a single model in a studio or a complicated location shot using dozens of props and a number of models. Everything must relate; everything must make sense both visually and emotionally. The fashion photographer is responsible for pulling together the energy and creativity of the members of the production team, whose efforts help to establish the style and tone of the photograph.

The fashion field is exciting. Glamour, beauty, models, money, a fast-paced life, the rich, the famous— all are part of the world of the successful fashion photographer. While working on my first book, *FASHION 2001*, I had the opportunity to travel to several countries, including Italy, France, and Venezuela; to meet and consult with top fashion designers from all over the

world, among them Oscar de la Renta, Emanuel Ungaro, Pierre Cardin, Claude Montana, Donna Karan, Giorgio Armani, Karl Lagerfeld, Gianni Versace, and Issey Miyake; to photograph their garments; and to discuss the why's and how's of fashion with them.

Like most other photographers, you may wish to enter the field of fashion because you are drawn to its prestige and glamour. Attractive faces and alluring garments are part of the make-believe world from which models seduce their audience. But this business also involves long hours, continual rejection, intense pressure, tight deadlines, and explosive temperaments.

If, after weighing the pros and cons, you remain convinced that this is the field for you, then you are on your way to an exciting and potentially lucrative career. As a fashion photographer, you will play a role in constructing the images that not only sell products, but also create a fantasy world of ideal beauty and style. The boundaries of that world will be determined only by the richness of your imagination. The garments you photograph will be delineated by the variables of color, form, line, and movement, but your own imagination will govern these elements from the moment you accept an assignment to the last click of the shutter.

Fashion is an ever-changing barometer; it reflects the social and political conditions of the world. As a fashion photographer, you will always have to be alert to trends—preferably not after they happen, but just before. You will need to anticipate the next significant step in fashion. You will have to be sensitive to the prevailing attitudes that shape such trends. For a good fashion photographer, these skills are second nature.

Fashion exists in and of the moment. Days of preparation and planning come together for one brief instant. How you capture that instant and what you instinctively register on film is what will make your work unique. This special personal style makes one fashion photographer different from any other.

UNDERSTANDING THE FASHION PHOTOGRAPHY MARKETS

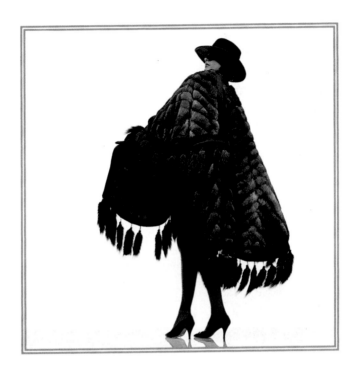

Before you embark on a career as a fashion photographer, you must come to realize that it won't always be an avenue for self-expression. If you are like many other fashion photographers, you will hope that 25 percent of your assignments will be ideal and end up in your portfolio. But you may find that you will accept 75 percent of your assignments just to pay bills. ✤ To enter the field of fashion photography and become successful, you first need to know that fashion photography is divided into three broad areas: editorial, advertising, and catalog. ✤ Each specialty has its own specific requirements. The editorial market enables photographers to express themselves rather freely; however, the corresponding fees are low. Beginning fashion photographers often must decide which is more important to them: creativity and exposure or a substantial income. The advertising field offers photographers just the opposite. While the fees are usually quite high, photographers must subjugate their personal vision to the ideas and instructions of the client and the art director. In addition, photographers rarely receive a credit line for their efforts. Finally, the catalog market falls in between the editorial and advertising fields. Fashion photographers are not allowed much flexibility when shooting catalog assignments as they follow the guidelines established by the client. Also, photographers can rely on this market for steady income. ✤ The following information about these three distinct areas of the fashion photography world will help you to choose the specialty best suited to your individual style, talent, and needs. ✤

EDITORIAL PHOTOGRAPHY

The editorial pages in fashion magazines consist of articles and columns illustrated with photographs; they represent the fashion editors' point of view. If you remove the advertisements, these pages form the core of the magazine. They showcase the fashions the editors have decided to show to their readers that season. The term *editorial photography* applies to all the photographs that accompany articles and columns. Although these photographs are not specifically meant to sell specific garments, the outfits get welcome publicity. (Don't confuse editorial photographs with advertisements. The latter are paid for by the designer or a particular store and focus on selling the product. The monies paid by the advertisers to the magazines cover the publication's production costs. Ads are submitted to the magazine in final form, while editorial pages are designed by the staff of the magazine.)

Editorial sections have a particular style that reflects the tastes of the fashion editor. As a photographer, you will be chosen for editorial assignments based on your style; obviously, you will not be selected for an assignment if your individual style is incompatible with the style of the magazine.

When compared to advertising, the editorial market allows you more freedom to use your style (assuming, of course, that your style meshes with that of the publication) and more time to express your ideas. However, the fee for such assignments is low, and can be as little as $150 a page. (Models and stylists are also paid very little.) Despite the modest fees, photographers are eager to do editorial work for prestigious magazines because they usually receive a credit line: that is, their name appears alongside their photograph. This assures them of a great deal of valuable exposure. Everyone in the advertising business scans the major fashion magazines to keep abreast of the latest trends. As a result, credit lines help build a photographer's reputation.

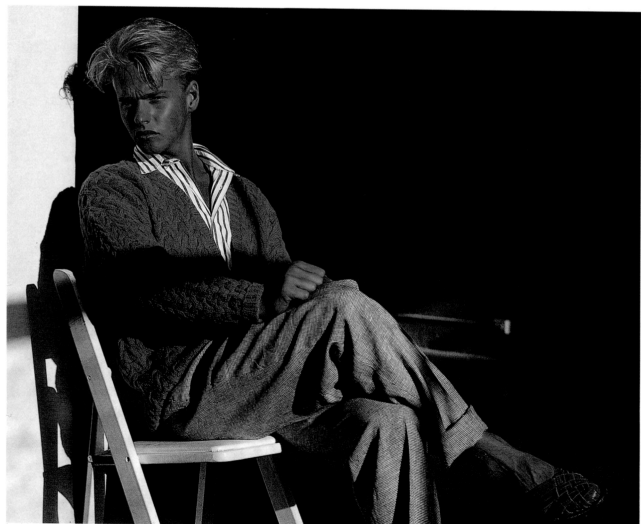

In this photograph, the model looks relaxed, not stiffly posed. Editorial photography often conveys a mood but doesn't necessarily show every line of a garment. Here, the bright existing light adds a crisp feeling to this photograph.

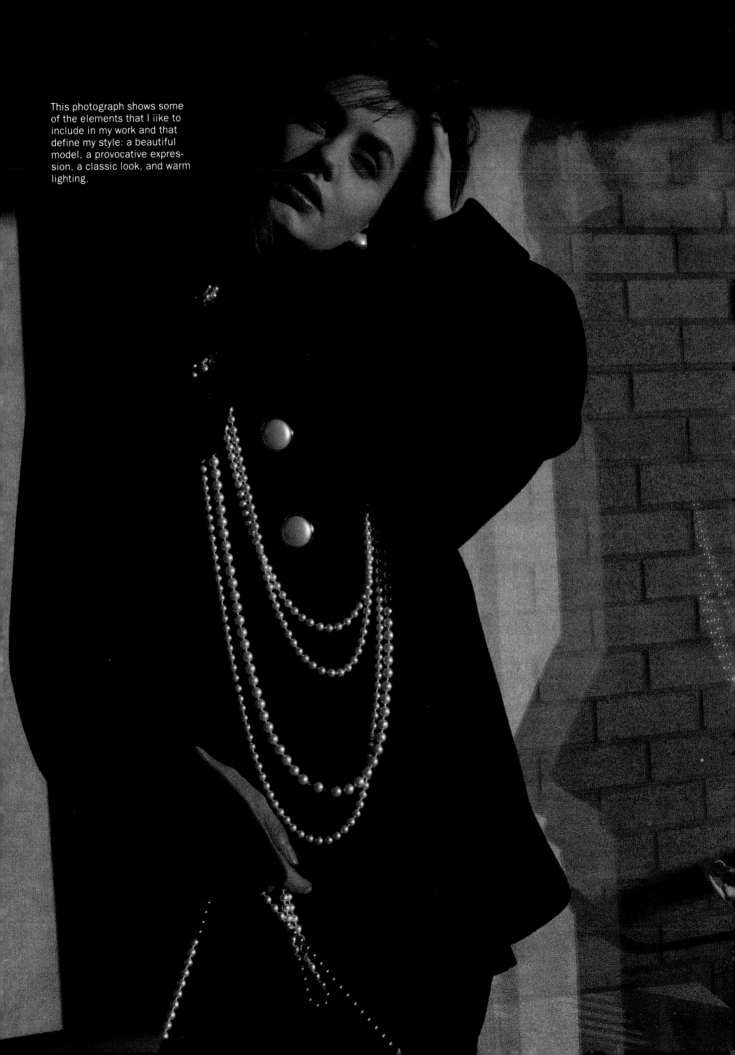

This photograph shows some of the elements that I iike to include in my work and that define my style: a beautiful model, a provocative expression, a classic look, and warm lighting.

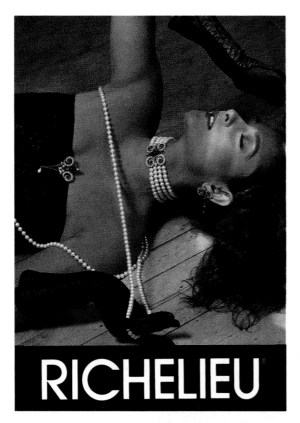

RICHELIEU

ADVERTISING PHOTOGRAPHY

The purpose of photographic advertisements is to sell a product. Advertising agencies are hired by clients to shape the image of their product for successful marketing. The products that often call for fashion photography are large in number and include cosmetics (lipstick, eye and face makeup, nail polish, skin care treatments), fragrances, and hair products. Photographic advertisements are also used by department stores to sell various items or to be included in in-store product promotions. Because advertisers use the latest fashions to sell a variety of products, your clients might not be limited to the fashion business. Even some advertisers of products that are not fashion-related may require fashion-oriented advertising: appliances, cigarettes, liquor, furniture, and real estate.

The advertising agency receives a marketing proposal stating an objective. Agency representatives confer with the client until everyone agrees on a course of action. *Layouts*, or visual plans, may be redone dozens of times before an agreement is reached. Sometimes as many as ten months can go into the planning of a single ad or campaign.

During this shoot for a Richelieu jewelry advertisement, I took advantage of the natural light to bring out the soft luster of the pearls. Once you establish good rapport with the client or art director, you may be given the freedom to experiment if time permits. This unplanned photograph was ultimately used for the ad, which is shown above.

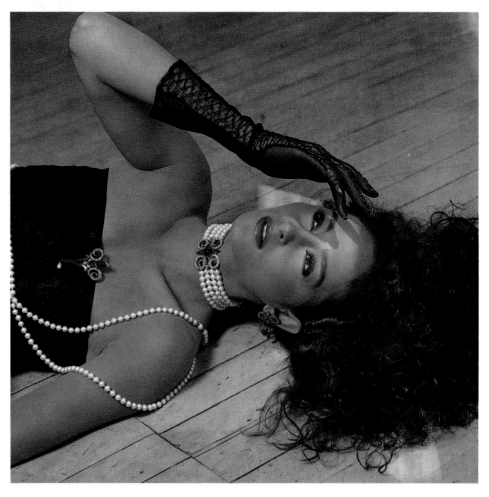

Once the agency has produced layouts that are approved by the client, the agency's art director calls in the supplier he or she considers best suited for the objective: you, the photographer. Because the art director must carefully match the photographer's talent with the approved campaign plan, many variables affect this decision. Keeping in mind the best way to effect the layouts, the art director may choose a photographer based on style, technical ability, or, perhaps, the rapport between them.

Because a photographer's skill in handling time and production details is paramount, an art director may prefer an established photographer. Time is money to the client. Models, hair and makeup artists, and stylists are paid top dollar, so a great deal of money is at risk. Consider the following fees for a typical one-day shoot for an advertisement.

Fees for a One-Day Advertising Shoot

Photography fee	$ 5,000
3 Models, each with a day rate of $4,000	12,000
1 Hairstylist with a day rate of $1,250	1,250
1 Makeup artist with a day rate of $1,250	1,250
1 Stylist	
2 Days of preparation	1,500
1 Day on set	750
Rentals	300
Messengers	150
Film and processing	1,200
Total	**$23,400**

You can see that even with just the bare essentials, costs add up quickly. Only when the film is delivered to the art director and receives a favorable response can the photographer relax. While the advertising field is both glamorous and lucrative for fashion photographers, it also requires a great deal of responsibility. And, credit lines are rare. However, if the client's budget is small and you are expected to work for less than the standard rate, you could probably negotiate for a credit line. Only such top photographers as Avedon, Horst, Scavullo, and Penn are paid handsomely and receive a credit line, too. These photographers are chosen because the client or the agency feels that the photographer's name lends prestige to the advertisement.

Once assigned, you are expected to execute the layout precisely. The art director lets you know if there is room for any self-expression; at this point, the agency may have only a few weeks to finalize the ad.

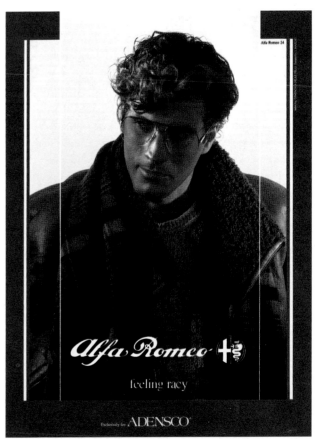

Even though I shot this photograph in a studio, the image was cropped in on the model. It captures the masculinity of the type of man who wears Alfa Romeo eyeglasses. The client wanted to emphasize the persona, not the frames, in this ad. The client also wanted a model who could wear the frames well and look rugged, handsome, and sexy.

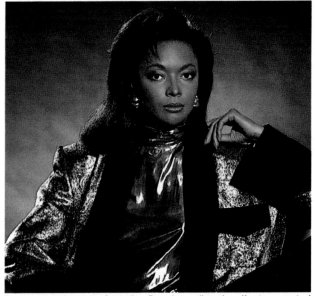

For an advertisement featuring Denaka vodka, the client requested a black female model who could convey a slightly haughty attitude. To complement the copy for the ad, the model was to seem as if she had it all and wanted only the best. This model was perfect: she looks beautiful, sophisticated, self-assured, and wealthy.

CATALOG PHOTOGRAPHY

When you are hired as a catalog photographer, you will be shooting for mail order houses, such as Spiegel and Avon, or for department stores, such as Macy's and Bloomingdale's. These businesses ship their catalogs to thousands of people on their mailing lists, including charge account customers. The ultimate objective for any catalog is to sell product. In fashion catalogs, the garment is always the focus of attention, and the presentation is crucial. Today, we are also seeing an interesting trend toward an "editorial" feeling in catalog work, as seen in the LIMITED chain store catalog. Here, the clothes are enhanced by a certain mood and atmosphere; in conventional catalog approaches, garments are presented without these elements.

What would the ideal catalog assignment be? The client would hire you for your flair and then allow you complete creative license: you could compose angles and choose lighting setups without restriction. The mechanics of the catalog would then be designed around the photography. I have had a few assignments that would qualify as ideal—but these situations are rare.

You can be creative even when you have strict guidelines to follow. It is in the nature of shooting catalogs that some assignments are more challenging than others. You must perform under tight time constraints and apply your organizational skills to their utmost. This in itself is a creative ability. You have to be good, and you have to be fast. Working on catalogs might not be as glamorous as editorial or advertising photography, and many photographers do not choose this line of endeavor. But, catalogs can be a steady source of income.

Billing is done customarily by the day or per shot. A large studio is necessary since most of the garments, props, and accessories are sent over in advance. Rates for catalog work are not nearly as high as those in the advertising business. As with advertising photography, credit lines are rarely given. However, you may get consistent bookings from the same client, and often several days and even weeks may be booked at a time. Many fashion photographers think of catalog assignments as bread and butter accounts.

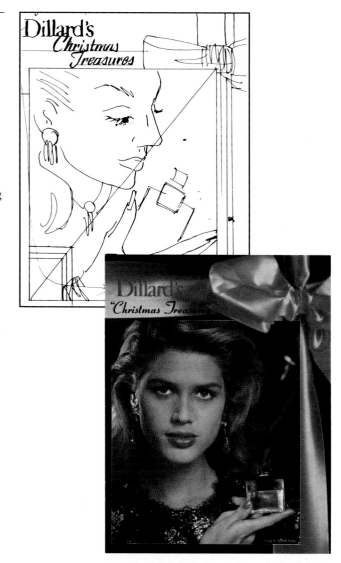

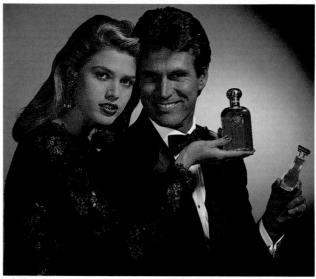

I followed the sketch at the top of this page when shooting a Christmas catalog for Dillard's department store. The catalog showed formally dressed models holding bottles of perfume and cologne. Both the cover and the inside shots echo the client's desire for a festive holiday mood.

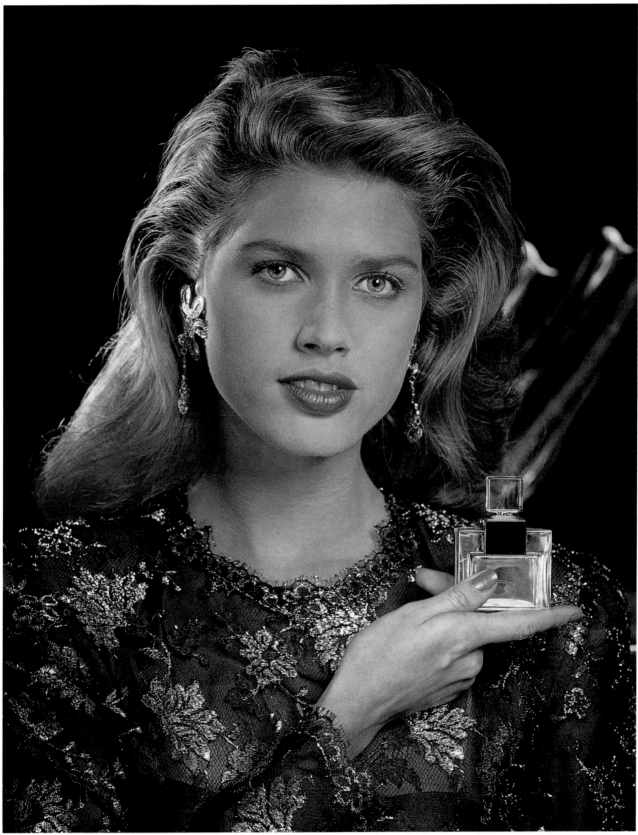

This photograph became the cover of the Dillard Christmas catalog. Here, I used an Opalite to illuminate the model from the front, a hairlight to highlight her hair, and a third light to capture the detail in the crystal vase. This image is elegant and romantic.

FOLLOWING YOUR INSTINCTS

When executing someone else's layout, you, the artist, face the challenge of remaining faithful to the original concept while still infusing the photograph with your style (see Chapter 6). A layout can be executed in any number of ways, but it is your instinct that transforms the art director's concepts and thoughts into a fully realized statement.

As the photographer, you are expected to be a skilled professional, an accomplished technician, and a problem solver. You must be able to produce what is communicated to you orally and in layout form—whether the concept will be simple to execute or will call for complicated lighting situations or special effects.

I find that advertising photographers would like to do editorial work, and vice versa. Of course, the ultimate situation, where many fashion photographers would like to be, is to work in both advertising and editorial markets. This is not an easy feat. Like actors, photographers tend to get "typed."

The following chapters will lead you step-by-step into the fascinating but turbulent world of fashion. You will encounter the challenges of day-to-day working situations: the temperamental cast of characters you will work with, the time pressures, the frustrating deadlines, the fast pace, and the split-second decisions you will have to make. This will help you to determine whether or not fashion photography is right for you.

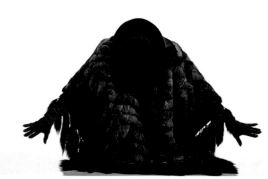

With just a few direct lights, I was able to achieve a dramatic effect for these shots featuring Givenchy furs. The white seamless back-drop provides a stark contrast for the Russian sable poncho shown above and the violet shearling coat shown on the right. The final ad is shown below.

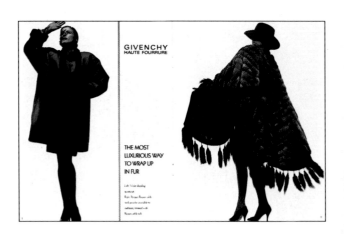

WORKING WITH MODELS

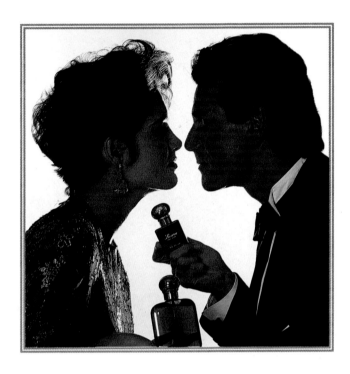

Modeling offers a wide range of benefits to both the lucky young women and men who are able to make a career out of it. First, it is probably one of the most lucrative fields young women can enter: they can potentially earn hundreds of dollars in an hour and thousands in a single day. And, because they have the opportunity to appear in fashion magazines all over the world, their faces can become internationally recognizable. Beautiful models are also always in great demand and are welcomed by a sophisticated and elite level of society. ❀ In addition, models' lives can be filled with adventure: the models may travel extensively, working and living in such romantic meccas as Paris, Milan, Rome, and Tokyo for months at a time. Life after a modeling career can be equally rewarding. The profession can be used as a steppingstone to a number of other careers. In fact, some famous top actresses and actors were originally models—think of Grace Kelly, Lauren Bacall, Cybill Shepherd, Ted Danson, Corbin Bernsen, and Tom Selleck. Other models often use their earnings to start businesses of their own. ❀ Men approach the business of modeling for somewhat different reasons. First, modeling offers more freedom than a conventional nine-to-five job. Enjoying all the fun and glamour, male models can earn a substantial amount while preparing for other careers, such as acting or owning and managing a restaurant. In fact, several successful restaurants in New York City are owned and run by former male models who invested their incomes in their businesses—and then had a ready-made clientele. So, while male models might not cause quite the sensation that their female

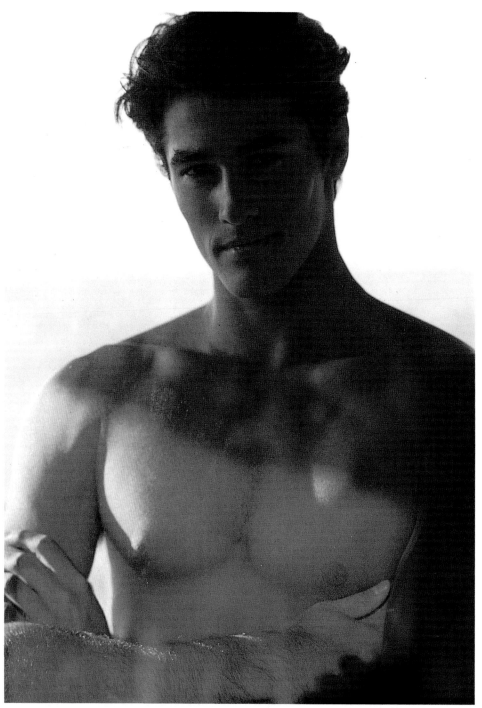

To be successful, models have to be attractive, as well as have a strong presence and striking features. The natural lighting and the shadows it created draw attention to this model's well-defined chest, but his intense, brown eyes are compelling, too.

counterparts do, they are compensated by the realization that male models usually last longer in the business—assuming they age well—than female models do.

As glamorous as a model's life seems, only a few dozen beautiful women and handsome men manage to make it to the top of this profession. Even fewer have careers that span more than five or six years. The personal sacrifices that a successful modeling career

demands can also be daunting. Taking care of and maintaining an attractive body can be almost a full-time job. Every once in a while you will read about a model who gorges on chocolate and spaghetti, never exercises, and goes to clubs until the wee hours every night. But these models are rare exceptions. Out of necessity, most models lead spartan lives. They have to keep track of every calorie and every ounce of fat. They exercise daily

and protect their faces and bodies from injuries that can cost them hundreds of dollars in lost bookings. Modeling exacts an emotional toll as well: personal tragedies can never be allowed to show on models' faces. When models walk into the studio or arrive on location, they must perform. The work itself can be grueling and uncomfortable. Often, layouts for fur coats are shot in the summer, while bathing suit ads are photographed during the winter months.

On their "time off," female models often look surprisingly ordinary. Because they want to give their skin some rest from the heavy makeup they wear on assignments, they use little if any makeup; they also wear far less glamorous clothes than you might expect. Often, clients cannot believe that the plain-looking model who walks into the studio on the morning of the shoot is the ravishing beauty seen earlier in a composite. But that's what modeling is all about: put on the makeup and turn on the lights, and something extraordinary happens. This transformation is not as apparent with male models: they look very much the same in front of the camera and in their private lives.

THE MAKINGS OF A SUCCESSFUL MODEL

What makes a good model? Nature has a great deal to do with it, since the primary prerequisites for a female model are that she be fairly tall and slender and have strong bone structure. She must also have charisma, that indefinable something that makes her interesting and not merely pretty; she must have one of those faces that the camera "loves." (As all photographers know, the camera makes its own rules in choosing which faces it will flatter and which it will reject, regardless of apparent beauty.)

Male models must be taller than average because they must be taller than the women they are photographed with. The term *good looking* is more loosely defined when applied to male models. They can look rugged, carry a little extra weight, and don't need to have perfect features.

I believe that talent is definitely involved. Top models reach the height of their profession because they know how to "turn on" in front of the camera and relate to it on cue. The best models also have a personality that captures the imagination of the viewer. Experienced models know how to move. They also know how to deliver a variety of looks and convey a wide range of emotions. They take direction. When you work with an experienced model, you can relax a little and do your job. I have worked with some top models who were so skilled at turning on in front of the camera that I could use almost every frame I shot.

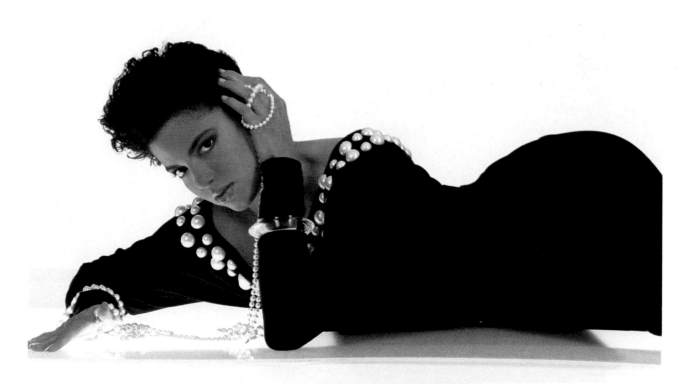

This model strikes a strong pose in a simple setting. Her beauty and charisma make this photograph a success.

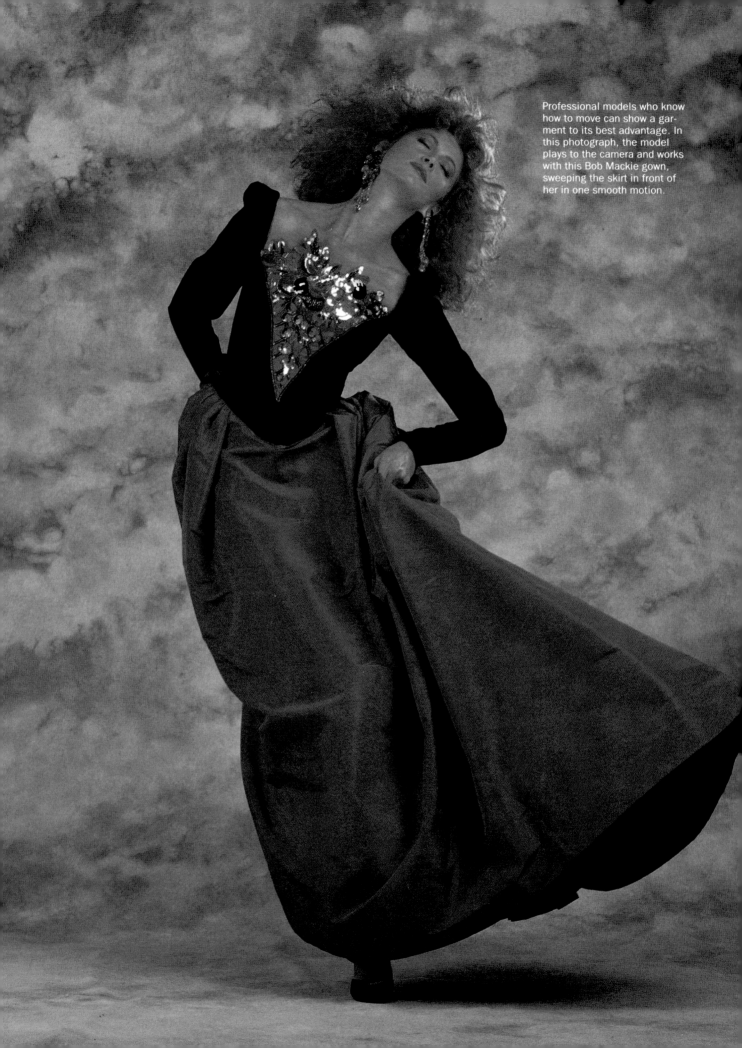

Professional models who know how to move can show a garment to its best advantage. In this photograph, the model plays to the camera and works with this Bob Mackie gown, sweeping the skirt in front of her in one smooth motion.

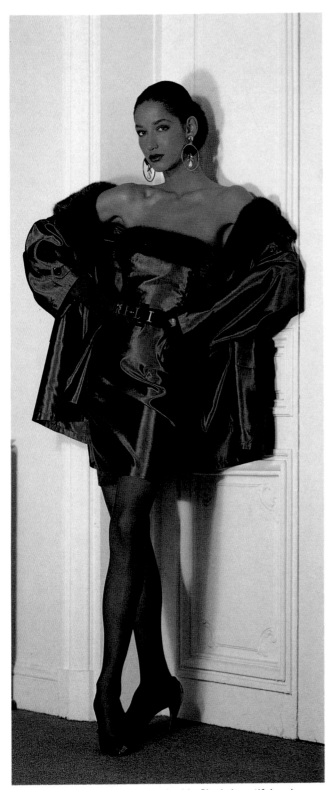

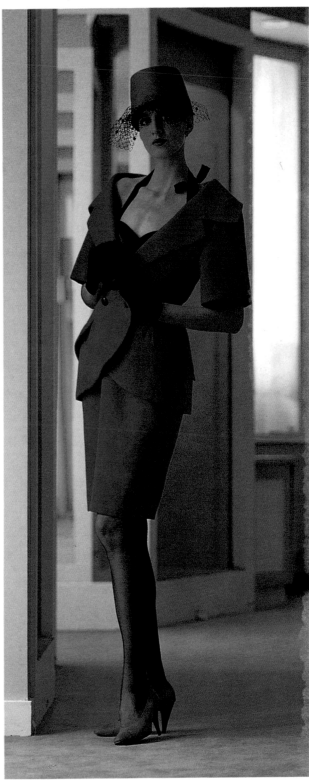

This model was a pleasure to work with. She is beautiful and dramatic-looking, and she is able to strike a variety of poses in spontaneous, fluid motions, making her a successful model.

I photographed this classic design at the Christian Dior show-room in Paris. The model was chosen because her presence and sophisticated look reflected the company's image. She carries the garment gracefully and elegantly.

You might feel that using a less experienced model with a lower hourly rate will save you money, but I have found that this rarely happens. Seasoned professionals can save you time and money because you shoot less film when you work with them. Models need more than an attractive face and a perfect body.

Some models are good for fashion shots, while others are good for beauty shots. Some models carry garments well and are best suited for full-length fashion layouts; others have perfect features and make their living doing closeup beauty shots. Some models move freely but can't hold a pose for long; others are more static but can strike a pose and stay that way for hours. Models who do catalog work know how to move correctly for this particular type of assignment: unlike other kinds of fashion photography, in which freedom of movement is desirable, catalog assignments require more static postures that reveal the details of the garments.

Beyond hereditary assets and on-camera talent, however, much of a model's success has to do with timing. Just look at magazine covers from only a few years ago, and you will see that preferences in facial features change as often as styles of fashion. Blue-eyed blondes may be in great demand one year, but exotic brunettes will be favored the following year.

A MULTITUDE OF SHAPES, SIZES, AND AGES

The modeling business is booming. Fees are skyrocketing, and more agencies and special departments within agencies have opened. These changes have evolved because clients began to realize that there must be a consistency between product and image. Until recently, a female model's career was over by the time she reached thirty, but now the burgeoning market addressed to more mature women has expanded the demand for older models. Modeling agencies have created divisions

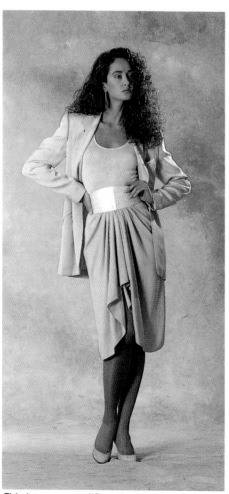

This image exemplifies what makes fashion photography so appealing: an attractive model dressed in a beautiful garment, striking a pose that showcases the design.

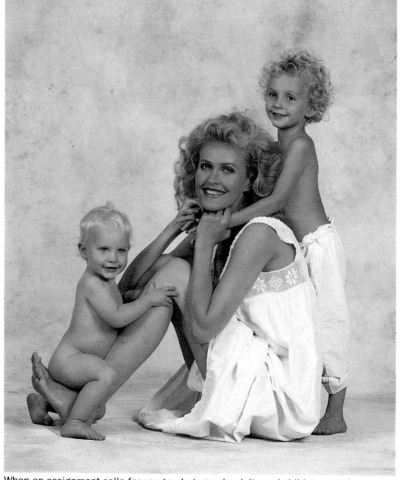

When an assignment calls for you to photograph adults and children together, you may find yourself working with members of the same family. You can be a little more relaxed and creative during such sessions: because the children feel comfortable with one of their parents near them, you can readily capture warmth and emotion. Usually, however, models aren't related, and you will need to coax the children into cooperating—and interacting with the adults.

to meet the market needs of businesswomen, petite women, oversized women, and other specialty groups. Research has proven that women in these groups want to see women like themselves in ads.

In response, companies have begun to address the various desires of their potential customers. For example, clients now put larger garments on large-size models. This strategy increases sales because this image is believable. Larger women look at the ads and say, "That outfit looks great on her. It will look great on me, too!" For the dozens of catalogs and specialty stores that cater to the oversized woman, there are agencies that represent models who wear size twelve or larger.

Traditionally, major agencies required a female model to be 5'8" or taller. Other agencies would accept shorter models, so when height was not an important factor for the product, you could book a shorter model if you wished. Today, there are more opportunities for petite models. They are often cast for cosmetic ads. Many fashion designers have started their own petite lines and work with smaller models. Some major agencies now have separate divisions for female models under 5'6".

These new divisions have not yet extended to the male markets. Although there are many male types, including the traditional "tall, dark, and handsome," preppy, Ivy League, rugged, and junior types, no catalogs are devoted exclusively to larger or older men.

Also, preconceived ideas about racial and ethnic types have relaxed during the last decade or so. Black models used to be considered appropriate for *Essence* or *Ebony* magazines only. Now, every magazine and product—from *Vogue* to Ivory soap—uses black models. Similarly, Oriental models are considered "cosmopolitan." The new attitude toward and appreciation of the variety of models available has enriched and expanded the world of fashion photography.

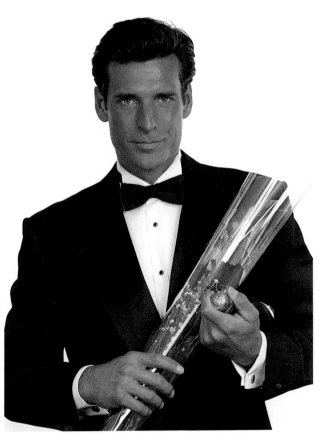

Male models are defined by their look, just as their female counterparts are. This model's classically handsome features appeal to most clients, but other types, such as rugged and preppy males, are often requested also.

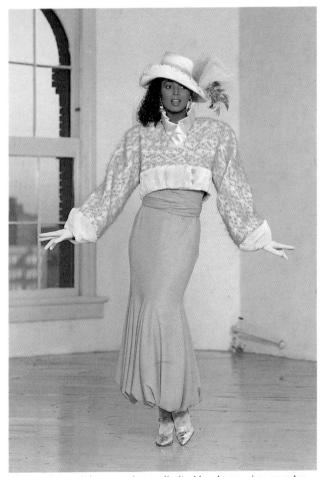

Successful models are no longer limited by shape, size, or color. Attractive models who can convey different attitudes and ideas through simple but effective expressions, gestures, and poses are sought after.

When an assignment calls for two or more models, their looks should be complementary. And, although they may meet for the first time on the set, they may have to appear to be involved with one another. The relationship between the "couple" in this image is mysterious and provocative: the man watching the woman arouses curiosity.

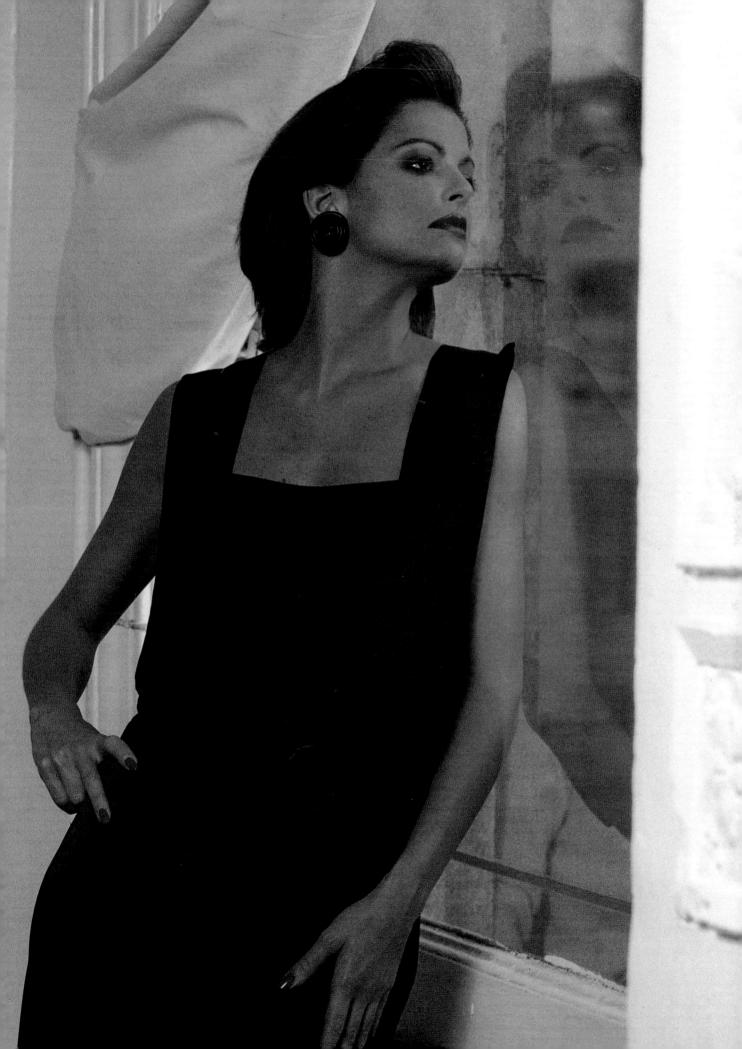

Specializing. Models who specialize in "body parts" remain anonymous to the general public. Hand models are very much in demand for hand care products, jewelry, and other accessories. There are also specialties within this specialty. You may want an elegant, long-fingered, youthful-looking hand; a "housewife" hand with shorter nails and fingers; or a "character" hand that shows some age. A "weathered and rugged" man's hand can be ideal for a beer or ale advertisement, and a manicured, graceful hand for an expensive watch.

Models with perfect feet are difficult to find because of all the abuse feet take from exercise, high heels, and ill-fitting shoes.

A model with a perfect body need not have a perfect face. Muscles seem to be enjoying a popular period, and bodybuilders—both male and female—who never considered modeling as a career before work all the time.

Another area is the runway model, who in the past was used for fashion shows only. Runway models must be tall and striking, and have a great stage presence. But they need not be photogenic, and neither their skin nor their features have to be perfect.

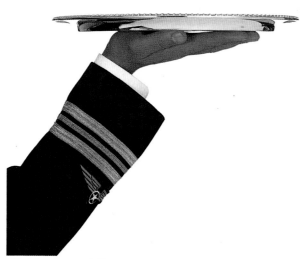

Models who specialize may seem to have relatively easy, glamorous jobs, but their work is often quite demanding. The hand model cast for this photograph, taken for the "Serving Up the Bahamas" campaign for BahamasAir, had to hold the tray in this position for an hour.

Muscular bodies are in great demand for sports-oriented advertisements. Bodybuilders like the model in this shot are quite adept at posing and flexing to show off their hard-earned physiques.

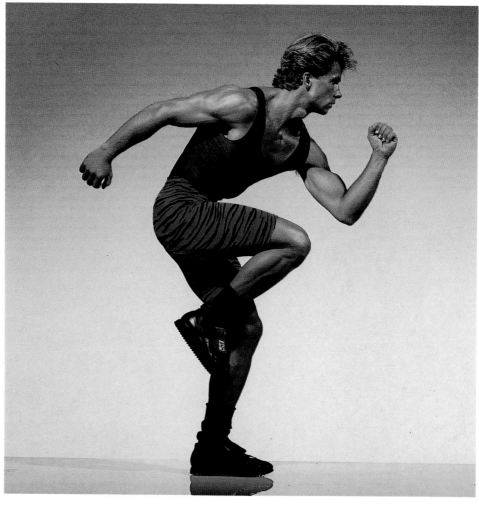

WORKING WITH CHILDREN

You may assume that your work in fashion photography will be with beautiful, sophisticated models. However, there will be occasions when you may work with children. It's always best, and certainly less time-consuming for everyone involved, if "professional" children are used. They are accustomed to being in front of the camera and know how to take direction. They are also aware that they have to be careful with wardrobe and props. Modeling agencies try to teach them what will be expected of them. (While larger agencies work with a limited number of children and handle them exclusively, there are many "managers" who represent a number of children and work with several agencies.) Despite the ease of working with professional child models, I have had some great photo sessions with "kids off the street," too.

During a shoot, I like to let children be themselves. This is the best way to capture their personalities. Like adult models, child

models have certain needs that you should attempt to accommodate. On the day of the session, have some toys around to interest them. Since their attention span is limited, you have to work fast. Some children are shy in front of the camera, but with a little coaxing and encouragement, you can get some endearing results. When you photograph young children, always cast and book backup models. This way, if one child is uncooperative or becomes sleepy or hysterical, the backup can take over.

Strict rules govern the use of children as models. When working with children, you must adhere to these standard practices and regulations. Each child under the age of sixteen must have working papers. It is your responsibility to check them, either during a go-see (see page 33), a casting call, or a photo session. Many photographers will not even allow a child in the studio without these papers. If there is an accident, your insurance company will ascertain whether

everything under your control was executed properly and legally.

In New York State, these papers are called Model Permits. *To apply for this permit, the child's parents or guardian must furnish the child's social security number, birth certificate, and a doctor's note with a legitimate signature stating that the child is in good health. If the child is of school age, a note from the school is also required. The permit expires every year.*

Children may work only a limited number of hours. The time they can work increases as they get older. They can work more hours during the summer than the school year. Children must be accompanied by a guardian.

Because of past abuses, there are now laws protecting the child's income. Checks are written in the child's name. Legally, the parents may not cash them: they must put them in a custodial account. The parents are allowed to take out only a small percentage of the money for expenses they incurred.

As a professional child model, this little girl knows how to pose, how to get on her marks, and how to show garments.

These children aren't professional models; they're just kids being kids. I gave them soap bubbles as a prop, hoping to keep them occupied and their attention focused during the shoot.

Photographing children requires you to respond quickly. I caught this baby in motion as she ran across the backdrop, completely unaware of the camera.

WORKING WITH ANIMALS

Several agencies in New York City book animals, from aardvarks to zebras. These agencies usually don't produce the same quality of beautiful books (see page 32) that "human" agencies do, but they do keep and continually update large looseleaf notebooks containing photographs of the animal models available.

When you first contact an animal agency and describe the session you are planning, the booker will send over the notebook. You can then narrow down your choices over the phone. If the animal must be able to perform tricks, the booker must know. Even simple commands, such as "Sit," can take hours if the animal hasn't been trained. If you need the animal to be able to complete a more difficult task, the booker will ask whether the animal's trainer can teach the stunt in the time available. If you need a newborn puppy or kitten, the booker can tell you which of the agency's "clients" are expecting.

The personnel at these agencies are quite helpful. They know that the average client will be no more specific than asking for "a fluffy, red puppy"—but the booker will help customers find precisely what they need. The booker might even suggest a go-see. Because an animal can't "hop on the subway," there will be a nominal charge for this service.

The booker will also suggest different breeds, and, in some cases, advise against a particular breed. For example, I once shot an ad that required white doves. The booker explained that white pigeons are larger, easier to handle, and, because they are not as rare or fragile, are much cheaper. I used the pigeons, and I don't think anyone knew the difference.

Baby animals, such as puppies, chicks, and foals, tire easily, don't like to be away from their mothers, have a short attention span, and are not particularly reliable. You will usually double-book a baby animal, so that while one sleeps, you will be able to work with the backup. Keep in mind that agencies require a two-hour minimum for booking animals.

Working with larger or more exotic animals is a little more complicated. New York City requires you to get a certificate of insurance for any large animal you bring into the city. You may also have to get a one-day rider from your insurance carrier to protect yourself against any damage done to equipment, property, or personnel. Remember, even though these animals are trained, accidents can happen.

Every animal on a set, even domesticated house pets, must have a handler or trainer. You wouldn't want a puppy running around loose near electrical equipment or a cat pawing wires.

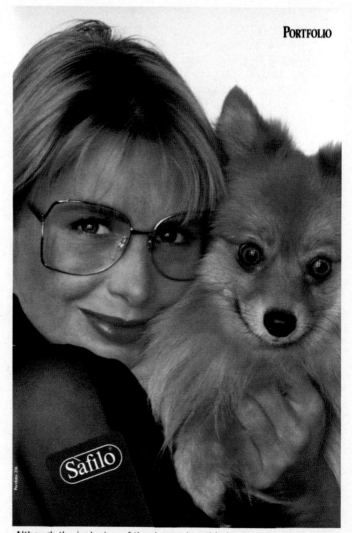

PORTFOLIO

Safilo

Although the inclusion of the dog makes this image more appealing, the focus remains on the subject of the assignment: the eyeglass frames.

MODELING AGENCIES

The major New York City agencies are Elite, Ford, Wilhelmina, and Zoli. Like their counterparts in other cities around the world, these agencies not only book assignments, but also oversee their models' careers. They continuously scout new talent. They look for photographic ability as well as such intangibles as presence, magnetism, spirit, and energy. If they spot that "certain something," they will work closely with that person. They will introduce the model to photographers and help her build a portfolio. They will guide the model step by step, starting her out with easy assignments in order to build her confidence. They will go over each test session with the model, slide by slide, pointing out pronounced imperfections and working with the model to correct them. They will help her put together a composite and line up potential clients.

The major agencies represent most of the highest-paid and successful models in the country. Female models who work through these agencies are usually tall, 5'7" and over, beautiful, and between the ages of seventeen and twenty-five. Male models are ordinarily between 6' and 6'2", a size forty, and handsome.

Because of the overwhelming abundance of models, there are also many smaller agencies that represent the multitudes of models who are working but will never be superstars. Some models feel they get lost in the shuffle in a big agency and prefer to work with a smaller one.

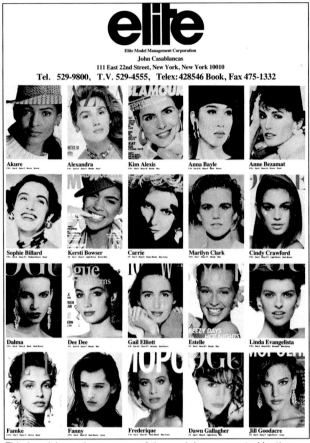

This headsheet shows some of the models represented by the Elite modeling agency. The models' photographs, names, and statistics, including height, dress and shoe size, and coloring, are included.

This uniform model voucher, which the Zoli agency sends to its models before they are booked for an assignment, confirms in writing the number of hours they are scheduled to work and the agreed-upon rate. The form must be signed by the model and the art director, or by the client or agency's representative. If neither individual is on the set, the photographer acts as the representative.

STARTING OUT

Initially, models must make the rounds and see almost every photographer in the fashion business. This is made easier for them by the testing boards within their agencies. It is the sole job of the bookers who comprise testing boards to set up appointments for the agency's newest models to *test* with a variety of photographers—a process that gives the models exposure within the photographic community (see Chapter 6, page 120).

The agencies act as liaisons between photographers and models, setting up shoot dates and discussing with each photographer exactly what type of photograph a particular models needs for her portfolio. This process requires give and take. For example, if I am planning a test using lingerie, I will ask the bookers to recommend a model or two who would be interested. Of course, when models are just starting out, they need most types of shots and are usually available on short notice.

At first, bookings may be few and far between. Once established, good models can expect their bookings to be more frequent. But, to earn repeat bookings and to build a successful career, models must always be professional by showing up on time and being ready to work. The model whose attitude reflects an unwillingness to cooperate or whose work habits disappoint photographers will soon be chronically unemployed.

MODEL PROMOTION

Agencies promote their models on an ongoing basis several ways. These promotions keep everyone in the fashion business up-to-date on the models currently available and introduce new talent.

Agency Books. Twice a year, I receive beautifully produced books from modeling agencies showing photographs of the models they currently represent. Agencies spend a great deal of money on these books, which are sent gratis to working photographers, advertising personnel, and other professionals who might be interested in hiring models.

Each agency's book has a specific style. Traditionally, each model is allotted a single page that consists of a half-page beauty shot, which is a closeup of the model's face, and half a page of smaller photos showing various poses and/or actual ads in which the model has appeared. The page also includes the model's height, weight, dress/suit size, shoe size, bust/waist/hip measurements, hair/eye colors, union affiliations, and any other specialties, such as "excellent hands." (You should pay close attention to this data when you are hiring a model; such details as hair color can be essential since lighting may alter true hair color.) Some books are produced totally in black and white; others include a mixture of color and black and white.

Along with the books, the agencies send a large pull-out sheet showing all of their models' faces. This pull-out is suitable for hanging on a wall as a ready reference. It serves as a reminder to potential clients and reinforces the agency's name.

Composites. A *composite* is a card that shows several different photographs of the same model, usually shot by various photographers. Designed like the pages in the agency books, composites ordinarily include a head shot, a body shot showing the models wearing swim-

Modeling agency books are
usually updated and distributed
twice a year.

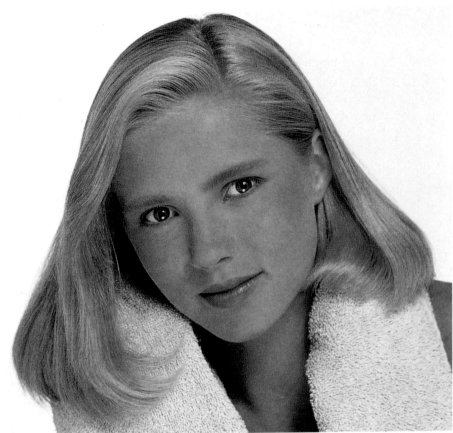

I cast this model because of her fresh face, which is perfect for cosmetic lines targeted at the teenage market. This youthful look is appropriate for advertisements in such publications as *Seventeen*.

wear or lingerie, and, perhaps, a couple of shots showing the model in various poses. The composites also list the model's measurements, as well as the other data found in the agency books.

Composites serve as the model's calling card. If models are out of town or otherwise unavailable for inclusion in the semiannual books, the agencies send out model composites from time to time. Composites may also be sent out on new models who come to be represented by the agencies between mailings. They are left behind on each casting call, so that the client and photographer will remember the model and have his or her vital statistics on hand. Models frequently update their composite with their most recent "looks."

As a working fashion photographer, I receive hundreds of model composites in the mail. I keep those I like for reference and have the most current agency books within easy reach.

Go-Sees. Occasionally, I schedule general *go-sees*. The term means exactly that: the agencies send any new models they represent to "go see" me at my studio. Bookers at the agencies call me to schedule sessions to meet their new people. I keep the number of models at each go-see to a minimum, so that I can remember my reaction to each model. I schedule models from several agencies in a two-hour period at the beginning or end of the day. I look at their books, keep their composites, and make notes if I think I would like to cast them in the future. I also ask if they are willing to test. I then have a pool of models to choose from.

CASTING MODELS

Casting the right model is essential. Of all the elements involved in fashion photography, I believe that your choice of a model comprises 90 percent of a photograph's impact. It is the model's appeal that will sell garments.

You must be exacting, specific, and sometimes technical when you cast. You have to know what you are looking for in terms of height, body measurements, and type. You wouldn't select a flat-chested model to wear a provocative garment, or a young, fresh-faced junior to model a $30,000 ballgown. Conversely, it would be a disaster to choose a strong, sophisticated-looking model to sell a product meant for the junior market. And, you would not cast a rugged, "outdoorsy" man when hired to photograph a classically tailored suit.

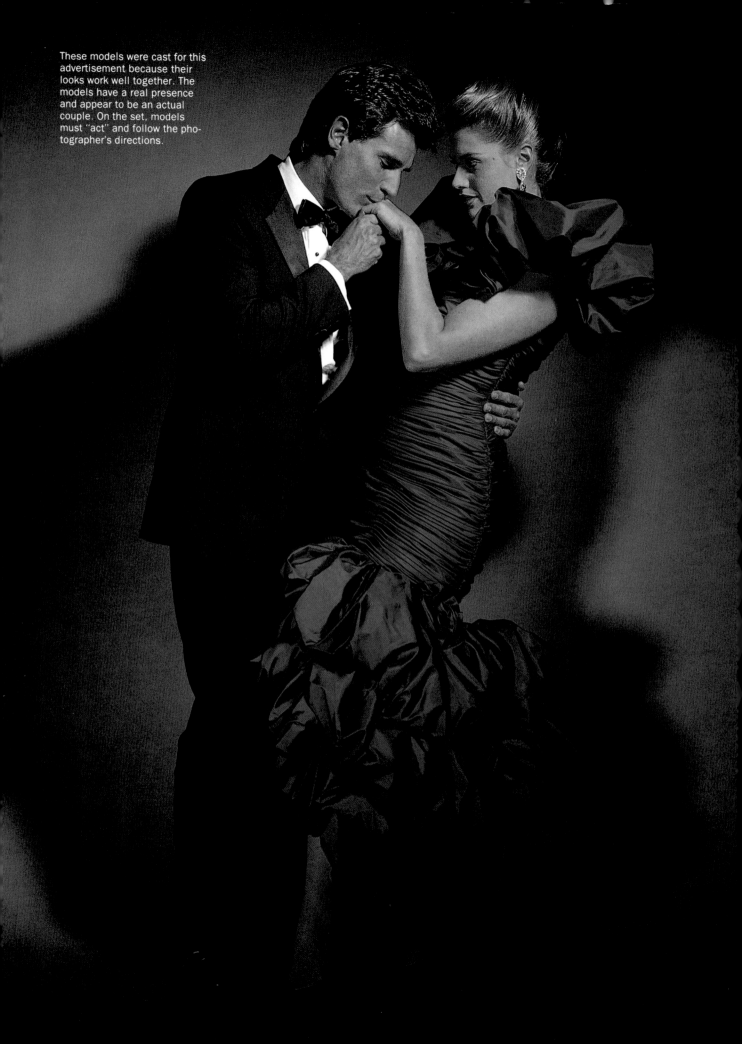

These models were cast for this advertisement because their looks work well together. The models have a real presence and appear to be an actual couple. On the set, models must "act" and follow the photographer's directions.

The first discussion with the client and the art director about choosing the most appropriate model for an assignment should be centered on defining the type of model they envision for the ad. Help them narrow down their choices. Are they looking for a junior, an all-American type, an ethnic type, or a sophisticated type? Ask detailed questions about hair color and length, and any other important distinguishing features or considerations they feel are necessary.

From your agency books and composites, compile a list of those models who might be suitable. Next, schedule a time to go over your selections with the client and art director. Because most art directors have their own copies of the agency books, you can review your choices of models over the telephone. Notice the type of model he or she gravitates to. Unless the client wants to book a model directly from the agency book, you may have to hold a casting call.

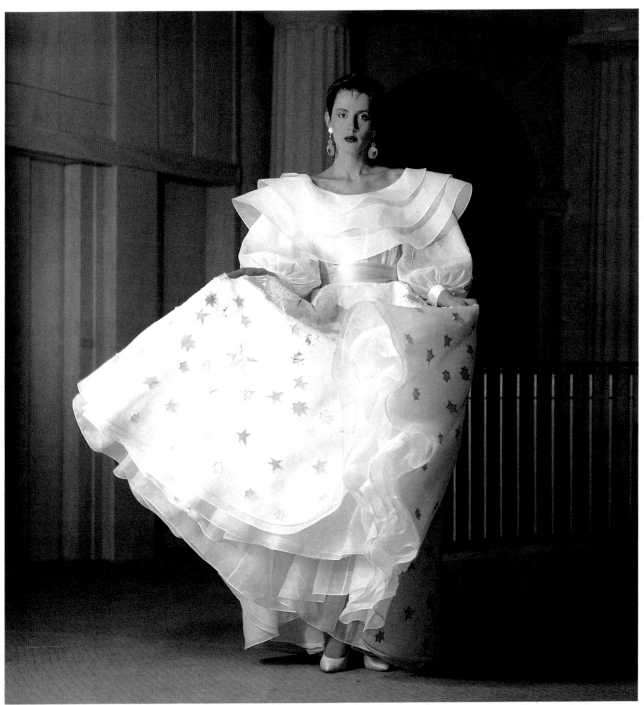

The model wearing this gown, photographed in Paris at the House of Nina Ricci, was cast by the design house. She was selected because her height and sophisticated look enabled her to carry this billowing garment well.

This session may be necessary for various reasons:

- The art director and/or the client may request a specific model who is unavailable. They may wish to see other, similar models from different agencies.
- You might need to show clients pictures of models with lower hourly rates if the preferred model's fee exceeds the amount budgeted.
- At times, clients or art directors have no idea what type of model they need and ask to see "every model in New York City!" If this happens, you must call almost every agency and set up a huge casting session, often referred to as a *cattle call*. These can be overwhelming for the models, for you, and for the clients. However, having seen every type of model available, the clients can then determine which qualities best suit their ad.

For cattle calls, have at least one assistant with you. If you are not well organized, the casting session can be chaotic and fruitless. When viewing the models, make two piles of composites: one with pictures of models who are being considered and one for those who aren't. After each model leaves, jot down a few notes directly on the composite to have something to refresh your memory later.

Top models are too heavily booked to go to casting sessions, so their agencies send over the models' portfolios; however, the client may still ask to see the model in order to fit the product. In this case, a time convenient for both will have to be agreed upon. Communication with your client is the key.

When casting for certain jobs, the client will ask you to take Polaroids of each model. If the job requires the model to hold a product, it's a good idea to place it in the proper position before shooting the Polaroids. Attach the Polaroids to the composites and send them to the advertising agency to be reviewed and decided on by the creative team.

Some assignments call for the models to have certain specific outstanding features. For example, if you will be working with a product for which fit is important, such as eyeglasses, you should request models with great faces and noses when scheduling a casting session. If the client is not able to attend, you may be asked to take a Polaroid of each model wearing the product.

If you decide to do catalog assignments, you will sometimes discover that the catalog house has a list of preferred models and will cast and book the models itself. When the company leaves the choice of the model up to you, be careful to ruthlessly scrutinize every detail of the models' features. If several models qualify technically, choose someone you think is "special." Use your instinct when determining which model best personifies the qualities you want. The emotional power of a photograph depends on an element you can't always identify or describe—you simply feel it.

With experience, you will develop preferences about models you want to work with and whose look is right for a particular assignment. If I have an opinion, good or bad, about a model I have worked with, I feel it is important that I share it with both the client and the art director.

PICTURES CAN LIE

Models may look great in their composites, but there's no guarantee that "what you see is what you get." This is a major reason why you should see models before booking. If they recently returned from a vacation, they might have a tan, which can cause problems. Also, the model's composite may list her dress size as seven/eight—which was true when that picture was taken—but when she shows up for the shoot, she is a size twelve.

Another problem you might encounter is a change in hair length or style. Even if you saw the model

on a general go-see a month earlier, you can never be sure that her hairstyle is the same. The difference can be extreme, and there you are, expecting a model with long hair and someone with a bob arrives.

The matter of height is especially important when booking two or more models. I once wanted to photograph two models posing as a couple. The client handled the casting without consulting me and booked models but neglected to consider their comparative heights. The male model was nearly a foot taller than his female counterpart.

To overcome this problem, we ended up standing the woman on a telephone book. Nevertheless, because she was tiny and he was big-boned, she looked quite out of place next to him. While many real couples are not nearly or exactly the same height, a big difference will throw off the balance of a photograph.

Although it is the agency's responsibility to make certain that its models' composites are current, you should check models carefully before casting them for an assignment.

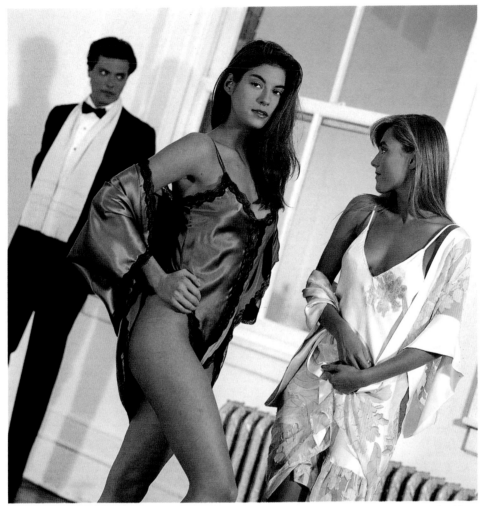

To overcome the problem of a noticeable height difference between the man and the women in this image, I asked the male model to stand against the wall in the background. Then I tilted the camera slightly to change the lines of and to add interest to this photograph, taken for a lingerie advertisement.

BOOKING MODELS

It is standard practice for photographers or their studio managers to book models. To do this, determine how many hours you will need with each model and, even more important, the purpose of the photographs. The first question the booker will ask is: "What is this for?"

If you need to hire just one model for an assignment, start with your first choice. Call the agency and ask for that model's booker. When booking a model for a major client with a major product, check with the agency to see that the model has no conflicts. A conflict arises when the model's face has appeared in an ad for a competing product.

For a catalog shoot, you will probably be interested in models from several different agencies. The first step in this process is to contact each agency. Because every model you are interested in may work with a different booker, you must ask for each booker individually to find out which models on your list are available. Unless you are lucky, many of the models will be unavailable for one reason or another. As mentioned earlier, many models spend much of the year traveling in Europe, working fashion shows and building portfolios. Some are under exclusive contracts. Others will be booked. Expect this, and don't despair: bookers will gladly suggest alternatives.

Once you have found a suitable model who is available at the scheduled time, you are ready to place a *tentative hold*. In this situation, you have the first option on that block of the model's time. Of course, since all the potential clients are trying to juggle schedules, the models you want may already be on a tentative hold. You may then get a *secondary*, which means that if the first client releases the model from that time, you will be notified and asked if you want to confirm the booking time or to put the model on a tentative hold.

When you are certain that all the other people involved are available for the photography session, you then confirm the booking with the modeling agency. You will release any other models you have on tentative and secondary hold at this time.

Usually, the agency records the confirmation and asks you for the date you are confirming, time slot, client, usage, and billing information. If the advertising agency has no credit history with the modeling agency and, therefore, is not in its computer, the agency will either run a credit check or ask that the model fees be paid upon completion of the shoot.

Next, tell the booker what you expect the model to bring to the session, such as pantyhose, shoes, ties, suspenders, and any other wardrobe items. Specify that a female model should come to the shoot with clean hair and no makeup, which means that a makeup artist and hairstylist will be at the studio, or with hair and makeup ready, which means that she should come with her hair styled and makeup applied. Precious time is wasted if the makeup artist has to remove old makeup before the application of fresh makeup can begin. Also, if you want the model to have her nails manicured in advance, you must mention it beforehand. Similarly, if she is to wear nail polish, you must specify the color.

If you are planning to shoot outdoors, indicate "weather permitting." Then, if on the morning of the session, you or your client feels that it is raining or snowing too hard for the shoot to take place, you will have the option of canceling the shoot and will be charged only half of the agreed-upon fee. I sometimes ask for a *weather permit* when I am shooting during the winter months and know that the client must travel a distance to get to the session. By doing this, I am telling the agency that if a rainstorm or a snowstorm prevents the client from getting to the shoot, I will have to cancel it. Of course, I explain this to the booker when I confirm the date.

Clearly, booking models sometimes becomes an exercise in organization and persistence. The process can be quite complicated, especially on a catalog shoot for which you have to coordinate the schedules of several models from different agencies, or with different bookers within the same agency, booking each model for only a few hours.

You will find that once you have confirmed a model, agencies are quite reluctant to let you cancel or reschedule without a penalty. Although each agency has its own policy regarding cancellations and rescheduling, most policies state the following: If the agency is notified of the change more than five working days prior to booking, you will be charged half the fee. For

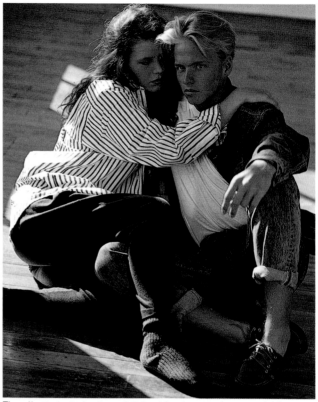

The client wanted a "couple" for this shot, so these particular models were booked because their natural looks suited the casual attire and pose, as well as each other—and because they had no scheduling conflicts.

notification three working days prior to booking, you will be charged the full fee. This policy is certainly understandable. Both the agency and the model would stand to lose substantial amounts of money if the agency permitted random cancellations.

Another standard practice is for the client or art director to sign the model's voucher at the end of the booking. This confirms the amount of time the model has worked and the amount of money that is due. One copy is given to the client. If the client or art director is not on the set, you will sign the voucher, acting as the advertising agency's representative.

DETERMINING FEES

Although modeling agencies have set fees for particular jobs, every price is negotiable. If business is slow and you are working on a tight budget, the agency might suggest several models who would be willing to work for less than their customary fees. Standard hourly rates range from $300 per hour to $5,000 per day, but you will also come upon special situations that must be negotiated separately.

Exclusive Contracts. When one company wants a particular model to be associated solely with its product,

it negotiates an *exclusive contract*: the model is not allowed to accept any work from competitors. Some companies, such as Estée Lauder and Lancôme, frequently want one model to represent their cosmetics and/or fragrance exclusively. Depending on the contract, the model may or may not be allowed to work for products other than cosmetics. Major designers also have exclusive deals with models; they can't work for any other designer. Models must be compensated handsomely for signing an exclusive contract because they are giving up the potential income they would be earning by working for other clients.

Lingerie. Although rates vary radically, depending on the model, lingerie modeling still commands much higher hourly rates than regular assignments do. An agency will usually charge double the hourly rate for the actual time the model spends in front of the camera. Makeup time, travel time, and fitting time are still charged at the standard rate, however. Be aware, though, that not every model will agree to pose in lingerie because of the stigma formerly attached to this type of modeling, despite society's more relaxed attitude toward it. Even television commercials now include advertisements in which models wear bras, panties, and briefs.

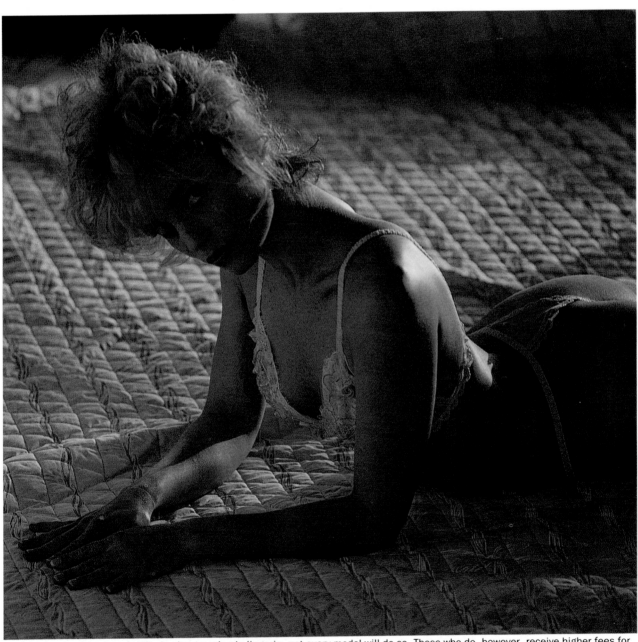

Despite the current relaxed attitude about posing in lingerie, not every model will do so. Those who do, however, receive higher fees for this type of assignment. Be sure to advise the modeling agency that you are planning a lingerie shoot. This will prevent a last-minute disaster: having a model show up on the day of the session and refuse to work.

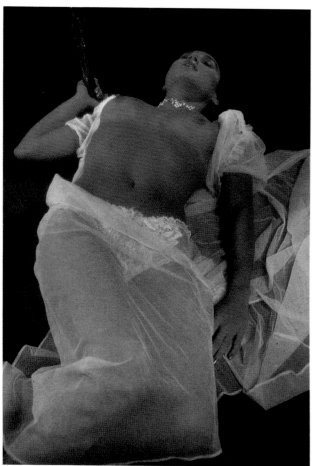

I wanted to create a sensual mood to complement this sheer garment, as well as to try an unusual approach for a lingerie advertisement. I asked the model to lie on the floor, and then I photographed her from various angles.

BOOKING CONDITIONS

All model rates including lingerie underwear will be published separately.
All usage must be negotiated as rates apply to shooting time only.

TRAVEL TIME: Full Fee

HAIRDRESSING TIME: Full Fee

TIME AND ONE-HALF: Before 9:00 a.m. and after 5:30 p.m.
Day rate bookings are eight hours between 9:00 a.m. and 5:30 p.m.
There is an agency service charge of 20% on all USA bookings and usage fees. All foreign billing will be charged at 20%.
A finance charge of 2% per month will be applied to all invoices not paid within 30 days.

PRODUCTS: Please check all consumer product bookings with us for conflicts and rates. No bookings for consumer product packages, riser cards, posters, use of models names, hang tags, or any display material, package inserts, etc. may be made without specific clearance.

CANCELLATIONS: Cancellations of definite bookings within five working days of the beginning of the booking will be charged at half fee—within three working days, full fee.

TENTATIVE BOOKINGS: Tentative bookings may be cancelled at anytime by either the model or the client at no charge. If the client does not release or confirm tentative bookings, the agency reserves the right to cancel.

WEATHER PERMITS: All same day cancellations—half fee.
Weather permits cancellations made earlier subject to normal cancellation policy.

VIDEO & FILM: All bookings involving motion picture film or video recording must be negotiated in advance.

DOUBLES, TRIPLES: When booking involves more than one model, it is the clients responsibility to inform the agency.

LINGERIE/UNDERWEAR: Must be done on closed set and the client must specify type of lingerie.

CHANGING FACILITIES: Client must provide private CHANGING FACILITIES on all bookings including location.

Each modeling agency has a set of booking conditions like those of the Ford agency.

Nudity. Unlike lingerie modeling, there is still a stigma attached to posing in the nude. Accordingly, models who agree to pose nude charge very high fees. You can expect to pay $5,000 or more for such work on an ad. Even though models are paid top dollar, not too many will do it. They are concerned about when and where nude photographs might turn up later. Large agencies that care about a model's long-term career do not encourage their models to pose nude.

The release form for a nude shoot must specify exactly the way the photographs will be used and for how long. Models are advised not to sign a photographer's release on this type of shoot because unauthorized shots could fall into the wrong hands. The agency must sign a release for the photographs actually used in an advertisement and stipulates that no other photos from that session are permitted to be used for any other purpose whatsoever.

There is not much call for nudity in fashion photography because magazines have restrictions on nudity. However, if you are hired for just such an assignment, you ask the model to pose nude on the set and then crop the shot to work properly in the ad, so that magazines are able to publish it.

Bonuses. These additional fees are paid to models whose faces appear on products, packaging, point-of-purchase displays, billboards, bus shelters, and other mass transportation spaces. The model is paid an hourly or daily rate for the session, and a usage fee is added for the first three- or six-month period. The agency usually gets three six-month options at the same rate.

Buyouts. A model is given a lump sum as a complete *buyout* for the use of a particular picture or pictures. She then signs a release stipulating that she will not receive any additional money regardless of future usage. According to the more prestigious agencies, buyouts do not exist; they feel that there must always be a cutoff time for usage. The agencies strongly advise models not to sign such an agreement unless they intend to leave the business.

Directing Models. The relationship you have with a model during the few hours he or she is in front of the camera is crucial to the outcome of the photograph. The rapport you have—or don't have—will most certainly be apparent. Your relationship is unique and intimate. You are asking the model to expose his or her feelings to you and your camera. Do everything you can to create a relaxed atmosphere.

In between shots, the makeup artist adjusts this model's makeup. It's important that the models are not unnecessarily distracted during the shoot: they will lose their focus. Photographers must make sure that they are the only ones who give models direction; too many instructions will only confuse them.

On the set, you should give models direction. If they are experienced, they will move freely and skillfully, bringing their own instinctive talents into play. Experienced models know their faces and bodies well and are aware of their flaws. They know which positions work for them. However, there are often technical reasons why a certain position that is unnatural or seemingly awkward must be assumed. Experienced models are familiar with such situations and will cooperate with you without any hesitation.

Often, you will spend more time preparing models for the shoot than actually photographing them. When directing models, notice their hand placement. The hands should have a natural, fluid movement. The models should also move their feet without any awkwardness. Be careful to avoid an artificial, posed look. Tell the models whether you want them to look directly at the camera or off to its side.

You should also inform each model what the day's plans are and, if possible, have a schedule available for all complicated shoots. Make sure that everyone on the team understands your concept in advance. The models will already have received certain basic information from their booking agencies, but creative concepts have a tendency to be misunderstood.

Accommodating Models' Needs. Music is important; it relaxes the model, establishes a mood, and blocks out distractions. It is essential, however, to play the kind of music that is right for each session. Rock is great if you need energy. Bach or other classical music works well if you want to create a sense of elegance on the set. I avoid Muzak, or "elevator" music, because it doesn't help create the atmosphere necessary for a high-energy, bursting-at-the-seams editorial shot.

During a meal break, the models must be careful not to upset their hair or disturb their makeup. You can make this easier for them by providing drinking straws. Such consideration is greatly appreciated.

Finally, keep in mind that models are sensitive, emotional people. When I was a model, I was often treated like a piece of furniture or a mannequin. To prevent any offense, ask the art director to tell you exactly what the models should do; then you and you alone, as the director of the shoot, should relay these instructions to the models. Other members of your staff should be cautioned not to give any instructions directly to the models because they can lose their focus quickly in the face of confusing, conflicting, or overlapping instructions. Models should look forward to coming to your studio and should enjoy working with you.

ASSEMBLING THE TEAM

The final photograph for a fashion assignment represents a team effort that displays the creative and artistic input of everyone involved, from the client to the model. But long before this photograph becomes a reality, the photographer has a great deal of preparatory work to do. This includes the very important task of putting together the best people for the assignment. The members of the photographer's team are the fashion stylist, the hair and makeup artists, and the assistants. ✿ As the photographer for the assignment, you are in charge of and responsible for the smooth running of the production. You have to choose the members of your team carefully. While you will, of course, be most interested in their individual skills, you must give some thought to the way in which they will work together and interact. For example, you should select a makeup artist who does a very fine, clean makeup to complement a hairstylist who specializes in natural styles (if this is the look the client and art director wish to achieve). ✿ The result of your individual team members' work should look cohesive, consistent, and appealing—and should reflect a carefully organized and orchestrated effort. ✿

STYLISTS

One of the most invaluable members of the fashion photographer's team is the stylist. This position requires imagination, foresight, and resourcefulness.

Once the decision to hire a stylist is made, the next step is to discuss who will choose the stylist. The art director may ask you to select someone you feel is qualified for the assignment, or may suggest someone. Every situation is different.

The stylist is hired to accessorize and pull together the "look" that will be photographed. She is responsible for the fashions and accessories (any item worn by the models, including garments, hats, gloves, and jewelry) as well as for the props (any object that isn't worn, such as furniture, equipment, knick-knacks, and *set dressing*—window treatments, wallpaper, and anything else perceived as adding atmosphere to the set).

Depending on the job, the stylist may be responsible for gathering everything needed, or just specific items. When she is hired as an "on-set" stylist, her responsibilities may begin and end at the actual session.

One of the stylist's most essential talents is an innate and well-informed sense of style. She must be out in the market continuously to keep abreast of the new fashions, and she must know what colors the designers are showing each season. The stylist must also focus at all times on the final result: the completed photographs. She must be sensitive to the balance, color, form, and textures working together in the images.

Furthermore, a good stylist is able to solve hundreds of problems that arise during a shoot. She knows how clothing should fit and can swiftly fasten and pin an ill-fitting dress until the proportions are right for the model.

On a more personal level, the stylist must be self-confident without being arrogant; she must also be compassionate, calm, and able to handle any crisis. There is no room for temperament. She must have the ability to understand and analyze divergent points of view. At production meetings, she listens to the client, the art director, and other members of the team who may articulate conflicting ideas. It is then up to the stylist to translate the essence of their ideas into props, accessories, and clothing.

Having a lively imagination is imperative, as is the ability to think fast. The stylist must respond quickly to impulses, performing magic on the spur of a moment—and on demand. With no more than a large piece of fabric and a few accessories to work with, she should be able to create a spectacular outfit.

Before the day of the shoot, the art director requested a variety of colors to choose from. Here, on the set, he and the stylist discuss which shirts he prefers.

Stylists spread out and organize all the items they bring to the shoot, so that the art director and client can choose accessories easily.

Here, a stylist checks details regarding the model's appearance, looking for problems and making necessary adjustments.

In order to hone her skills and broaden her base of knowledge, the stylist spends a great deal of time canvassing stores, developing resources, and working on her craft. If she had to produce a prop, such as a valuable antique, a smart stylist would get permission to use it at no cost in exchange for a credit line on the advertisement it is needed for. This is the kind of diplomatic bargaining that becomes second nature for a top stylist. She must also maintain a variety of contacts with her sources and know what she can retrieve through them. In fact, being able to locate props—from the simplest to the most extraordinary—is an essential skill.

During the shoot, the stylist must make sure that the props are not mistreated or abused; after the shoot, she must return all borrowed goods in their original condition.

Only a few stylists have that "extra something." During one of my shootings, I wanted the stylist to accessorize the model's hair with something different, but nothing on hand seemed appropriate. The stylist took a black dress, twisted it into a crude rope, and wound it around the model's head. Voila! A fabulous turban instantly!

Many newcomers enter this field believing it offers a great lifestyle, easy money, and the opportunity to shop continuously. Many novice stylists also think that they need only a portfolio to call themselves stylists. Be careful when you hire, and remember, no fashion sources lend expensive clothing to just anyone who walks in and calls herself a stylist. She must have credibility.

Developing Sources. A novice stylist may have a unique sense of fashion, but she will need time to develop prop and garment resources. Usually, a woman interested in becoming a stylist works for someone in a similar capacity, perhaps as an assistant to an in-house stylist at a company or a magazine, or for a photographer.

In large cities, the stylist must be familiar with the flower, antique, trimmings, and millinery districts, as well as the garment center. She must know which fashion houses carry which types of clothing. When she finds a department store or boutique that carries items she likes, she must introduce herself to the public relations staff. Stylists must also keep current by attending the various "expos," trade shows, and fashion shows.

Many experienced stylists spend years building their contacts. Having a source for a specific type or color of garment or a chair that is "just right" is as important as the stylist's inherent taste.

Buying, Renting, and Borrowing. For each assignment, the stylist has to determine what she must buy outright, what she can rent, and what she can borrow in exchange for a credit line. (A typical credit line might read: "Dress by John Doe.") While some clients prefer to buy everything needed for a shoot rather than give a credit line, the credit line is a customary point of negotiation with suppliers.

When a stylist borrows items in exchange for a credit line, I feel more comfortable when she puts the agreements in writing. Often, a stylist will promise a credit line to a source but will not follow up to make sure it appears. This is unfortunate, and once the ad runs without the credit line, the omission is hard to rectify. Such disasters may discourage a particular source from ever lending garments, props, or accessories again. To prevent these problems, sources have become more demanding when lending their garments, and clothing manufacturers who are experienced with stylists will often request a letter from the client or

From left to right: Elasta 3038, Contempora 751, Sporting 7506, Elasta 1507

For this Safilo eyeglass promotional campaign, the stylist was asked to create several characters through the use of different outfits and props. The stylist relied on a number of sources, gathering everything from a tuxedo and a rose to a golf shirt and clubs.

advertising agency stating that the manufacturer will definitely receive a credit line.

Renting or exchanging shoes for credit seems to be universally difficult for stylists. Luckily, the large number of stores that sell less expensive shoes has eased this problem, without straining budgets. If a stylist does manage to borrow expensive shoes, make sure that she covers the soles entirely with masking tape before the model wears them; this prevents the soles from getting scratched or scuffed. Even a clean studio floor will mar brand-new soles.

A few large department stores have a "studio service" that is a great convenience for the fashion stylist. She makes an appointment to choose merchandise she thinks the client will approve. After the stylist signs out the items she wants, the client has five working days to choose pieces for the shoot. The client is obligated to purchase a minimum of 20 percent of the merchandise. Once the minimum is reached, the client can return any unused merchandise at no cost.

Some stylists make a practice of buying an article of clothing from a retail shop and returning it for a refund after the shoot. I try to discreetly ask potential stylists if they use this approach; I am unwilling to hire such stylists because I think that the practice is dishonest and unfair to the retailer.

Finally, while the photographer or advertising agency involved with a shoot should remember to send tearsheets to the people who supplied the props, fashions, and accessories, it is up to the stylist to make sure that this is done. Thanking sources is a welcome touch and helps stylists maintain professional relationships.

Working on an Assignment. Understanding the concept that guides an assignment is the stylist's first task. She then must communicate with the essential individuals involved in the execution of the layout. To fully utilize the stylist's talent, you may need to schedule one or more preproduction meetings.

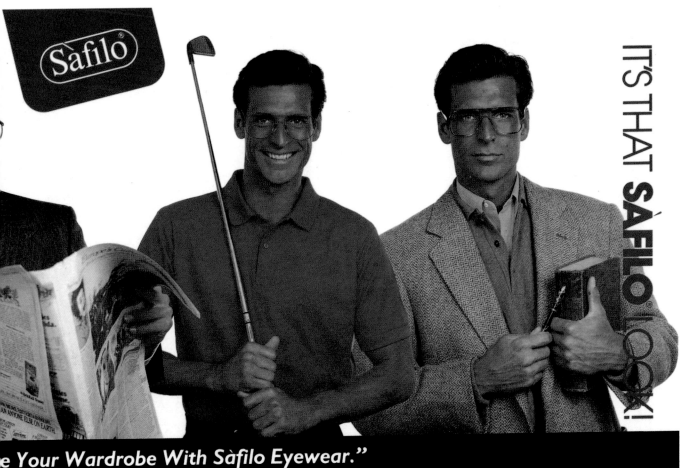

Preproduction Meetings. Before you confirm a booking with a stylist, you must discuss the layout. A simple job will probably require only a single day of preparation. If the assignment is complicated, allow for additional time. You must also consider and decide upon in advance the number of preparation days required.

A stylist might have one or more preproduction meetings with you and the art director to discuss specific color themes and to plan the session. She can have a tremendous influence on the final photograph because she, more than anyone else involved, knows exactly what is available. Stylists are good sources of information. They are exposed to various situations with many different models and have firsthand knowledge that can affect your own decisions. The stylist might know if a specific model has a tan, or she might be aware of other problems that wouldn't appear on a composite.

If you have flexibility in scheduling the shoot, check with your stylist to learn whether the date in mind falls during "market week." This is when manufacturers who would otherwise lend their clothing need their samples to sell the line. A stylist may be forced to obtain clothes from the last season and, in general, may have fewer garments and styles to choose from.

The budget must also be discussed. The stylist should have a realistic idea of what she is truly capable of getting for credit, and what she must rent.

Preparation. Depending on the scope of the assignment, the stylist will spend part of a day, one whole day, or even more time gathering props, fashions, and accessories.

Preparation days are hectic and involve a great deal of legwork. If the stylist has several shoots to prepare for at once, she will try to consolidate them. Her first task might be to make a list of all the resources she wants to cover, such as showrooms, manufacturers, and department stores. Next, she will make personal appointments if necessary and try to allot blocks of time in specific geographic areas, keeping in mind that although some retail stores remain open after 6 o'clock in the evening, most showrooms and manufacturers close at 5 o'clock.

When she finds items that she would like to use—garments, for example—she has several options: she can take Polaroids for the client to review and make choices; she can send the garments to the photographer or client for approval several days in advance; or she can send the clothing to the studio the night before the shoot, giving the clients a wide variety to choose from. Every situation is different.

The schedule on the next page represents a typical preparation day for a stylist in New York City. The stylist has to gather the items needed for the shoot: one woman's formal gown, with accessories; one woman's cocktail-length evening dress; one man's dress suit, with shirt and accessories; one tuxedo; and sheer drapery.

After laying out and organizing the outfits needed for a shoot, the stylist keeps an exact inventory, noting which sources provided which garments. After the shoot, the stylist makes sure that no garment has been damaged, checks the inventory list, packs the garments neatly, and returns everything to the various sources.

One-Day Preparation Schedule

8 A.M.–9 A.M.
–Look through files for appropriate sources

9 A.M.–10 A.M.
–Make telephone calls to schedule appointments
–Make 3:45 P.M. appointment with art director to review Polaroids of clothing

10:00 A.M.–10:30 A.M.
–Travel to garment district

10:30 A.M.–12:30 P.M.
–Keep appointments with four contacts in two different buildings in garment center
–Take Polaroids of six women's formals, three cocktail dresses, and four silk shawls

12:30 P.M.–1 P.M.
–Eat lunch on the run while walking to fabric center

1 P.M.–1:30 P.M.
–Scout fabric sources
–Take six swatches

1:30 P.M.–1:45 P.M.
–Travel to jewelry center

1:45 P.M.–2:30 P.M.
–Keep three appointments in jewelry showrooms in the same building
–Sign rental form for five pairs of earrings, two bracelets, four rings, and three necklaces

2:30 P.M.–2:40 P.M.
–Travel to menswear showroom

2:40 P.M.–3:30 P.M.
–Keep appointments in menswear showroom
–Select three navy suits and one black tuxedo
–Call car messenger from showroom and arrange for delivery of suits and tuxedo to photographer's studio

3:30 P.M.–3:45 P.M.
–Travel to art director's office

3:45 P.M.–4:30 P.M.
–Review Polaroids of clothing with art director
–After clothing selection is done, arrange for pickup of garments at showrooms and delivery to photographer
–Send check to cover jewelry rental
–Send jewelry via messenger to photographer's studio
–Ask for check to cover the cost of the drapery
–Call fabric store, and order drapery
–Set up appointment to pick up the drapery at 8 o'clock the following morning

During a session, a stylist helps a model change quickly into the next outfit she is scheduled to pose in. Stylists must pay close attention to small but important details, such as wrinkles and obtrusive pins and clips.

Duties on the Set. The stylist is responsible for the clothing when it is at the photographer's studio. Other duties include pinning and clipping; taping up a collar or a belt end, so that it lies flat; or clamping the back of a jacket, so that it doesn't move every time the model shifts positions. The stylist must iron any wrinkled garments without burning or damaging them.

A prepared stylist brings scissors, a pincushion, and double-sided tape that will not ruin a garment. Small details requiring a minor adjustment can actually be quite costly. During a shoot, one of my assistants was trying to be helpful by using black masking tape to hold down the end of a belt worn with a silk dress. Without realizing that he had damaged the dress, we returned it to the designer. When the designer examined the $1,500 garment, he was quite upset. He expected to be reimbursed for the full cost of the dress. Luckily, I was able to have the dress cleaned and the adhesive removed for a mere $60.

During the shoot, the stylist remains on the set and, standing behind the photographer, watches the model, so that she can view the scene at the same angle as the camera. She must focus her attention on such details as the placement of clamps, pins, and double-sided tape. If any of these fasteners start to show, she should alert the photographer. When the session is rushed, the photographer can't always be responsible for seeing every detail. It's aggravating to have to throw away an entire roll of film because no one noticed that a blouse was buttoned incorrectly or that a clamp showed from behind.

Clearly, an on-set stylist has to work well under pressure. I once had to stop a flustered new assistant stylist from steam-ironing a sweater *directly on* a model.

Styling for the Fashion Markets. As fees increase throughout the fashion photography world, there is more and more specialization. Each client, and each job, requires unique elements. Fashion stylists are becoming experts in individual areas and, as such, are identified by different titles (see below).

Freelance stylists work for individual photographers, catalogs, magazines, and advertising agencies on a by-assignment basis. Some freelance stylists are represented by agencies that also represent freelance makeup artists and hairstylists.

Established freelancers often have their own staff. They can work on several jobs concurrently by having one or more assistants to do the legwork. If the stylist is scheduled to be on the set, her assistant can be in the field gathering props for the next assignment. The assistant can pack and return garments, thereby freeing the stylist to start on another project.

In general, a fashion stylist can work in any of the following areas.

Editorial. In the editorial market, top magazines frequently have stylists on staff who are sometimes called *sittings editors*, or *editorial stylists*. These individuals style the fashions that appear on the editorial pages. They also attend all designer fashion shows and are familiar with the latest collections. Within a magazine, there may be specialists who cover a specific area, such as shoes, clothing, or accessories. The sittings editors then put it all together.

As trendsetters, they play an integral role in developing the fashion outlook for the magazine. And, because magazines offer a credit line for the use of clothing and accessories, sittings editors rarely need a rental budget.

Advertising. Stylists who help to execute commercial advertisements must have an eye for detail and great contacts. These stylists ordinarily have a budget for the rental of clothing and accessories because most clients don't want to share their advertising space or to give credit to other manufacturers. Stylists who do advertising work are freelancers and must be booked in advance.

Catalog. When you are booked to shoot an assignment for a fashion catalog, the garments have already been selected by the mail order house or department store. A stylist can prop and accessorize, as well as locate, such items as shoes, gloves, scarves, hats, and handbags. If working for a department store, the stylist may requisition props directly from the store itself. Photographers whose catalog work comprises the major portion of their business employ a full-time stylist. Also, many catalog houses supply a stylist for the session.

Production Coordination. For some assignments, you will need a *production coordinator*, a stylist who organizes the entire shoot. This situation usually occurs

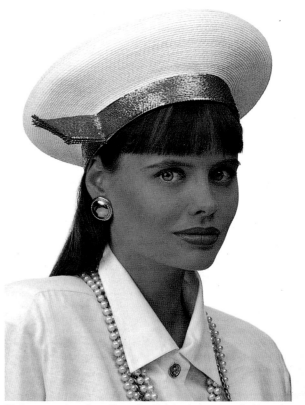

Styling can alter the effect of a finished photograph. Here, I photographed the same model in three different outfits to achieve various looks. In this shot, the white blouse and white hat with gold trim convey a sense of elegance.

with jobs that have large budgets and with layouts that require many models, numerous props, and close attention to countless details. The production coordinator, the photographer, and the art director communicate continuously between the preproduction meeting and the session.

Depending on the situation, the production coordinator may be responsible for scouting locations, casting models, booking the hairstylist and makeup artist, and bringing a diverse selection of clothing, accessories, and props. This is an enormous, challenging task. The whole "look" of the finished photograph depends on the production coordinator's contributions.

Hiring a Stylist. A stylist may be hired by the client, art director, or photographer; this decision is addressed during preproduction meetings. Once hired, the stylist will probably work with all three individuals. A stylist is hired for many reasons. When you are working on a shoot that will require many garments, accessories, and props that will not be provided by the client, you need someone to research, select, gather, and deliver them. For example, during the preproduction meeting, the

client tells you that he wants several pairs of long, dangling diamond earrings and five sexy, black dresses to choose from, so that everyone involved will have enough options available and will then be able to select the best one for the ad. He also wants a specific prop: a Lalique vase that was made many decades ago. Locating these items might take days. If you are scheduled to shoot another job that same week, you will barely have time to attend the meetings let alone to scout out the requested items. This is the time to hire a stylist.

Even a seemingly uncomplicated shoot can prove to be quite a challenge for a stylist. Suppose the proposed layout for a cigarette advertisement shows a model in a business suit seated at a conference table in a paneled room. Easy? Yes and no. You would simply have to rent an office for this assignment, but the stylist would have to bring an assortment of suits in various colors with matching blouses, pantyhose, and shoes; assorted notebooks, telephones, pens, and pencils; as well as other props to place around the set. Although the art director would probably offer direction as to color scheme, the stylist would still bring in a wide range of garments and office paraphernalia to give the art director a choice.

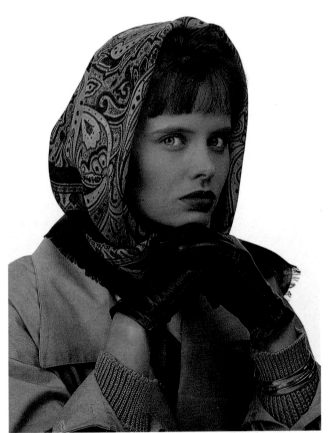

For a more casual feel, the stylist selected a polished-cotton raincoat, a black and gold scarf, and green leather gloves.

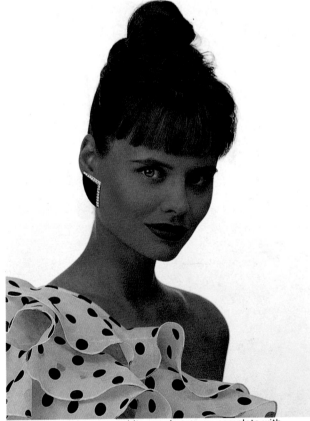

Here, the model wears a white evening gown, complete with ruffles and black polka dots, and looks quite glamorous.

Interviewing and Evaluating a Stylist. Before you book a stylist, you must get to know the person you're considering working with. A stylist can make or break a shooting. When you interview a stylist, it's important that you ask the right questions. You can't always take a stylist's word on faith alone, and because you don't want to hire someone who is not right for a particular assignment, you must always check references. Spend the time and make a few phone calls to people who have worked with the stylist before. Ask for recommendations and choose carefully.

Ask the following questions about each photograph when looking through a stylist's book:

- Did you get this clothing through your contacts?
- Were you able to obtain the clothing in exchange for a credit line? Did you have to rent or buy anything?
- Were you responsible for the accessories or were they supplied by the client?
- What about props? Did you get them?
- Was the original layout specific?
- Did you plan the color scheme?
- Was this effect your idea?
- Did you stay within your budget?
- How many days did you need to prepare?
- Were you the stylist or the assistant on this job?

It's important to ask specifically what the stylist brought to each photograph because her responsibilities vary from job to job.

I can't stress enough how critical it is to scrutinize the pictures in a stylist's portfolio. You may see a striking, well-styled photograph. While the stylist may have been on the shoot, she may have had nothing to do with bringing in the clothing and accessories. You won't know for certain unless you ask the people involved.

Building a Repertoire of Stylists. No two stylists are alike. Each one has secrets she is unwilling to share and, of course, individual strengths and weaknesses. As a result, you need to acquaint yourself with a variety of talented stylists, so that you will know which one to hire for any particular job. Some stylists are more aesthetically sensitive than others. One might have a keen awareness of textures; another, the interplay of colors. Certain stylists are ideally suited for advertising campaigns, others are better for catalog jobs, and still others are perfect for editorial assignments. Some stylists are masterful at gathering unique, wonderful accessories and props: they know twenty-five jewelers, ten florists, and fifteen pillow companies. I keep notes in my files on each stylist's strong and weak points.

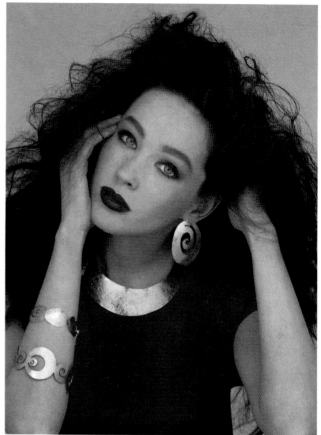

For this photograph of Diane Von Furstenberg jewelry, the makeup artist used rich, bold colors, and the hairstylist worked with the model's thick, luxurious hair to match the designer's look.

My favorite stylists are flexible in their approach and feel comfortable working with any scenario. For example, some clients prefer to give the stylist a great deal of creative freedom. They frame a general idea of the feel they are looking for and simply outline the types of props and garments necessary. Other clients give a stylist specific instructions; they know precisely what they want and simply need someone else to produce it. In either case, the stylist must work according to the client's needs and desires. (You will sometimes have to serve as an arbitrator between the stylist and the client and/or the art director. Keep in mind, however, that it is the client who pays the bill.)

Fees, Cash Advances, and Payments. Any on-staff stylist, whether she works for an individual photographer, a catalog house, or a magazine, receives a salary. Salaries vary greatly depending on the job description and the specific situation.

Freelance stylists are paid per diem. Day rates do not include any expenses incurred preparing for the shoot. The stylist will also be reimbursed or paid in advance

(usually by the advertising agency) for rentals, purchases, transportation, messengers, and other out-of-pocket expenses. She will also be paid for the day(s) she spends getting ready for the shoot, the day of the shoot, as well as the time it takes her afterward to return everything she gathered for the session. To be properly reimbursed, a stylist must keep an accurate accounting of her expenditures, including receipts.

The stylist's fee depends in part on her reputation. A competent, respected stylist can command a large fee because of the knowledge, expertise, and background she brings to any assignment.

WORKING WITH A LIMITED OR NO STYLING BUDGET

During budget discussions in pre-production meetings, the client and the art director must set realistic goals. Obviously, if they have a limited budget to work with, they must realize that the stylist will have to borrow clothing and accessories in exchange for a credit line. Most stylists also have an assortment of items of their own to draw from.

When a client cannot afford a stylist, the stylist's duties may fall upon you. In the absence of a clothing budget, you will discuss with the models whether or not they would be willing—or able—to use their own clothes for the session. Some models have a suitable wardrobe, while others (including some of the highest-paid models) do not. Your role will be to advise the art director or the client of what the models own and to see if they have any other alternatives in mind. If the model brings his or her own clothing to the shoot, everyone on the set must pay extra attention to the garments and the way they fall. This will help the photographer, who is working without the benefit of the stylist's attentive, critical eyes.

You might even be able to supply some of the clothing and props yourself. When you enter the fashion photography business, you may have the time to look for a specific prop and to start building your resources. This valuable experience will give you a better understanding of the problems stylists often confront.

As your business builds, keep on hand manuals and books that list prop houses, furniture showrooms, costume companies, and other sources. Familiarize yourself with these publications, and visit the various businesses to see exactly what they stock. Four excellent annual sourcebooks that I frequently use are: The New York Theatrical Sourcebook *(Broadway Press),* Photo Source *(Professional Photo Source),* Tipps Directory *(Harbin Communications Group), and* The Madison Avenue Handbook *(Peter Glenn Publications).*

Through the years, I have built up quite a collection of gloves, hats, jewelry, and accessories, as well as an extensive wardrobe to turn to in case of an emergency. I found these items at flea markets and antique shows, and my clients are always delighted to draw from this resource. You also can—and should—keep an eye out for unusual finds as you pass vendors on busy city streets, browse in shops in sleepy rural towns, and attend auctions.

My collection of costume jewelry comes in handy when there is no budget for a stylist—and grows year after year.

HAIR AND MAKEUP ARTISTS

Not too long ago, on all but the most prestigious shoots, models were expected to apply their makeup themselves and to style their own hair. Models traveled with enormous makeup cases, hairdryers, rollers, and hairspray. Today, the skills of applying makeup and styling hair have developed into an art, and you will be working with specialists who do only hair, others who do only makeup, and still others who do both. You must know an artist's special skills and talents when hiring someone or making a recommendation to a client.

This is why I keep three separate files labeled "Hair," "Makeup," and "Hair and Makeup." In each entry in my "Hair" category, I list the hairstylist's name, rate, strengths, and (if appropriate) agency. If he is represented by an agency, I include his home phone number for two reasons. First, I have sometimes had to reach a hairstylist during off hours and was not able to because the agency was closed. Also, from time to time, hairstylists switch agencies, so having their home number saves me the time of tracking them down.

In addition, in the entry I also note if a hairstylist can work fast; if so, he would be good to hire for a catalog job. On this type of shoot, you're working quickly but still must produce a variety of different looks. The hairstylists' entries also list strengths, such as "great with hairpieces" or "best with long hair."

Finally, remember that the artists you choose must be current. Hair and makeup trends change as quickly as clothing trends do, and a dated makeup or hairstyle can ruin an otherwise perfect shot.

Selecting a Hairstylist. Some hairstylists are better at a more "styled" look (one that clearly requires the skills of a hairstylist), while others feel more at home working on a natural look (one that might conceivably have been achieved by the model herself). Achieving either of these looks requires skill and talent, and some hairstylists can accomplish both.

Before selecting a hairstylist for a photo shoot, you must pay attention to the client's needs and/or the art director's ideas. If a natural look is requested, you must be able to turn to your files to find a hairstylist who can create this effect. Although I occasionally have to book someone I have never worked with and hope that everything works out satisfactorily, I prefer to know the

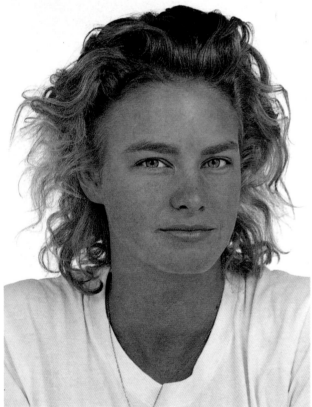

I had arranged for both a hairstylist and a makeup artist for this test, so I asked the model to arrive on the set with clean hair and no makeup. Makeup artist Peter Brown and hairstylist Timothy Downs, experts in their fields, worked together to create the following three different looks.

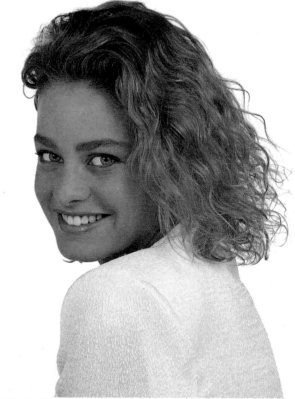

For this "editorial" look, the hairstylist created a casual hairstyle, and the makeup artist complemented it with a clean, soft, and natural makeup.

personalities and abilities of all of my team members—especially how much time they require.

When booking a hairstylist, you should consider the model's hair type, so that you can estimate the amount of time needed for the styling. For example, suppose you have booked a model with naturally curly hair that is also full and long, but the client wants her hair to be straight in the photograph. Effecting such a dramatic change in appearance—by blowing dry the model's hair layer by layer—might take half an hour or more. In another situation, a client might want finger waves in the model's hair. To achieve this look, the hairstylist must use a setting lotion or gel on her hair to hold the waves while the hair dries. Allow more time for this process. As this happens, the makeup artist should begin working to save some time.

Professional hairstylists arrive at the studio or location equipped with hot rollers, a curling iron, a blow dryer, various types of combs and brushes, styling gel, mousse, and hairspray.

Selecting a Makeup Artist. Makeup should enhance, not overpower, a model's features. (If you will be shooting in black and white, however, keep in mind that makeup for this type of photography can be heavier and much more defined than makeup for color work.) The competent makeup artist regards a model's face as his palette, and just as there are all kinds of painters, so are there all kinds of makeup artists. Some create sophisticated, "made-up" looks; others excel at clean, natural looks; and still others love to experiment. Be familiar with the special skills of the makeup artists you usually work with, and watch out for those who get a bit carried away with leaving their mark on a particular assignment.

To choose a makeup artist wisely, you must first be able to recognize a poor makeup application. Signs include a shiny face (unless a special effect is desired), lumpy mascara, and unevenly blended eyeshadow or blush. Makeup should look the same on each eye (unless the model's eyes are dissimilar, in which case the makeup artist must compensate for the difference).

Once you book a makeup artist, you should tell him or her as much as possible about the shoot: whether it will last the entire day, how many models will be on the set, how many setups there will be, if the photographs will be taken closeup or from a distance, and what looks

For a sense of elegance and drama, the hairstylist pulled the model's hair off her face and swept it up on top of her head; the makeup artist added to her strong, sophisticated look by intensifying the colors of the eye makeup and lipstick.

This "catalog" photograph called for heavier makeup and a more structured hairstyle than the "editorial" shot.

the hairstylist will be expected to create. The makeup artist should take direction from you alone.

Selecting a makeup artist carefully is crucial to a successful shoot. The camera is ruthless; it picks up every line and smudge. A photograph can be ruined by a small lipstick smudge in the corner of the lips on an otherwise beautifully made-up face. As a former model, I am particularly sensitive to flaws and am quick to spot them in a photograph. Although makeup mistakes can seem minor, they can ruin entire rolls of film. Be sure to hire skilled professionals whose work you know and trust.

When you work with a particular makeup artist, you are putting your name on his or her work. This is, perhaps, the most important reason to hire an individual carefully. And, because makeup ads shown in portfolios might have been extensively retouched, it might be difficult to judge the artist's actual work. (If you suspect retouching, you might ask to see some of the original chromes.) It's a good idea to arrange a test session with the chosen artist before the shoot. The test not only reveals strengths and weaknesses, but also shows you the amount of time the artist requires to complete the work. A test with a truly outstanding makeup artist can inspire you to experiment and discover intriguing new ideas (see "Finding New Talent" on page 55).

Finally, be aware that because fashion photographs are usually shot from a distance, the precise blending of makeup is not as critical as it would be in, for example, a closeup beauty shot for a national ad. In most fashion shots, assuming the makeup is applied competently, the look will do. There are no set rules.

Coordinating the Artists. As the photographer for an assignment, you are responsible for planning and implementing a feasible schedule. To do this efficiently, you need to know how long each artist will take to finish working. Rushing someone on the set is never pleasant, and while you and the client may feel that great hair and makeup are worth waiting for, you may change your minds as the hours drift past and the models lose their energy. There's a fine line between exacting work and excessive work. Everyone in the fashion business must work with one eye on the clock. Because hair and makeup artists tend to get carried away, you may be forced to shoot under pressure. To prevent this potentially serious problem, you must take control of your team. Remember, this is your shoot, and your name is on the line.

To coordinate schedules when several shots are involved, I sometimes distribute a shooting plan at the

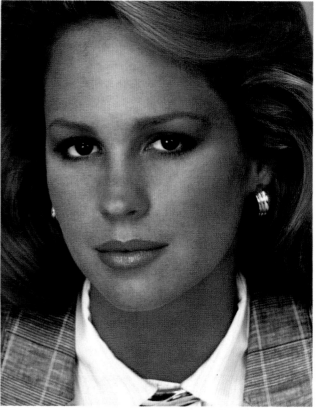

This beauty shot shows an excellent example of a clean makeup: soft and well-blended. The makeup enhances the model's features without calling attention to itself.

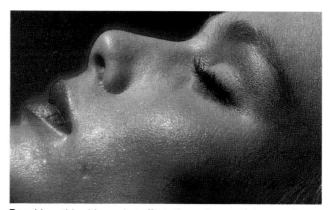

To achieve this shimmering effect, the makeup artist sprayed water on the model's face.

start of the day. I used the following shooting plan for an advertisement for eyeglasses.

Shooting plans let the hair and makeup artists know how much time is scheduled for them to work before each shot. For example, if I am photographing a beauty shot for a national advertisement, I allot more time than usual for hair and makeup. On the other hand, for a catalog assignment, which can require fitting ten to fifteen shots into a single day, I schedule less time for hair and makeup; I expect the artists to change the models' looks and styles quickly.

Photography Schedule: Safilo Shoot, 1/26 and 1/27

Studio: Tekno/Balcar Studios, 15 E. 30th St., Studio A, 5th Floor, 889-5080

DAY 1, Tuesday, 1/26

Shot #1, 10:30 A.M.
"Grocery Shopping" (Long shot)*
Model—Stephanie
Props—Eyeglass frames, baby, bag of groceries
*Note: Baby will arrive at 10:15 A.M.

Shot #1-A, Noon
"Grocery Shopping" (Three closeups)
Model—Amie
Props—Three frames, changes of tops, and accessories

Lunch, 1 P.M.–2 P.M.

Shot #2, 2:30 P.M.
"Career" (Long shot)
Model—Stephanie
Props—Frames, typewriter, telephone, computer paper, colorful file folders, pocketbook

Shot #2-A, 3:30 P.M.
"Career" (Three closeups)
Model—Amie
Props—Three frames, changes of tops, and accessories

Shot #3, 4:30 P.M.
"Evening" (Long shot)
Model—Stephanie
Props—Frames, multiple frames for tray, two silver serving trays, champagne glasses, tuxedo, tuxedo shirt, cufflinks

DAY 2, Wednesday, 1/27

Shot #3-A, 10:30 A.M.
"Evening" (Three closeups)
Model—Amie
Props—Three frames, changes of tops, and accessories

Shot #4, 11:30 A.M.
"Sporty" (Long shot)
Model—Stephanie
Props—Frames, tennis racket, skis, ski boots, snorkel, golf club, Ping Pong paddle

Lunch, 1 P.M.–2 P.M.

Shot #4-A, 2:30 P.M.
"Sporty" (Three closeups)
Model—Amie
Props—Three frames, changes of tops, and accessories

Shot #5, 3:30 P.M.
"Shopping for Clothes" (Long shot)*
Model—Stephanie
Props—Frames, dog with leash, hatboxes, pocketbook, assortment of shopping bags
*Note: Dog will arrive at 3:15 P.M.

Shot #5-A, 4:30 P.M.
"Shopping for Clothes" (Three closeups)
Model—Amie
Props—Three frames, changes of tops, and accessories

CUTTING CORNERS

When working on some assignments, you may find that a limited budget prevents you from spending a great deal on hair and makeup. On catalog shoots, models can be expected to do their own light makeup before they arrive on set; a hair/makeup artist will be on set only to adjust and do touch-ups. This arrangement saves the client several hours of models' fees and works best with seasoned professionals.

FINDING NEW TALENT

I continually update my files and build new working relationships with hair and makeup artists. This is a simple task because I receive a large number of composites through the mail that show an artist's most recent photographs and jobs. If I am impressed by an artist's work, I call his agency and ask to see his portfolio, which shows what the artist does best.

If the portfolio sustains my interest, I call the agency and ask if the artist will do a test photograph with me. I feel much more comfortable on a job when I have worked with the hair and makeup artists before. Sometimes, I test with someone to specifically see if we can work together well.

Testing is an ideal way to meet and work in a less pressured atmosphere, as well as the perfect time to experiment with new effects.

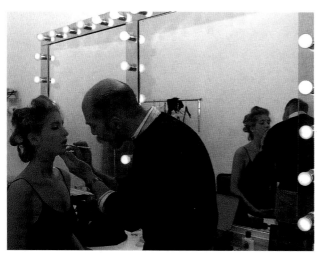

For this shot, the hair/makeup artist intensifies the color of the model's lips and puts rollers in her hair in order to create a more sophisticated look that will coordinate with the garments.

Here, the hair/makeup artist brushes the model's hair on the set, making final adjustments while I adjust the clothing before shooting begins.

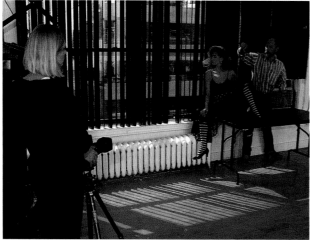

The hair/makeup artist is also responsible for watching the model throughout the shoot and doing any necessary touchups.

Duties on the Set. Which artist goes first, and why? The answer depends on what is involved in the creation of the photograph. If complicated hair waving is necessary, the hairstylist begins the lengthy procedure by putting rollers and clips in the model's hair; then, while the hair is setting, the makeup artist will get started. If the hairstyle requested is relatively simple, the makeup artist will probably work first, perhaps leaving only the powder and the lipstick to be applied after the hairstyling has been completed. Communication between the hair and makeup artists is obviously essential, so that their needs can be accommodated.

Once the model is fully prepared and is on the set, both the hairstylist and the makeup artist stand behind the photographer and check to make sure that, for example, no piece of hair sticks out; that the fan is not blowing the model's hair across her lips, smudging red lipstick on her chin; or that the model's skin is not starting to shine because of the hot lights. Clearly, then, the responsibilities of the hair and makeup artists do not end when the model is on set. They should watch her closely at all times, looking for the small imperfections that ruin photographs.

Remember that you must be the director on the set. Your job is to coordinate the requests of the client and the art director, and to establish the lines of communication. If the client or the art director tries to take charge, you must point out as diplomatically as possible that you will act as liaison and will tell the other members of the team what is wanted. Don't get involved in power plays on the set. They can be quite destructive and time-consuming.

You must also frequently check to make sure that the makeup is being applied and the model's hair is being styled according to the original plan for the shoot. It would be disastrous to give the artists carte blanche and wind up with a look that is wrong for the assignment. If the model is supposed to have a natural look but the hairstylist has a heavy hand with hairspray, ask him to brush out the hair immediately. Don't wait for the model to step onto the set.

HAIR/MAKEUP ARTISTS

Because a client may sometimes have too limited a budget to book two individual artists to do hair and makeup, it's valuable for you to have a separate file of hair/makeup artists to recommend.

Selecting a Hair/Makeup Artist. Artists who do both hair and makeup are usually stronger in one area, and this is important information to have on file. Because an artist is often reluctant to admit this, I have to determine

if an individual is better at hairstyling or at applying makeup. To make my decision, I carefully review the artist's portfolio. I look at each picture, evaluating the hair and makeup separately. Occasionally, I discover someone who is excellent at both.

Booking Hair and Makeup Artists. Hairstylists and makeup artists are booked the same way models are. If they are represented, you must call their agency, coordinate available time, put them on a tentative hold, and finally confirm the booking. Rates vary according to both the type of job—cosmetic ads offer the top of the pay scale, catalog shoots pay less than magazine ads, and editorial assignments pay very little—and the artist's reputation. Superstar makeup artists exist, too.

Many artists who do freelance work handle their own negotiations. This system has both advantages and disadvantages. If a client has a small budget, I'm more likely to call a freelance artist and negotiate a fee. On the other hand, agencies keep me informed as to who will be available, as well as take care of all bookkeeping responsibilities.

HAIRSTYLING AND MAKEUP FOR MALE MODELS

I am often asked whether male models need to have their hair styled and wear makeup for a shoot. The answer is yes. The camera does not discriminate: it is as ruthless to male faces as it is to female faces. Male faces are often ruddy, sallow, or blotchy. As a result, male models—who should come to the set freshly shaved or should be prepared to shave upon arrival—may need a light coat of powder to even out skin tones or shading to define their face a bit. Occasionally, mascara and a touch of eyeliner are applied to accentu-ate the eye area. Of course, makeup on male models should look completely natural.

Hairdressers are also hired to style men's hair. Although a male model might not have long blond hair, a hairstylist must still style and groom the model's hair. Those specialists who call themselves "male groomers" are particularly valuable on a catalog shoot when most of the styling time will be spent on the female models. Groomers even out skin tones, style hair, and pay attention to these small details that are sometimes forgotten.

A good rule of thumb to follow when you check makeup on a male model is: If you can see the makeup, too much has been applied. Here, the model's makeup is unnoticeable.

HAIRSTYLING AND MAKEUP FOR CHILDREN

Children require very little makeup, so when it is applied, it should never be obvious. The makeup artist should use a light hand. A small amount of blush and lip gloss may be all that is necessary for little girls, and little boys may need only to wet their lips. If the art director wants a curly hairstyle, remind him or her that children's hair is fine and delicate. Also, hot rollers must be used with caution, and the use of hairspray kept to a minimum: children may suffer allergic reactions.

Most children have clear, radiant skin, so makeup should be applied sparingly. Just a little blush and a touch of lip color will not alter a child's natural look.

ASSISTANTS

I hire assistants to make my job easier and to allow me to concentrate on the actual shooting. A good assistant understands this and thinks for himself. He is a professional in his own right. The assistant should know and understand the moves and needs of the photographer.

When interviewing an assistant, I make it clear that I expect them to be responsible and professional, and that assisting me is not simply a nine-to-five job. I sometimes need my assistant to be at my studio by 7 or 8 o'clock in the morning or even earlier to set up or to pack or carry equipment to a location. Also, my assistant's days rarely end at 5 o'clock. Even if the shoot ends on time, he must break down the set, put equipment away, and review the film and records with me. I find that a ten- or even a twelve-hour day is typical in the fashion photography business.

You will also quickly learn that the nature of fashion photography sometimes makes it necessary for you to book assistants at the last minute. My first phone calls are to my "regulars," assistants I know I can depend on from both a technical and a personal point of view. If all

of these individuals are busy, I then contact people from my backup files. Having several assistants you have worked with before is important to the smooth completion of a shoot. Working with a new assistant, especially on a job, can be difficult and disconcerting.

When I call freelance assistants, it is their responsibility to return my call as soon as possible. They must be professional, dependable, and punctual.

Depending on their expertise, assistants can be hired as a first or second assistant. I expect first assistants to be experienced technicians. They should be capable of handling twice the amount of responsibility as second assistants and will sometimes function as studio managers. They are indispensable.

Second assistants are hired when another pair of hands and eyes are needed on set. On a large production, the second assistant's job is to focus on details, to aid the first assistant, to be aware of all lights firing, to help carry and hold equipment, and to load film. In general, the second assistant is a "gofer," taking lunch orders and making telephone calls. When I book a second assistant, he takes direction from me, unless I

Before a shoot, assistants hang a backdrop on autopoles. Two sets of hands may be necessary when the seamless is extra long.

Assistants are responsible for setting up the equipment according to the photographer's directions.

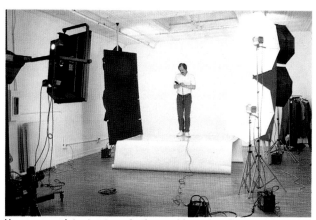
Here, my assistant acts as both stand-in and assistant as he takes a meter reading from his own face. He then checks the meter reading and balances the lights until proper exposure is achieved.

When a shoot is in progress, my assistant sometimes has to take additional readings and adjust the equipment: a shift in the model's position may require lighting modifications.

specifically advise the first assistant to direct him. The larger the production, the more assistants you need.

Duties on the Set. Assistants working with professional photographers should work in a professional manner themselves. They must be aware of all their duties on the set: examining and preparing the camera equipment, arranging and checking the lighting equipment, handling the film, keeping careful records as the shoot proceeds, and, finally, packing the equipment after the session ends. Assistants also must listen closely to the photographer and respond immediately to any request or instruction.

Before the Shoot. In preparation for the shoot, the assistant is in charge of seeing that all of the photography equipment, including electronic flash units, modeling lights, and power packs, is in working order. The assistant should double-check the cameras, replacing batteries and cleaning lenses if necessary. The assistant is also expected to adjust the lights according to the photographer's instructions and to understand and read meter exposures; to set up the shooting area, hanging any backdrops on autopoles; to build or compose the set; and to prepare for the shoot.

In addition, the first assistant acts as a stand-in on the set while the photographer takes a Polaroid to test the lighting arrangement, or may even take the Polaroid himself, using someone else in the studio as a stand-in. Then after the photographer examines the Polaroid to check the exposure, the assistant alters the lighting equipment or the exposure as instructed if the photographer thinks an adjustment is necessary. The assistant must make sure that the background lights are not spilling onto the back of the model. If they are, he will gobo the lights to keep them from reaching the model. The assistant will then set reflectors, read the exposure on the model's face, and balance the lights according to the *f*-stop the photographer chooses.

Finally, the assistant also prepares an on-set data sheet to keep exact records of the day's shooting.

During the Shoot. While the shooting takes place, the assistant must continue as needed to load and reload film, change lenses, and hand the camera back to the photographer. The assistant records the vital information about each shot, numbering each roll of film in order and listing the exposure and the meter reading. He notes the garment the model wore and if the lighting changed even slightly. The assistant also marks the rolls of film to be *clip-tested* (see Chapter 7, page 133) and notes their numbers on the data sheet. (Some photographers prefer to reserve one roll as a test roll, placing that film back in the camera and shooting one frame whenever a test is necessary. This roll is then processed normally, and each frame can be judged in case processing adjustments are needed for the balance of the film.)

When I use Kodachrome film, I require my assistant to be able to bracket one-third to one-half stops on the camera as I am shooting. This may sound like an easy task, and most assistants will say they can do it. But it is not simple: I move around a great deal when I am shooting. I concentrate on the model and do not concern myself with bracketing, so I must have an assistant who can bracket as I continue to photograph. This is why I prefer to try someone new on a test or small job, and why it is critical to choose assistants who are knowledgeable.

On the set, assistants must be alert. If they feel that something is not working properly, they must advise the photographer immediately. If this happens, the photographer evaluates the problem and takes an additional Polaroid to double-check that everything is in order.

Finally, an assistant's behavior on the set during a shoot is of the utmost importance. He must be low-key. He must not socialize with the clients. If he disagrees with what the photographer is doing or interjects his own ideas in front of the client, the assistant is acting in an unprofessional—and unacceptable—manner.

An assistant must have a code of ethics and must not attempt to pursue the photographer's clients for his own. Word gets around in the fashion business when someone resorts to such tactics, and a promising career can quickly come to an end.

After the Shoot. Once the session is over, the assistant is in charge of breaking down the set and putting away all equipment neatly. I have had many assistants who were completely disinterested in this part of their job and "dumped" the equipment. This is not the type of person I—or you—want to work with.

As you can see, the tone of the session depends on the people you assemble as your team. If you are confident in and comfortable with them—and there are no last-minute problems—the shoot will proceed smoothly and the photographs will look exactly as you expected them to. But even in those unfortunate circumstances when personality conflicts arise and the members of the team don't mesh, you are still responsible for making sure that the client gets the best results possible. You are all working toward that goal, and the professional fashion photographer lets nothing stand in the way.

DECIDING WHERE TO SHOOT

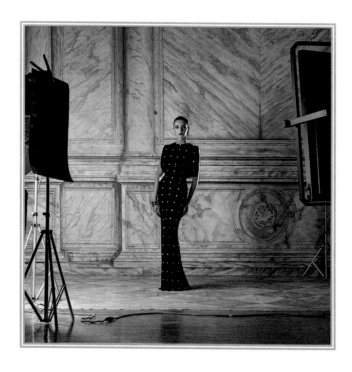

Your choice of location or background can greatly alter the overall effect of your photographs for an assignment. The first decision you and your client make is whether you will shoot in your studio or on location. For a sense of realism, the art director's first inclination may be to shoot on location. But, after some thought, the art director may opt for a painted backdrop. ❀ During the course of this decision, the question as to whether or not people can tell an actual location from a backdrop or a set may arise. There is a difference; however, it can be great, or it can be negligible. The final decision may be determined by budget and time limitations. ❀ You will find that you will have the most control over the shoot when you work in a studio. You will not have to be concerned about the weather. You will be assured of an adequate power supply and safe conditions. And, usually, you will be able to send the necessary garments, equipment, and backdrops in advance. ❀ When you photograph the session in your own studio, you will have even greater control. After all, you know what type of equipment you own, where you can best set up for each shot, and how much available natural light there is. If your studio has a good amount of natural light, you will know where and when it falls, and how to photograph it to its best advantage. Finally, you will probably feel most comfortable and at ease working in your own studio. ❀ For some assignments, an art director's first inclination may be to shoot on location to create a sense of realism. But, as a fashion photographer, you will soon realize that shooting on location can be quite expensive: fees for models, stylists, hair and makeup artists,

and assistants, as well as travel costs, add up quickly. A less expensive alternative is to rent a painted backdrop that has the look of the desired background and that will please the client.

You will find a large variety of painted backdrops to choose from. Many "background" artists paint backdrops on canvas, and then either rent or sell them for reasonable amounts. You can also commission a backdrop according to specific requirements. These artists usually advertise in photographic publications in major cities, and also often have a complete catalog that features a selection of canvases.

Check the backdrop's measurements before ordering, especially if a full-length shot is needed. Many backdrops do not "sweep" in front, which means that they are not long enough to cover the floor in the foreground. Although such backdrops are not suitable for full-length photographs, they are fine for closeup or three-quarter-length shots. (An even less expensive alternative—if you are artistic—is to paint the backdrop yourself.) Keep in mind that painted backdrops must be handled with care.

Finally, some clients insist on shooting on location— and have the budget to do so. But any time that photographers shoot outside of their studios, they find that they are unable to control certain elements. These include building restrictions, inadequate power requirements, and weather conditions. In this situation, gather as much information in advance about the location you will be working in.

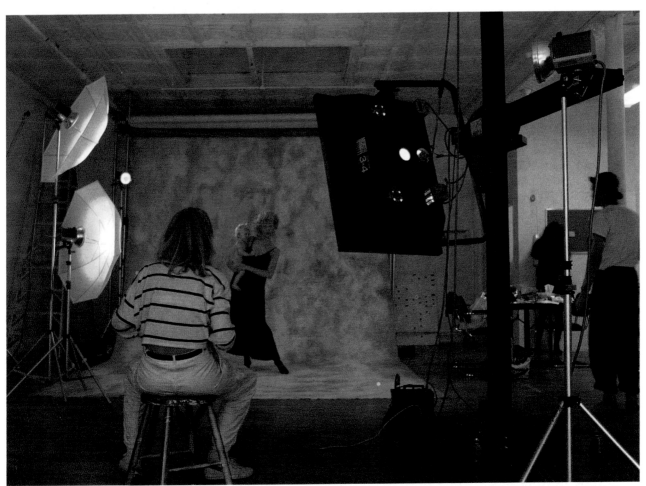

This shot shows a behind-the-scenes look at photographing in a studio. Through the use of a backdrop and carefully placed lighting equipment, photographers can create many effective "sets" and other illusions. Working in the controlled environment of the studio can be advantageous, not limiting.

The mottled backdrop gives this shot a feeling of elegance. I like the freedom the backdrops offer: I can choose subtle shades that either contrast with or complement a garment.

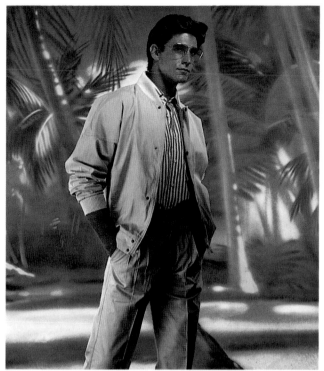

This is a large section of the "beach" backdrop seen at right. The brochures background artists send out sometimes show how to use a single backdrop several ways. For example, you can create two different effects by draping the backdrop or combining it with another one.

To create the illusion of a beach using this background, I illuminated the subject with artificial lighting that seems to be sunlight. The position of the light source allows the model's shadow to fall in the same direction as the palm trees' shadows, which appear on the sand.

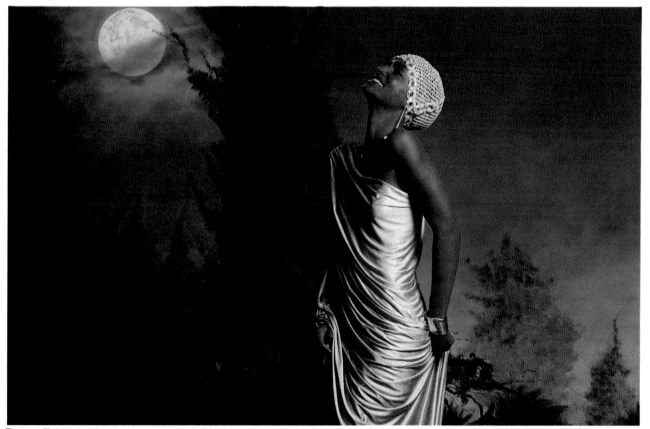

To set off this simple silver gown, I chose a painted "jungle" backdrop. The stylized leaves, trees, and sky add an element of fantasy to this image.

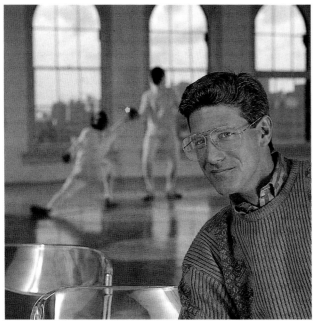

This image was one of the first photographs I shot during a session that began in the early afternoon. As the light changed when the sun went behind a cloud, I was able to capture various moods.

This shot was taken late in the afternoon. Filtering through the windows, the sunlight cast lengthening shadows across the fencers and warmed the tone of the photograph.

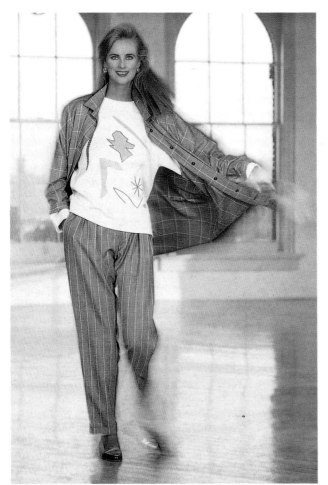

This photograph was taken in the middle of the day of this session. The available light here is just as effective, creating an ethereal mood.

For this photograph, I used various slow shutter speeds ranging from ⅛ sec. to �/₃₀ sec. This allowed the available background light to filter through the garments.

FINDING LOCATIONS

In every city, interesting locations that can be used as backgrounds are easy to find. Courthouses and other government buildings offer an intriguing range of architectural styles. Museums, libraries, historical sites, train stations, formal gardens, old movie theaters, restaurants, bars, churches—all deserve careful scrutiny. Your choices are unlimited, if you use your imagination.

A permit is required to shoot on the street in large cities. Check with local authorities to find out where to apply for this permit and what, if any, restrictions apply. For example, in order for you to shoot an assignment on a crowded street in the middle of a business day, an area will probably have to be roped off so that "civilians" will not appear in the photograph. This will prevent problems later: you must obtain releases from everyone in a photograph, but you won't be able to track down a dozen people you don't know.

Certain public buildings and areas require rental fees.

To shoot in these locations, such as museums, you must make arrangements with someone in the curatorial offices. You will be charged an hourly rate and usually will have to guarantee a minimum of several hours; this fee includes the services of a guard. An extra charge will be added to the rental agreement if an in-house electrician must be on hand during the shoot. (Before deciding on photographing an assignment in a public building, be aware that an increase in vandalism has made staffs less willing to work with photographers.)

When you rent the lobby of a building, management office personnel may ask for similar fees, as well as proof of an insurance floater specifying that you and your team are covered for the day of the shoot and that the building management is exempt from any liability. A specific dollar figure may be required on the insurance form. For a small premium, you can usually get a waiver policy through your insurance company to cover you for that particular day.

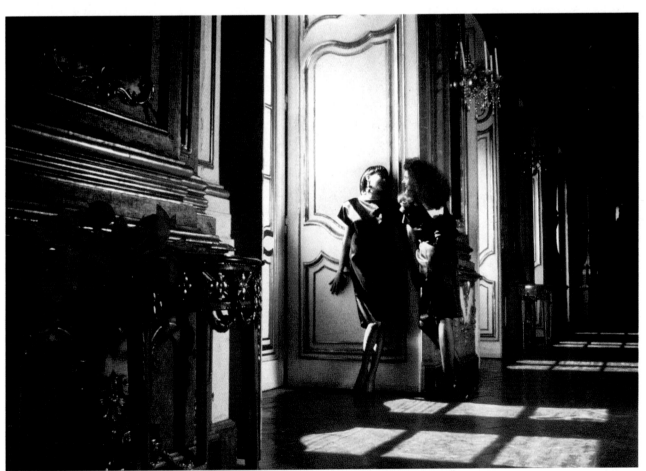

To provide a contrast to the grandeur and opulence of Lisbon's Palace Belem, I added several simple calla lillies, a native flower of Portugal. Although an abundance of sunlight streamed in the large doors, I still had to use a fill light to the models' right to show detail in their black dresses.

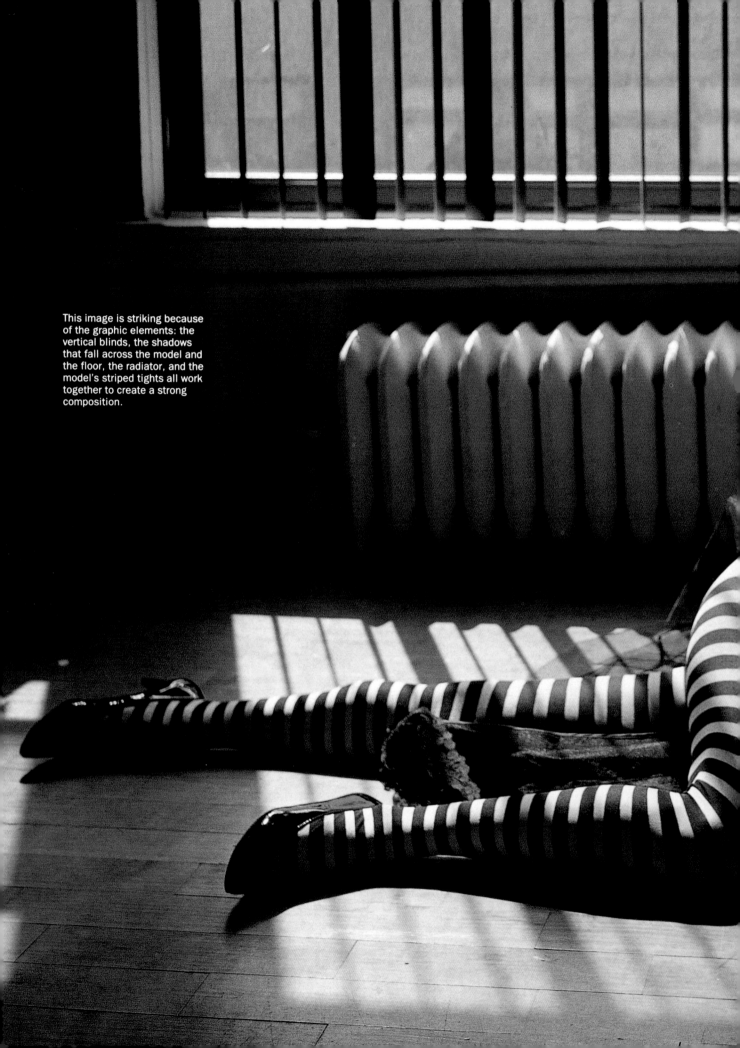

This image is striking because of the graphic elements: the vertical blinds, the shadows that fall across the model and the floor, the radiator, and the model's striped tights all work together to create a strong composition.

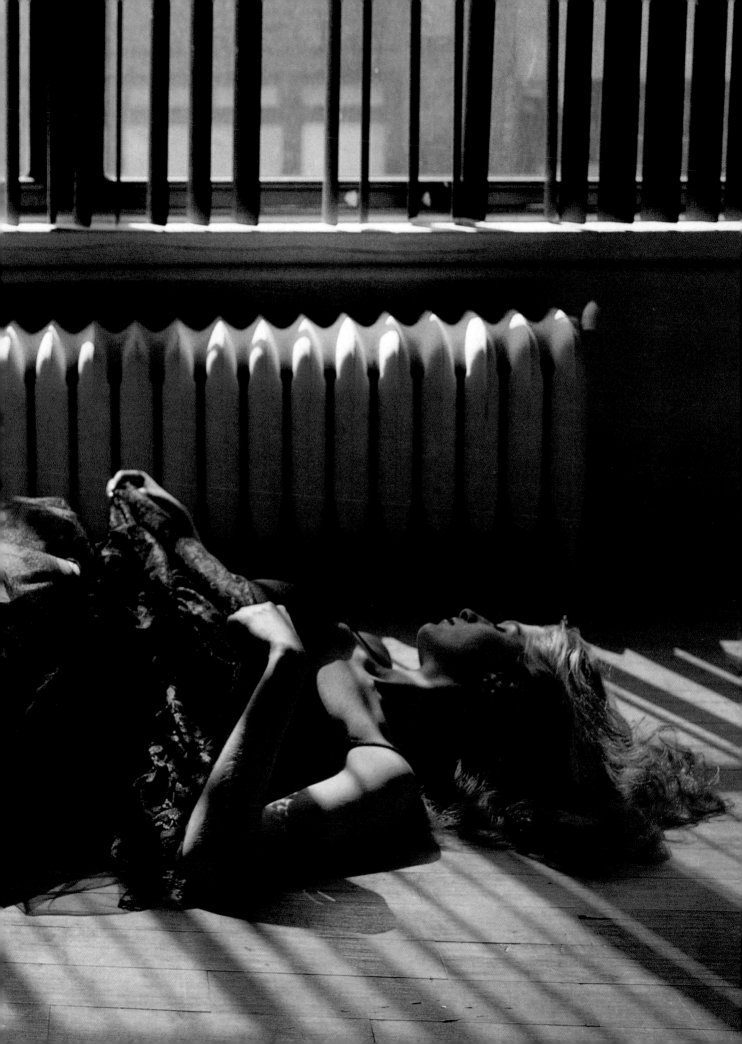

ON LOCATION IN PORTUGAL

A fashion photography assignment that calls for you to travel to new places can be both exciting and inspirational. Meeting people from exotic cultures—and adjusting to their lifestyle—broadens your perspective and enriches you personally. Travel also allows you to explore different sites as backdrops for your photography.

I was commissioned by a Portuguese designer, Sao, to travel to her native land and photograph some of her garments. For this *assignment, I was to photograph Sao's designs using Portugal's museums and historical sites as backgrounds. I frequently worked with Pamela Housman and Deborah Kujawa, the models Sao had booked, and we were all looking forward to the trip.*

One of the locations Sao had arranged for the assignment was the Palace Belem, also known as the "Portuguese White House." Here, I photographed the models strolling around the elegant formal gar- *dens. Portugal's celebrated hand-made tiles adorned many of the surrounding walls, and I wanted to include them in a number of my shots.*

Pamela and Deborah knew exactly how to move in Sao's beautifully hand-worked garments, so working with them was a pleasure. I photographed the models in various rooms in the palace, which were ornate, and as such, were perfect complements for the garments.

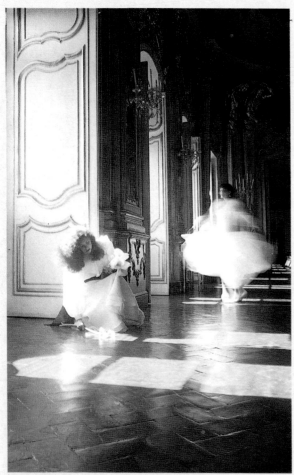

I wanted to create an artistic feeling for this shot of the models wearing flowing white dresses, so I instructed one model to glide across the floor of this room in the palace. The sense of motion makes this image special.

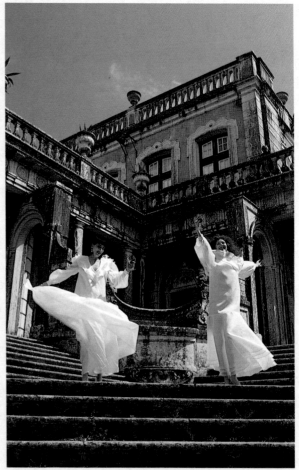

This photograph, taken outside the Palace Belem, shows that exotic locations can provide the perfect setting for a fashion shoot. They can also inspire the photographers—and models—to do their best work.

ON LOCATION IN NEW YORK

New York City has an inimitable style. The skyline, photographed from any angle, in any light, and during any season, is magnificent and immediately identifiable. New York architecture is an exciting mix of the old and the new, all competing for space and attention. The city has a great deal to offer: from the Cast Iron District to the Ladies' Mile to the Museum Mile, you can find architecture from almost any period of American history. Many photographers believe that New York City is the world's most exciting backdrop.

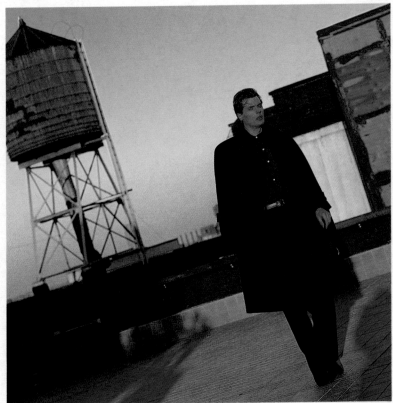

This photograph was shot on the rooftop of The Columns in New York City. The wooden water tower in the background gives the picture a casual but urban quality.

Checking Power Capacities. Whenever you are going to shoot on location, I suggest that you carefully investigate the electrical situation in advance. As a precaution, divide up your cords so that power isn't drawn from a single circuit. Otherwise, circuit breakers will be blowing continually, causing delays throughout the shoot. To reach different outlets, you may need a number of extension cords; always have an ample supply on hand.

You should also find out before you shoot whether there is a fuse box or a circuit breaker. The latter is better because you know exactly which circuit was using too much power if it blows. You can reduce the power and simply flip it back on. Most photography studios, however, are well planned before they are constructed or renovated, and have adequate power.

USING A LOCATIONS SERVICE

Found only in larger cities, locations services offer expert advice about sites that can be used for photography. These services tell you about available locations,

including rental costs, and they sometimes act as a liaison between you and the building owner or staff. Pictures in the locations services' portfolios can range from villas, country homes, offices, and boardrooms to stylish restaurants and elegant hotel suites. Locations services charge a minimal fee for their time and effort to fulfill your needs; they receive a percentage of the rental fee paid to use the location.

When you call a scout at a locations service, you describe the type of location you need. The scout then finds examples of possible locations and, perhaps, puts together a book of photographs or arranges go-sees for you. Locations services also may negotiate fees and inform you of any necessary permits and insurance.

You book these locations the same way you book hairstylists, makeup artists, and models. You put a tentative hold on the date you want, and later confirm that date when you have arranged the rest of the team.

When shooting in other parts of the country, ask the locations service you ordinarily work with to refer you to scouts in that area. You have another option as well

Professional photographers receive a large number of brochures that feature locations services and show the wide variety available to them.

when you know that you will be traveling to another city for a shoot: you can send an assistant in advance to scout locations and to make the necessary arrangements and begin the paperwork. Your assistant can also take Polaroids, so that you can narrow down the choices. This will save time when you and the rest of your team arrive (see page 76).

RENTING LOCATION VANS

When traveling with a large group to a location, you may need to rent transportation. Location vans are self-contained vehicles specifically outfitted for photography shoots. They are air-conditioned and have their own generator. They also have a makeup station, a bathroom, wardrobe racks, and dressing areas. You can book a small van that will accommodate up to eight people, or a 40-foot van with as many as four dressing rooms.

The fee for a location van, which can start in the hundreds and extend into the thousands, includes a driver. Most companies require a nonrefundable rental fee when you confirm the booking. The client pays all rental fees.

USING PRIVATE RESIDENCES

Photographing an assignment in a private residence is an appealing idea for many reasons. With the proper research and resources, you can locate practically any style and color scheme you need. If the layout calls for a French Provincial look, you can save yourself and the stylist days of searching and propping by finding a home decorated that way. A real home also offers a lived-in

look and a distinct personality and eliminates the need—and the time required—to build a set.

Location scouts can be a great help when you are looking for a private residence. They usually have an easier entrée into beautifully decorated houses. If homeowners wish to be listed with a locations service, they can always contact a scout; however, if a house is interesting and has the potential to be ideal for shoots, a scout will probably contact the owner first. One of the scout's tasks is to go to such homes, evaluate them, and determine how they could be used.

Renting a private location requires you to have proof of insurance, just as renting a public place does. The insurance can be obtained by either the advertising agency or the client, but sometimes you will have to arrange for it. If you already have insurance, you will have to produce a copy of your policy before you start shooting. This is to assure the homeowner that if anything is damaged during the shoot, such as carpeting, furniture, or artwork, your insurance will cover their losses. You must check your policy to see if you are covered for the specific needs of the assignment (see Chapter 8, page 139). If your insurance is inadequate, the client or the advertising agency must provide a *floater policy* for the day, which is insurance taken for a specific location on a specific date.

To eliminate the possibility of such a problem, always be especially careful when you shoot in someone else's home. Accidents happen all too easily, and many furnishings, such as heirlooms and antiques, may be irreplaceable. Check with the owners to find out if you

have their permission to move furniture. If so, remember to instruct everyone to lift rather than drag the furniture: bare floors scratch easily. If you plan to replace a painting, remove knickknacks, or in any other way alter the room, advise the owners in advance. This is not only polite, but also can prevent a nasty confrontation later if the homeowners seriously object to any of your ideas. If you intend to produce a specific effect, such as smoke, be sure to let the owners know exactly what will happen.

You should also tell the owners where you will be shooting specifically, how many people will be on the shoot, and how long you will need to use their home. Remember at all times that even though you are paying for the privilege to shoot in the house, you are guests. Don't complain or make rude comments about the decor. Don't use the refrigerator unless you receive the owners' permission to do so. Finally, make sure that everyone on your team understands the rules: you are responsible for their behavior, too.

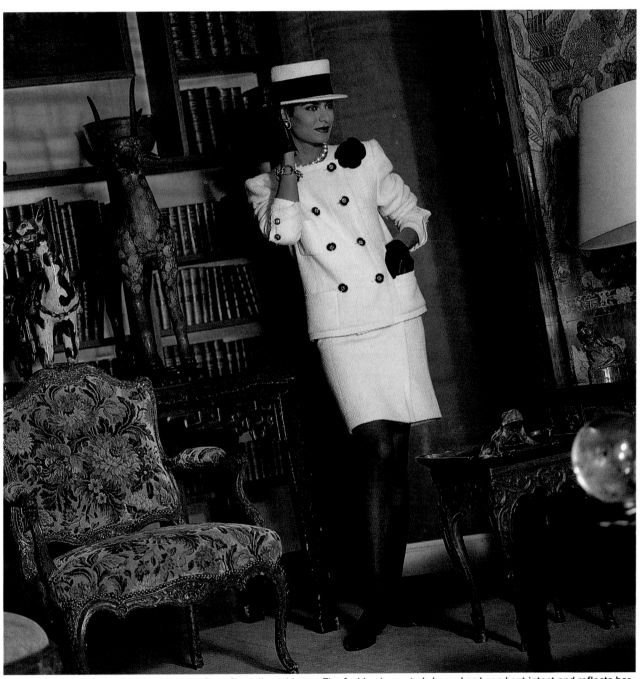

I photographed this stunning ensemble at Coco Chanel's residence. The fashion innovator's home has been kept intact and reflects her sense of style. Working in both Paris—the fashion capital of the world—and the designer's residence was thrilling.

TRAVELING TO A DISTANT LOCATION

Traveling offers photographers many opportunities: meeting new people, exploring different cultures, photographing exotic sites, and accepting the challenges of each new assignment. But, while traveling can be exciting, photographers on assignment must be prepared, organized, and flexible.

Making a Checklist. When planning a trip, make a list of all the equipment you will need to bring with you, including filters, cords, reflectors, and other accessories. Before you leave, double-check, and then check again. Have your assistant go over the checklist, too. It would be disastrous to arrive at an unfamiliar destination and find limited resources. In many locations, such as the Caribbean, film may be much more expensive, and a well-stocked camera store may be unheard of.

If you don't already have a passport, apply for one immediately; if you do, make sure that it is still valid. You can never be sure when you will get an overseas assignment. Choose an assistant who already has a passport, and remind everyone on your team that they will need one. Also, depending upon the country or countries you will be visiting, you and the members of your team may need visas and/or vaccinations. Embassies can provide you with information about their countries' policies.

Making Reservations. When reserving hotel rooms, keep in mind that the members of your team often can share rooms. This depends, in part, on the job, the budget, and their personalities. As the photographer, you are sometimes given your own room, as is the art director. But the final decision is up to the client.

Next, make arrangements with the art director for the latter to pay the hotel bill, as well as expenses incurred by the members of your team. You cannot—and should not—be expected to cover the expenses involved with a location shoot. This would be an enormous financial responsibility.

Finally, be sure to double-check all of the room reservations in advance. Imagine how you would feel if the hotel did not have enough rooms for everyone on your team when you finally reached your destination.

ON LOCATION IN PARIS

Although the market for haute couture has diminished, Paris is still considered to be the fashion capital of the world, wielding enormous power and influence internationally. So much fashion begins here. There is something wonderful, something unexplainable in the fashion atmosphere, and reporters from all over the world assemble in Paris for the all-important seasonal collections.

As such, anyone interested in fashion photography can discover the true energy of fashion in Paris. I have been lucky enough to meet with some of France's top designers and to photograph their garments, using the elegant ambience of their showrooms or homes. Shooting in a designer's home or workspace is a unique experience. The designer's personality permeates the atmosphere and enables you to capture the elements that contribute to the creation of his or her designs.

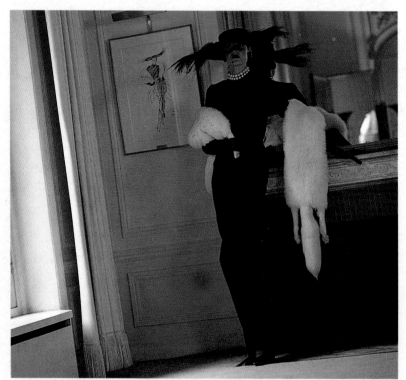

I photographed this original Pierre Balmain dress, which was selected for me from the designer's archives, in the house's Paris showroom. A sketch of the dress hangs on the wall behind the model. Although the garment was created thirty-five years ago, the style is timeless.

LOCAL CUSTOMS

If you fail to acknowledge that customs and laws vary from city to city, region to region, and country to country, you or a member of your team could be imprisoned. For example, shooting a beach scene involving nudity might not cause any problems in France, but it might be against the law in other countries. So, before you travel to another country on an assignment, familiarize yourself with that country's laws and customs. You must also make it clear to the members of your team that no one should attempt anything even slightly illegal: no blackmarket purchases, no drugs.

Foreign countries may have customs that can lead to other types of problems. For example, Latin American countries have an understanding of the concept of time that differs from the norm. If you schedule an appointment for 8 o'clock in the morning, you won't be expected to arrive until about 9:45. So, if you want to protect a shooting schedule that begins at 9 o'clock, you should tell the local people you will be working with to meet you at 7 o'clock. In New York City, however, people are expected to arrive on time or a few minutes early for appointments, and to begin working as soon as they arrive. A word of advice: strict adherence to a schedule is difficult to find outside the United States.

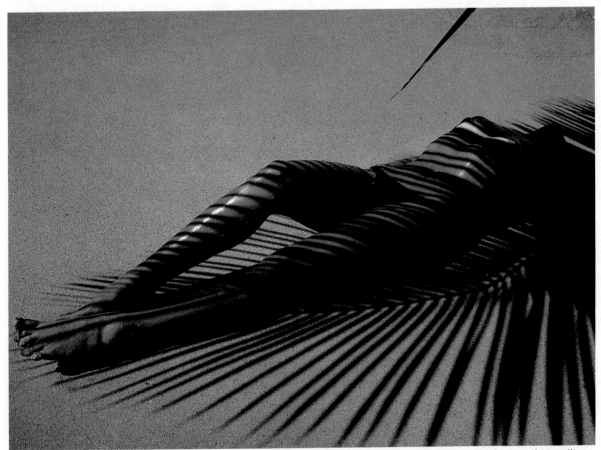

For this photograph of a partially nude model on a beach, I checked local customs before the shoot to make sure that nudity wouldn't be a problem.

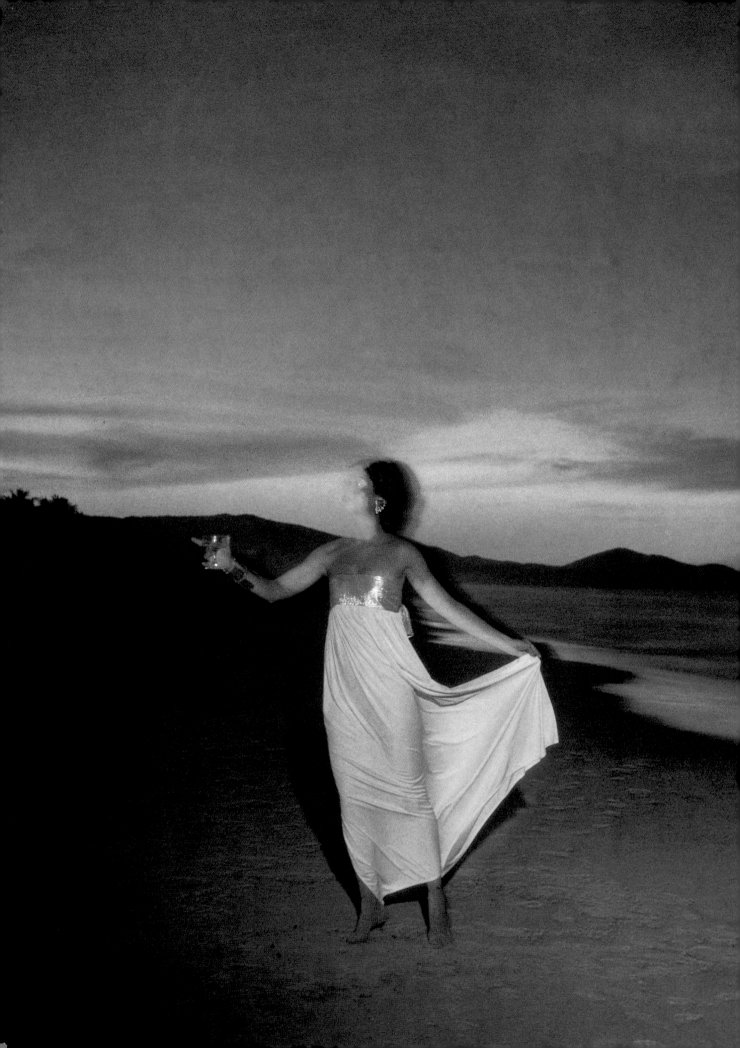

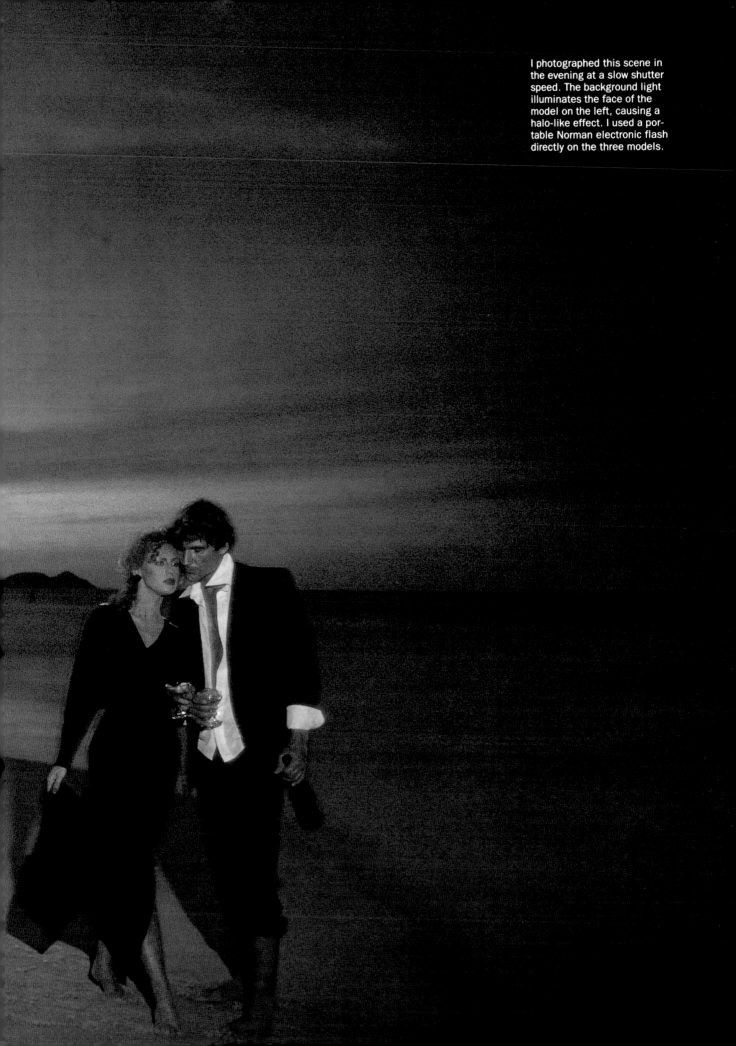

I photographed this scene in the evening at a slow shutter speed. The background light illuminates the face of the model on the left, causing a halo-like effect. I used a portable Norman electronic flash directly on the three models.

Organizing the Team. When traveling with a group of associates and assistants, you, the photographer, must take control. Establish your authority immediately. You must deal with many different personalities in unfamiliar surroundings. I prefer to travel with people who are easygoing and flexible. With the amount of pressure associated with shooting in a remote location, I don't need the additional problem of temperamental associates. While it is not always possible to assemble a group that works well together, it certainly makes the assignment a more pleasant experience. Also, when a scheduled shoot is about to begin, you must make sure that everyone is awake, alert, organized, energetic, and enthusiastic.

Expect that professional people will behave professionally. People who are undisciplined and hard to manage can cost you extra money by wasting time, and those who make outrageous demands or expect too much can spoil the trip for everyone. Your entire team may need to be reminded that this is a job, not a vacation.

If you send your assistant ahead to scout locations and take Polaroids, he or she can also initiate paperwork, set up travel plans, and take care of other necessary details that will save time when you and the rest of the team arrive. With this information in hand, you can plan a schedule before you travel. When you arrive at a location with your team, you will already have a sense of the area and what will be available to you. The cost for sending the assistant to scout will be more than balanced by the amount of time, energy, and money you will save by being well organized.

Getting Through the Airport. Moving your entire entourage—including models, stylists, assistants, cameras, and equipment—can cause unexpected problems at airports and customs checkpoints. It may be smart to make one person (preferably yourself) responsible for handling everyone's passport and customs paperwork. You should also make a list of all your equipment, with serial numbers, especially if anything is new. If you present this list to the customs office before leaving a country, you will prevent problems upon returning. Customs agents are paid to collect duties and are instructed to question anything that looks as if it were bought in another country.

Bringing a large amount of equipment with you on a shoot in a foreign country requires some additional planning. When you travel to Europe, you can save money by dividing up the heavy equipment among those members of the team traveling lightest: there is a specific weight allowance per person on these flights.

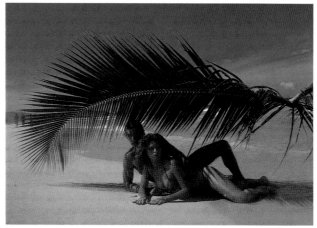

Because this beach lacked a distinguishing feature, the art director decided to give nature some assistance. He broke off a branch from a nearby palm tree and held it over the models, creating interesting shadows on them.

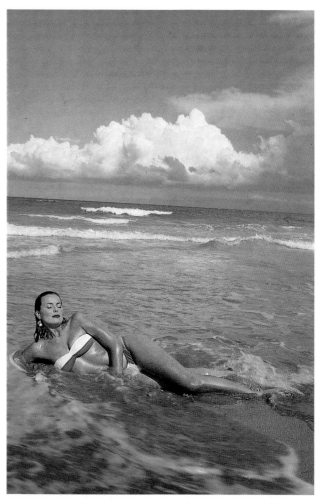

In this photograph taken for an ad promoting Puerto Rico, the colors of the sky and clouds were intensified through the use of a polarizing filter. I always bring a polarizer with me when I travel.

On flights within the continental United States, each passenger is allowed two pieces of luggage and one carry-on bag; again, you can distribute the extra pieces among those bringing only one or two. If you are taking along a very valuable item, such as a large piece of equipment or a designer gown, it may make sense to buy a discounted airline seat for that purpose.

Transporting Equipment. When you plan to travel to a foreign country for an assignment, call the country's tourist board and find out as much as you can about any matter that might influence what equipment you decide to bring with you. Ask what the standard electrical voltage is. Find out what rental equipment is available, how much it will cost, and what the value of the dollar is. You will discover that renting equipment and studios usually isn't difficult to do in Europe, but that it can be quite a problem elsewhere.

When I travel to Europe, I prefer to take my portable Norman electronic flash unit with two heads and several battery packs; this is as compact as I can get. On the Norman, I can adjust to foreign voltage with the flip of a switch. My suitcase also contains a couple of umbrellas,

a few stands, some folding reflectors, sync cords, and a small tool kit for emergencies. I also take along various types of film, including tungsten film for shooting at night. Even though I may plan to shoot only Koda-chrome 25, for example, I bring some rolls of Ekta-chrome 400 in case the weather changes or other unpredictable situations arise (see page 77).

As for camera equipment, I take along two Nikon F3 bodies, a 35mm lens, a 105mm lens, and a 200mm lens. I also take my Hasselblad with a 150mm lens and a 250mm lens, along with a Polaroid back and several other film backs. I always bring several filters, a tripod, a flashlight, compressed air, lens tissue, lens shades, and gaffer's tape.

When traveling to a location shoot, you must be sure to pack a polarizing filter, particularly if you will be photographing outside during the day. Because the sun can cause reflections that diminish the clarity of your subject, a polarizing filter is an essential piece of equipment; you can move it to a certain angle to eliminate most reflections. This filter also intensifies the blue in the sky, adding much more drama to your photographs.

PREPARING FOR ALL TYPES OF WEATHER

You may sometimes want to shoot in such adverse weather conditions as wind, rain, and snow for the different photographic effects they offer. If, for instance, you're shoot-ing an assignment for a skiwear catalog, snow adds an interesting effect.

Sometimes, though, you may have to work in less than perfect weather and in conditions that hamper the photograph. When at-tempting to photograph in rain or snow, place your camera in a clear plastic bag and cut a hole for the lens. Protect your equipment. In cold weather, it's smart to wear a loose-fitting jacket, so that you can keep your camera near your body.

Cold weather can also affect the life of a battery. Keep plenty of fresh batteries on hand.

To check weather forecasts around the country, you can call the National Weather Service.

Although inclement weather causes problems for most on-location sessions, it sometimes produces surprising—and pleasing—photographs, like this shot taken in the rain.

On Location in Venezuela

One assignment brought me and my team to tiny Margarita Island, which is off the coast of Venezuela. The layouts required complicated lighting setups. I called ahead and learned that I would not be able to rent any equipment. But I also found out that the voltage is the same as that of the United States. So I packed my studio electronic flash units and power packs rather than portable equipment.

We arrived in Venezuela in the late afternoon and were able to get ourselves and the equipment settled into our suites at the hotel. We relaxed the rest of the day and planned our itinerary for the next several days. At 7:30 the next morning, we were ready to work and were awaiting our driver and van. At 9 o'clock, the driver still hadn't arrived! He finally showed up at 9:30, as he had every right to do

according to the custom of his land. In Latin American countries, everyone arrives about two hours late for appointments, frustrating those of us who are clock-watchers. Then I thought of a sensible solution: for the next nine days, we would simply give the driver a much earlier arrival time.

The weather was unbearably hot, and as we proceeded to unload the equipment for our first shot, we discovered that all of it had fogged. We hadn't had the foresight to realize that because the rooms were air-conditioned, the much higher temperature outside would cause condensation to form on the cameras and lenses. It took several hours for the equipment to clear. Luckily from that point on, we stored the equipment on the terrace of my room. The temperature of the equipment was now the same as

that of the environment we were shooting in, so no condensation would form and pose a problem.

Even after working all day, I was able to get everyone excited about an evening shoot. We decided we would explore the island, and we had the driver take us to a remote village in the hills. As our van entered this village, we were enchanted by the sight of many native children. We approached them and tried coaxing them into being part of the photograph by standing near one of the models, Terri Ellis, but they were terrified. They looked at us as if we were strange creatures from another planet, especially Terri, who was wearing a purple and rose silk dress that billowed in the breeze. After the driver helped to convince the children to let me take their pictures, I managed to get two shots of them with Terri.

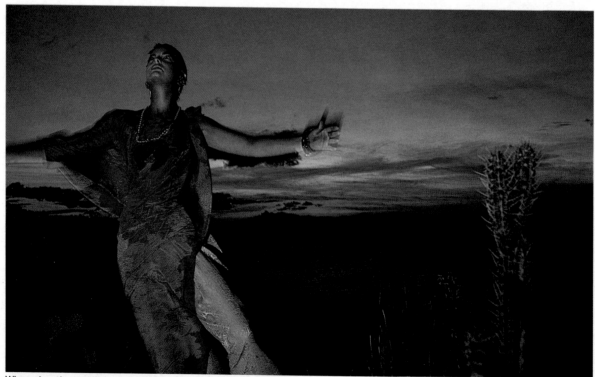

When shooting outdoors, photographers always hope for good weather. This is one reason why clients sometimes prefer to travel to tropical locations: sunshine is almost guaranteed. I photographed this spectacular sunset on location in Venezuela using a direct electronic flash and a time exposure. Many people, however, believe that I used a backdrop because the colors in the sky are so vivid.

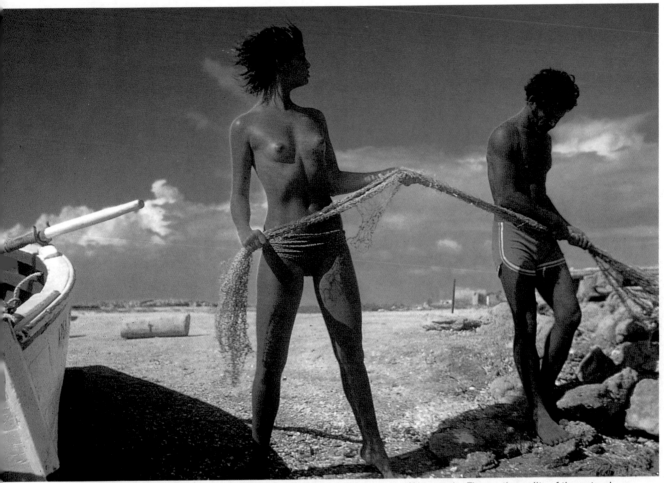

This unplanned shot was taken on a near-deserted island off the coast of Venezuela. The exotic quality of the natural surroundings complements the model's seminude pose.

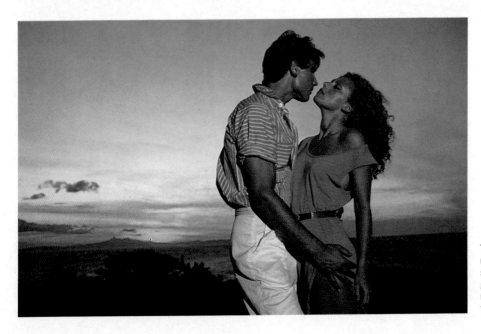

The chemistry between the models, the Venezuelan sunset, and the lighting give this photograph a romantic and highly charged feeling.

79

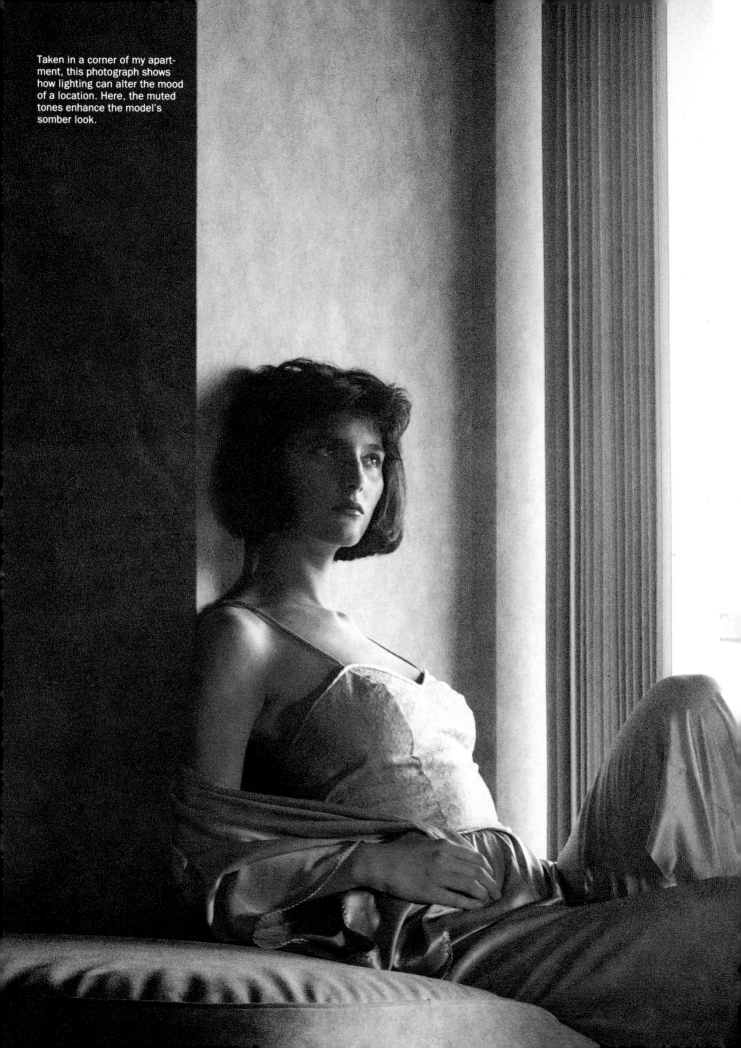

Taken in a corner of my apartment, this photograph shows how lighting can alter the mood of a location. Here, the muted tones enhance the model's somber look.

I always take this much equipment with me—even when I work in Europe despite its resources. Then, regardless of what type of equipment is available, I have the assurance of my own equipment for any unexpected event. I am familiar and comfortable with the idiosyncrasies of my own equipment.

But this security has its price. As compactly as I think I pack, I have spent between $400 and $500 in extra weight traveling from Paris to Milan, and another $500 from Milan to Lisbon. The key to packing is: "Think light!"

A final point: I have always made it my policy to carry my cameras as hand luggage when I board a plane. It would be disastrous to find yourself in a foreign location without your most essential piece of equipment because it had been lost enroute. When I travel, I hide my camera bag inside a cosmetics bag in order to keep it out of sight—and out of the hands of those who roam airports looking for small, expensive items to grab.

Protecting Film. I prefer to buy film in the United States and run a color test on it. If at all possible, I try to have it developed here also, at labs where I have established a working relationship with the staff mem-

bers. Obviously, when I am on assignment in a foreign country for several months, I work with that country's film and labs.

Before flying to a location, I pack the film in protective bags. For the return trip, I personally carry all the film in a protective bag; I feel safer knowing that the film is by my side. I try to persuade the guard to glance inside the bag and not put it through the scanner, but some guards insist, claiming that the film will not be damaged. I am not convinced. High-speed films are especially vulnerable to X-rays. Kodak has done studies of film exposed to X-rays and has concluded that cumulative doses of more than five exposures to X-ray radiation can cause fog damage to film. Consequently, I am meticulous about checking my protective bags, and I replace them immediately if I think they are defective.

Photographs taken on location will reflect the ambience of the surroundings. Although preparation takes time and effort, locations can inspire photographers. But shooting in the studio offers photographers more control. Whichever arrangement a particular assignment calls for, be sure to fully utilize its unique aspects. And remember, each new experience will help you develop as a fashion photographer.

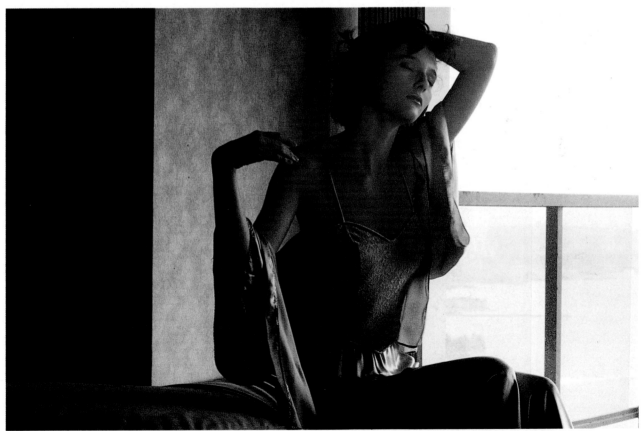

By recomposing and directing the model to strike another pose, photographers can change the look of a shot completely. For this photograph, taken moments after the picture on the opposite page, I asked the model to appear dreamy rather than somber; also, the horizontal perspective softens the image.

PUTTING A SESSION TOGETHER

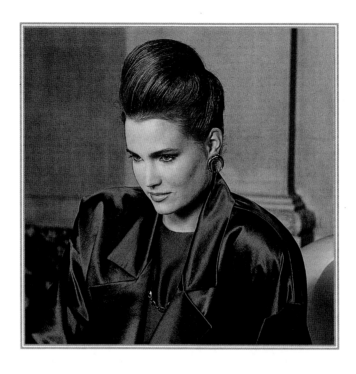

very session has its own rhythm. While many of the details that go into the preparation of the shoot are repeated over and over again, each day is unique. You can think of yourself as the captain of a ship: you know the vessel and have plotted the route and the destination, but you must allow for unpredictable weather—and surprisingly beautiful sunsets. ✶ Each assignment—from the smallest to the largest—is composed of three sections: preproduction, the shoot, and postproduction. During the preproduction phase, you discuss with the art director the client's goals, budget, and time frame, as well as the details involved in executing the layouts. Next, during the shoot, all of the preproduction work comes together. This is when you direct the members of your team as they expend their energy and combine their efforts to produce the finished photographs. While many talented individuals collaborate on the creation of these images, it is up to you, the photographer, to capture the moment. Finally, during the postproduction phase, you develop, edit, and deliver the photographs to the client and the art director for approval. Your responsibility does not end until they have the processed film in their hands and are satisfied with the results. ✶

PORTFOLIO

PHOTOGRAPHING A FAMOUS MODEL IN A FAMOUS SETTING

This assignment for Portfolio, an Italian-based firm, to promote the company's name through an image of an elegant woman in a beautiful setting. This assignment brought with it several problems. These included having to abandon the original plan. Luckily, I was working with art director Sabino Caputo. Our business relationship began many years ago and has continued to grow. I know that Sabino is flexible and can always come up with creative alternatives, but he is willing to listen to my suggestions. Sabino knows that my ideas are worth listening to and realizes—and appreciates—the lengths I will go to get that one perfect shot.

Preproduction. When Sabino and I began planning the shoot, he explained that he wanted an upscale, almost aristocratic look. To capture these qualities, Sabino was adamant that we book model Willow Bay. At that point in her career, Willow was the Estée Lauder "girl," and in order for us to book her, we had to confirm her time at least six weeks in advance. When a model is successful, she is booked continuously, and it can be quite difficult to find a day in her hectic schedule that coincides with the tentative dates of a shoot you want to hire her for.

The next problem involved finding an appropriate—and available—location. Sabino and I agreed on the first choice, the Brooklyn Botanical Gardens. He loved the idea of beautiful flowers in natural sunlight. Unfortunately, not one of Willow's few free dates coincided with those of the Botanical Gardens.

Sabino's second choice was an outdoor location on Long Island. At this point, assuming that the members of the team would have to travel together to the chosen spot, we booked a location van. However, using an outdoor location for this shoot posed more and more problems, including the amount of time wasted traveling to the location and the cost of renting the site. Because the shoot would take place outside, we would be at the mercy of the weather. With all of these problems and uncertainties looming large, Sabino decided that we should alter our plans drastically and investigate possible indoor locations close by.

Sabino then suggested that we take a look at the National Academy of Design, located on Manhattan's Fifth Avenue. I called for an appointment to visit the building and shot Polaroids of the two rooms Sabino was particularly interested in. I liked one room more than the other and took several photographs of it to show to Sabino. (Ordinarily, I would send an assistant to scout locations, but because I was pulling the whole feeling of the shoot together, I wanted to see the building myself.) When Sabino saw the Polaroids, he agreed that this was the perfect setting for the shoot.

Because Sabino and I chose to shoot at the Academy, the team would not have to travel far. We called the van company and tried to cancel our reservation but were unsuccessful. We ended up forfeiting the agency's deposit of $400.

With the date, model, and location set, I requested a purchase order from Sabino, which included my photography fee, estimated film and processing costs, and miscellaneous expenses.

My next step was to book the rest of the team. I decided to book Allan Forbes to do Willow's makeup and Ron Capozzoli to do her hair. I gave the details about the assignment to the booker at the agency representing Allan and negotiated a fee. Because Ron wasn't represented by an agency at this point in his career, I was able to call him directly to book him. Finally, I hired an assistant I like to work with.

Gathering the perfect props for the assignment was my next major concern. I had a $500 prop rental budget to work with. Sabino's new concept included an antique chaise longue, but finding a suitable one to rent was not an easy task. I was quite disappointed in the selection I saw at the first prop house I visited. I then went to Newel Art Galleries, one of the largest suppliers of antiques in New York City; the gallery rents and sells antique furniture to television and movie studios. I had to pass up many beautiful chaise longues because their rental fees exceeded my total prop budget.

Soon, however, I came across three fine chairs that had rental fees that fell within my limits. I took Polaroids of them, so that Sabino would be able to determine which one he preferred. We agreed on the white chair, and he gave me a check for $400 to cover the rental and trucking fees. I immediately reserved the chair for the date of the shoot and paid the gallery. Any delay might have meant not being able to rent the chair of our choice: another photographer or movie company might have already done so. The gallery delivered the chaise longue to the National Academy of Design the day before the shoot, carefully wrapped in brown paper.

I moved on to my next responsibility: styling the clothing and accessories for the session. My assistant made appointments for me to meet with several

designers in their showrooms to choose garments. I then scheduled meetings with various accessory companies in order to have a wide selection of jewelry on hand during the shoot. I arranged for all of these items to arrive at my apartment the day before the shoot. This would prevent last-minute mixups, and I would be certain that everything I was to have at the shoot would be there—on time.

The Shoot. I arrived at the Academy with my assistant, my equipment, and all the necessary clothing and accessories at 8:45. We met everyone on the team coming in at about the same time. The only person missing was the building's rental agent. Ever time-conscious, we began to work. Ron and Allan set up their supplies, and Ron then blew out Willow's hair.

A short time later, the agent arrived, saw where Ron was working, and became hysterical. In fact, he was ready to order us to leave. Without thinking—or any other member of the team noticing—Ron had set up too close to a valuable painting, and the caretaker was terrified that the hairspray might get onto the painting.

Although the agent's reaction seemed excessive to me, I realized that if I did not placate him, we could all be thrown out. Thinking of the thousands of dollars already invested in the shoot, I apologized and offered to shoot under any conditions he named. (I prudently decided not to mention that he should have been here on time to tell us what restrictions applied.) Finally, the agent relented. We agreed to move Ron and Allan into the room where we were shooting.

My assistant and I then moved the white chaise longue to various places in the room in an attempt to decide on the first setup. Once this was agreed upon to Sabino's satisfaction, I directed my assistant in setting up the lights. For the main lights, we positioned an electronic flash head so that it bounced into an umbrella to my right. For fill light, we placed a second electronic flash head on the left so that it bounced into two white reflector cards. We then positioned another electronic flash head with a grid spot attached off to one side to highlight Willow's hair. Finally, we placed a fourth electronic flash head with a large grid spot to highlight the walls illuminating the background.

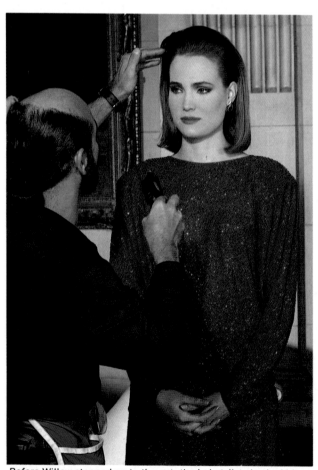

Before Willow stepped on to the set, the hairstylist checked his work and fixed a few stray strands of hair.

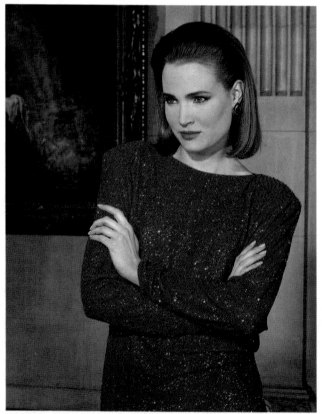

After the makeup artist and the hairstylist completed their work, Willow was ready to be photographed in the red dress. Her understated hair and makeup were perfect complements for this simple but elegant gown.

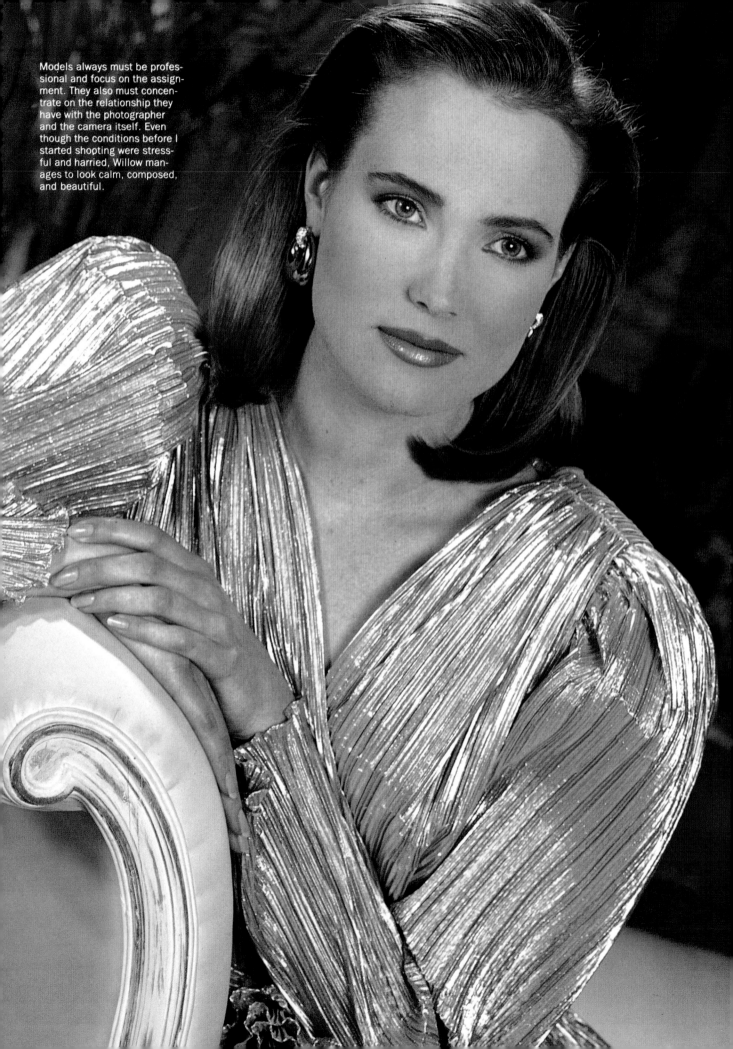

Models always must be professional and focus on the assignment. They also must concentrate on the relationship they have with the photographer and the camera itself. Even though the conditions before I started shooting were stressful and harried, Willow manages to look calm, composed, and beautiful.

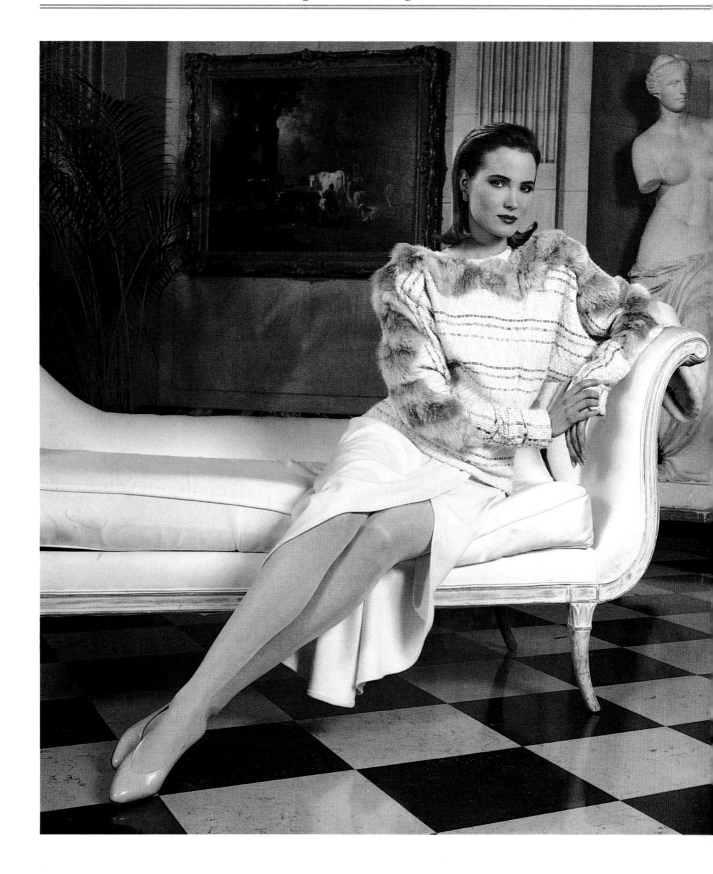

This shot, taken with a wide-angle lens, shows why the white chaise longue was a wise choice for this session. The chair matches the opulent decor of this room in the New York Academy of Design.

For this shot, I moved closer to Willow to photograph her from a different angle to give the client a larger selection of images to choose from. The chaise longue, statue, and painting are less visible, but still provide an interesting background. The lighting setup used for this photograph is shown below.

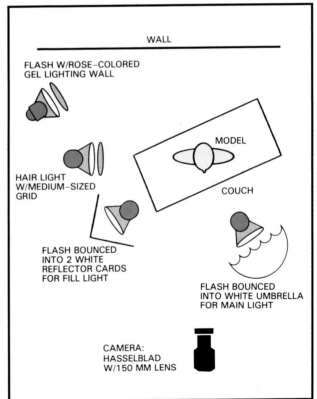

WALL

FLASH W/ROSE–COLORED
GEL LIGHTING WALL

HAIR LIGHT
W/MEDIUM–SIZED
GRID

MODEL

COUCH

FLASH BOUNCED
INTO 2 WHITE
REFLECTOR CARDS
FOR FILL LIGHT

FLASH BOUNCED
INTO WHITE UMBRELLA
FOR MAIN LIGHT

CAMERA:
HASSELBLAD
W/150 MM LENS

When I started shooting at about 11:00 o'clock, no more problems arose. Willow is a true pro and a joy to work with. She knows how to move and has great facial expressions. Sometimes less experienced models are stiff and uncertain, and you must devote large amounts of time and energy coaxing them into natural poses. I photographed Willow wearing various dresses and from many camera angles. Sabino likes to have a wide range of angles to choose from when he looks at the photographs, so I usually shoot distance shots first and then come in close for beauty shots.

When lunchtime came, the agent advised us that we would have to eat in the staircase. No food or drinks were allowed in the room we were shooting in. A guard was standing by at all times to make sure that we were obeying the rules.

During the break, we discussed the afternoon's shooting plan. Because we had spent the morning photographing Willow seated on the chaise longue, we decided to photograph her standing near a statue for the second half of the session. Ron made a few hairstyle changes. Next, Allan touched up Willow's makeup, coordinating the color of her lipstick with her change in clothing.

Postproduction. At the end of the day, the chaise longue had to be wrapped again, and I told the agent when the gallery was going to pick it up. (If we didn't return the chair promptly the next morning, we would be billed another day's rental.) The shoot was a success, and everyone packed to leave.

Of course, like every client, Sabino needed the film as soon as possible. I edited the developed film and sent it, with my choices indicated, the next day to Sabino. Willow Bay's elegance had been captured on the film.

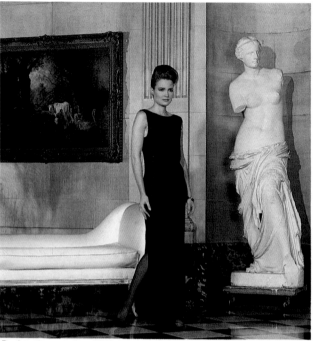

During the session, Willow wore several different garments, and the hairstylist and makeup artist changed her hair and makeup to coordinate with them.

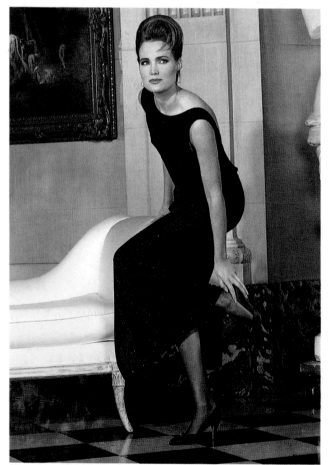

Here, I captured Willow in a natural, unposed moment. I think this image, taken between setup shots, is a compelling study in spontaneity: Willow always moves gracefully.

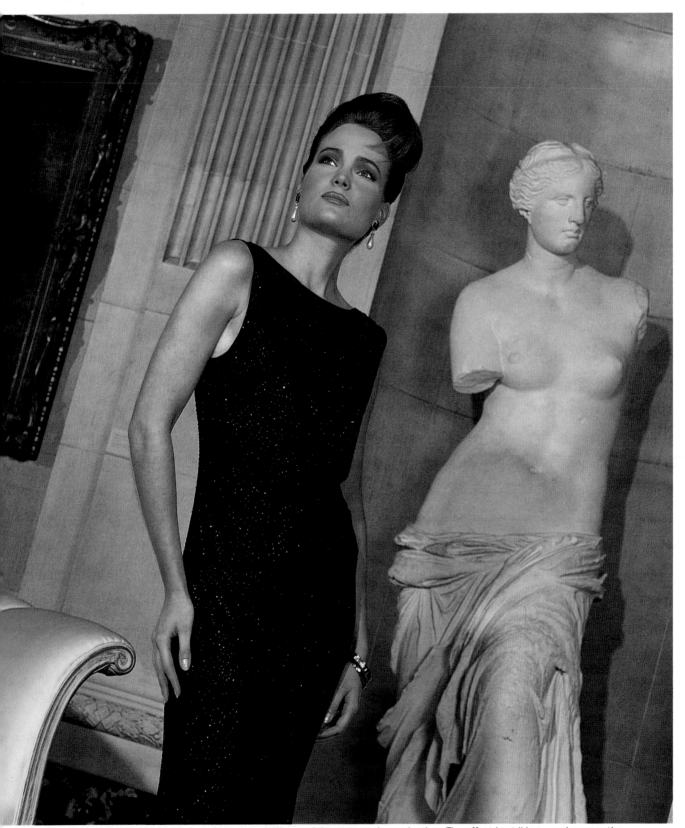

I decided to shoot at this angle in order to have Willow and the statue echo each other. The effect is striking—and provocative.

GIVENCHY

CAPTURING THE IMAGE OF A CLIENT

One of my clients, Frank Liberto, and I have had a good working relationship for ten years. We first met when he booked me to model jewelry, and we became friends. After I made the transition from model to photographer, Frank gave me the opportunity to prove myself, hiring me to photograph company ads when he worked at Pierre Cardin. Eventually, Frank moved on to Bijoux Givenchy, the jewelry licensee for Givenchy. Because no advertising agency was involved, he approached me directly for this assignment.

Preproduction. During our first conversation about the assignment, Frank explained that the photograph was going to be used as both an in-house poster and an in-store promotion card for a continuing campaign.

Working only with the concept in Frank's mind and no layout, we discussed the type of woman who would wear the jewelry: who she was, what she did, where she was going. She would be relaxed, glamorous, and elegant. Frank also felt the image should capture a moment just before the woman went out for the evening; after dressing, she would pause to have a drink.

Next, Frank and I discussed the budget. We would be able to hire both a hairstylist and a makeup artist, as well as a model from a top agency. We planned the shoot to be a full-day session and set a date for two weeks later. Because Frank and I had worked together for a long time, we trusted each other's taste. After analyzing our location needs, we decided to shoot in my apartment. We agreed that a warm environment would impart a sense of intimacy.

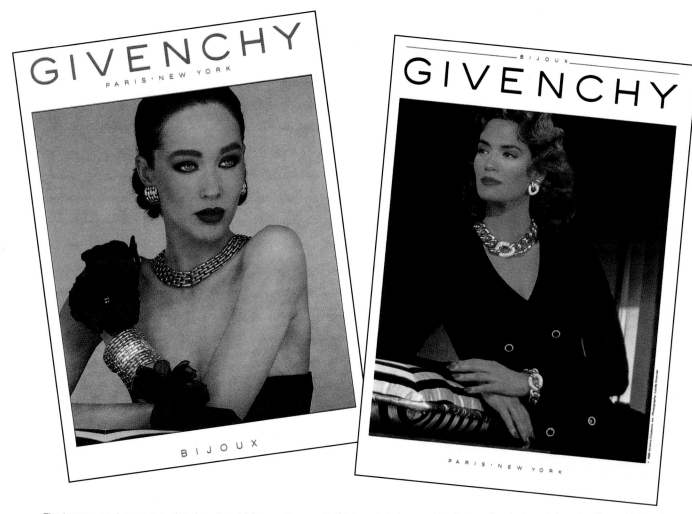

The images on these promotional cards, which were the result of this ongoing campaign, feature the designer's jewelry. The gold, black, and white colors of the pillow, the dresses, and the jewelry echo and enhance one another. Although different models and different pieces of jewelry were used, the moods of the images are the same.

Keeping this idea in mind, we searched the agency books for a "Hollywood" type: a dark-haired model who was sophisticated, elegant, and a bit jaded. A perfectionist, Frank wanted a wide range of models to choose from. To facilitate the selection process, we arranged a casting session. We saw twenty-five models, but Frank thought that only one had the look we wanted. We agreed to put her on tentative hold for a full day. Our plan was to confirm the booking after I made certain my choices of hairstylist, Timothy Downs, and makeup artist, Clorinda, were available on that date.

Bijoux Givenchy is a licensee of Givenchy, so Frank and I were expected to use Givenchy clothing for the assignment. Frank chose several garments that would work with the "Hollywood" concept.

The finishing touches included an arrangement of flowers for the background. Frank decided that the graceful lines of several calla lilies would add a glamorous 1940s accent. Frank had often admired one of my vases, and I suggested we use it. He arranged to have the calla lilies delivered to my apartment at 8:30 on the morning scheduled for the shoot.

Other props we discussed using were pillows, and I offered to look for ones that would be perfect for the set. I went to The Pillow Salon, a boutique that specializes in extravagant pillows in a wide range of fabrics. The selection differs from week to week depending on what has already been rented. When I arrived, my eye immediately went to a black-and-white striped satin pillow with gold trim. To me, it embodied the essence of Givenchy. The combination of black and white is classically elegant, and the color of the trim would echo the gold jewelry. Also, because Frank had chosen a black evening dress for the shoot, I rented two other solid-colored pillows, one mauve, one turquoise, to give us some possible variations.

Finally, Frank and I decided to photograph the ad near my piano, with the model resting an arm on the black-and-white pillow.

The Shoot. On the morning of the shoot, Frank and I thought that we had everything under control. Frank had come on time with the Givenchy jewelry and clothing. The flowers were delivered to my apartment promptly at 8:30. Upon arriving, Timothy and the makeup artist started setting up an area in which to work. We were enjoying a continental breakfast when the model showed up, obviously upset. She had awakened that morning with a large blemish on her face. Although she was willing to work if we insisted that she did, she suggested we call the agency to arrange for

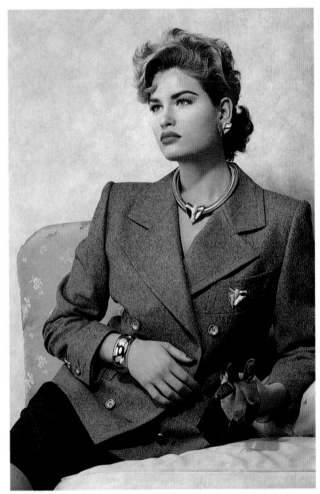

Although this image captures the classic look associated with Givenchy, complete with a sophisticated business suit, gloves, jewelry, and pillow, the art director preferred the "Hollywood" look he originally had in mind.

an alternate. Suddenly, our perfectly planned schedule for the day had fallen apart.

In an effort to solve our problem, Frank and I briefly discussed photographing the model at an angle and retouching the shots afterward, but we felt this would be limiting and expensive. In addition, we wouldn't be able to use any other shots from the shoot for public relations purposes. We decided to let the model go and to book a replacement.

In response to our urgent request, the agency immediately sent over models who were available at a moment's notice. One of the first to arrive was Lynne Paddy, who had short, blonde hair. Even though Lynne did not have the "Hollywood" look that Frank originally had had in mind, he liked Lynne's appearance, and we decided to book her until 1 o'clock. Timothy and the makeup artist began preparing Lynne for the shoot. A short time later, I was able to photograph a sophisticated-looking woman wearing a business suit.

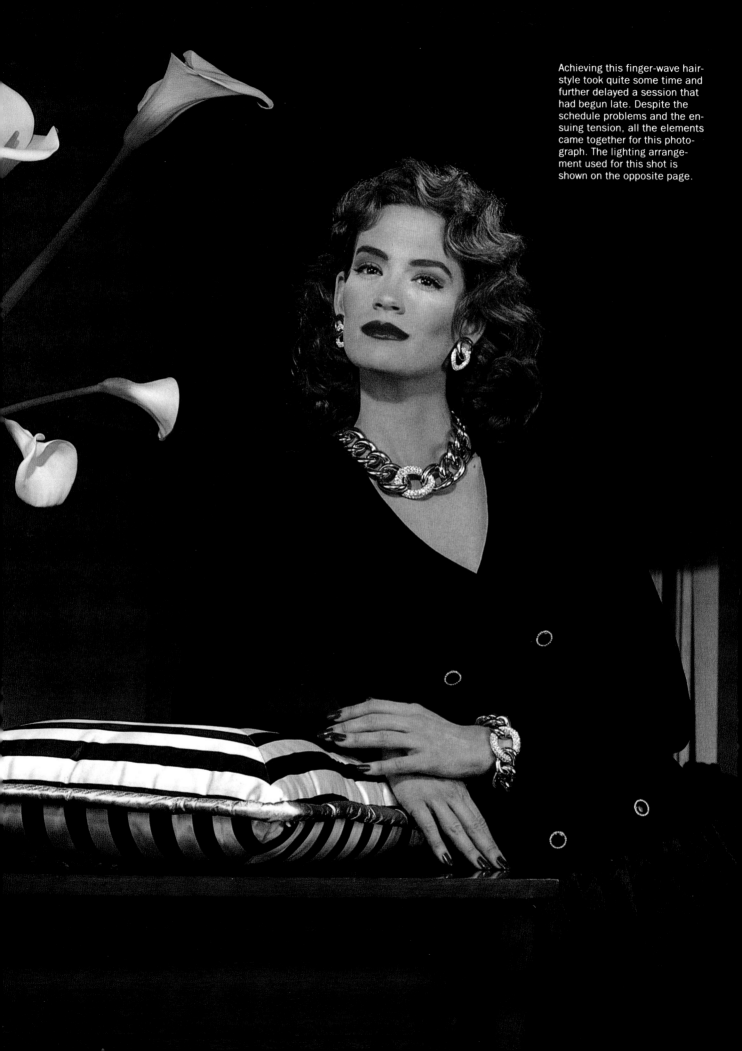

Achieving this finger-wave hair-style took quite some time and further delayed a session that had begun late. Despite the schedule problems and the ensuing tension, all the elements came together for this photograph. The lighting arrangement used for this shot is shown on the opposite page.

While we were working with Lynne, another model, Ely Pouget, arrived. When Frank saw Ely's dark hair and "Hollywood" look, he decided that he preferred the originally planned image, so we booked Ely. It was now 12:30, and, once again, Timothy and the makeup artist went to work. However, achieving a structured finger-wave hairstyle was quite time-consuming, and at 1:45, we were far behind schedule. We confirmed with the agency that we would treat Ely's time as one full day and would work until 8 o'clock. (Although models are usually paid time and a half for working overtime, the agency agreed that this was a special situation.)

When Ely was ready to be photographed, Frank and I directed her to lean against the piano. Luckily, the black dress Frank had selected had a V-neck, so the gold and silver jewelry Ely wore picked up light and color from her skin rather than from the dress. I took a Polaroid and carefully examined the image with Frank; we wanted to see if the jewelry needed to be illuminated more. Once we were satisfied, we checked Ely's hair and makeup, as well as other details. The makeup artist then lightly powdered Ely's face. After I took a few more Polaroids to verify that the changes we made were appropriate, I was ready to shoot.

Despite the session's shaky start, we now had a working rhythm, and I was confident that we were getting good results. We were ready to move on to the next variation. We changed the lighting setup and asked Ely to put on a dramatic red dress and lean against a marble pedestal. We then draped some gold fabric, which was stored on my prop shelves, to create a curtain effect. The fabric repeated the theme of the gold jewelry.

Postproduction. Emergencies like the one that happened during this session lead to unexpected, and sometimes puzzling, reactions: you never know if the resourcefulness, imagination, and energy required to solve a problem will invigorate or exhaust you and the team.

Fortunately, at 8 o'clock in the evening, after a long, hard day, I had the satisfaction of knowing that I had successfully completed a challenging shoot.

Because the client was so pleased with the results of this session, I was hired to photograph other models for this ongoing advertising campaign. All of the models had an air of sophisticated elegance, enabling me to capture the spirit of Givenchy during each session.

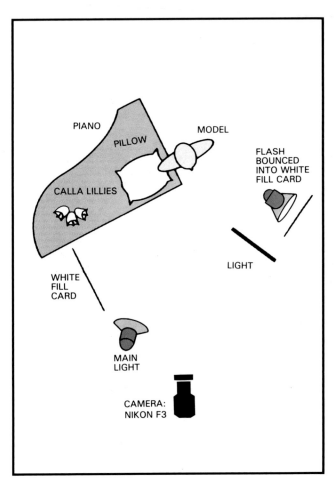

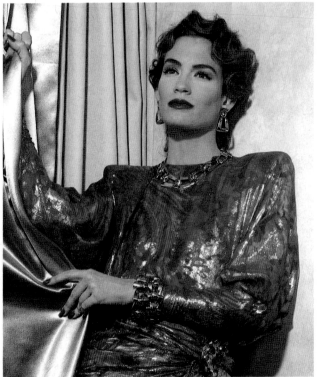

To provide the client with some variety, the art director wanted me to photograph this model in a red dress. We gathered some gold fabric from one of the prop shelves in my apartment and draped the material, forming a "curtain." Although the model's hairstyle and makeup echo the "Hollywood" look, the art director decided to use the more dramatic "Hollywood" shots with the black-and-white pillow for this continuing campaign instead.

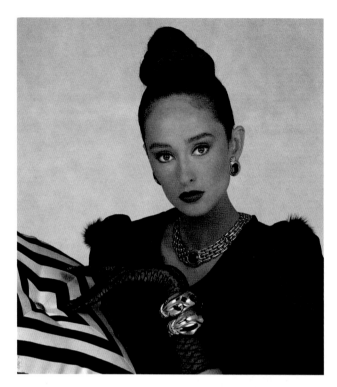

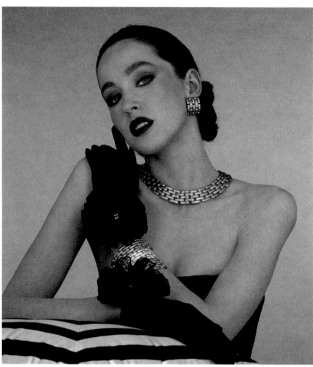

For this ongoing Bijoux Givenchy advertising campaign, the art director wanted the models to look sophisticated. Their tightly pulled back hair; long, bare necks; and well-defined lips work together to embody the spirit of Givenchy: classic elegance. The black-and-white pillow was used to establish a sense of continuity for the campaign. As a prop, the pillow was the ideal accent for Givenchy's image.

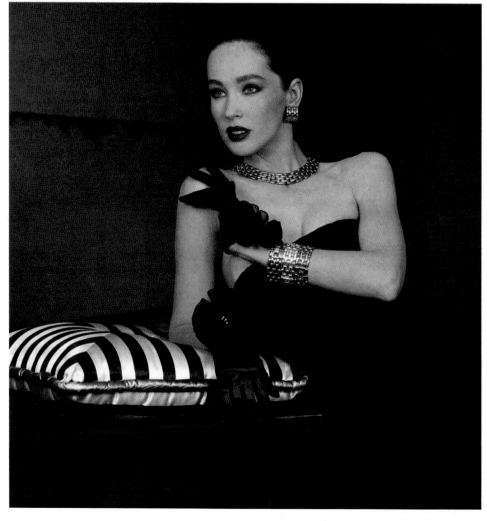

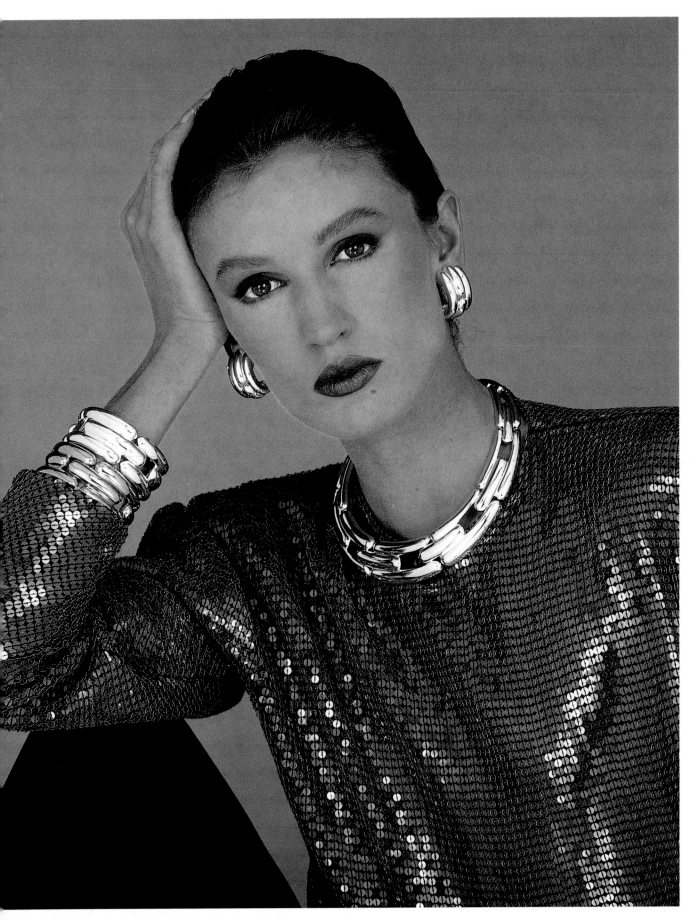

KIRKENDALL

PHOTOGRAPHING A CATALOG ASSIGNMENT

Over the years, I have received assignments in all the conventional ways, some easier than others. Some even seem to just fall into place, such as the session with fur designer Kip Kirkendall. Kip designs her own line of fur ensembles that feature unusual colors and textures. When Kip and her husband decided to produce a sales catalog to promote her latest collection, they hired me as the photographer. I had been recommended earlier to Kip by a makeup artist who suggested that I use Kip's designs for my photography. Kip hired Karen Novak as the art director. Karen had helped to design some of my promotional pieces and had also worked previously with Kip.

Preproduction. At the first preproduction meeting for the assignment, Kip explained that she wanted me to photograph twelve fur ensembles in an interesting location. The catalog would be in color, with the exception of one black-and-white shot to be used for public relations purposes and as the center layout of the catalog. One of the color images would also be used separately as an advertisement. Kip wanted Karen to design a catalog that would reflect the photography, so the photographs had to be complete visual statements. To show both the range and the uniqueness of her collection, Kip felt that three distinctively different models were needed for the shoot.

While planning the session, I decided to shoot in the 2¼ format using Ektachrome 64. I estimated that I would need forty rolls of color film, six rolls of black-and-white film, and three packs of Polaroid film. I always bring extra film with the same emulsion number—to ensure consistent results—to a shoot in case I exceed my estimate. (When I buy a batch of film, I always shoot and expose two rolls with the same emulsion number to test for color. My film supplier keeps the balance of the film on hold until I am satisfied with the test results. If I find that only minor color adjustments are necessary, I accept the rest of the film and use Kodak color-compensating filters to correct the color balance.)

The next step was to find a location. Kip suggested that Karen and I investigate a loft that a friend of hers had mentioned. When I met Karen at the loft, however, we decided that the space was uninteresting and the available light was limited. I then recommended looking at a studio in the Puck Building, where an abundant amount of natural, ever-changing light filters through huge, vaulted windows. Even though the rental fee was a bit steep, the studio offered so many possibilities that spending the extra money would be worth it. The placement of the windows and the unblocked light create wonderful patterns on the walls and floors. I was able to envision how the play of the changing light on the models and the garments would add an element of excitement to the photographs. Kip and Karen looked at some photographs I had done in this building and agreed that it would work beautifully. We targeted a tentative date.

We then had to book models. Kip had very definite ideas. She had worked with Shelya Huff, loved her look, and wanted to work with her again. Shelya is a light-skinned black woman with black hair. I recommended that we also hire Sophia Koustis, who has brunette hair and is unusually beautiful. For the third model, we needed to cast someone with blonde hair. We scheduled a go-see at Kip's showroom, during which each model tried on a garment, so that we could determine if she could carry it properly. After the go-see, Kip, Karen, and I agreed on hiring Erika Wilson from the Ford agency.

The next step was to find hair and makeup artists. I suggested hiring José Occasio and Eddie Santos, a hair-and-makeup team whose work, I knew, would complement Kip's garments. After she agreed, I checked to make sure that they were free on the planned shooting date and then booked them directly: they were not represented by an agent. During the conversation, I stressed the importance of working quickly and of coordinating their efforts.

Everything seemed to be falling into place. The date was confirmed, first with the Puck Building, and then with the hair and makeup team. Before booking the models, Kip and I discussed scheduling. We would need Sophia for most of the day and Shelya and Erika for four hours; two models' hours had to overlap, so that we could photograph them together. With this time schedule set, my assistant called the agencies and confirmed the models. She instructed the bookers that the models should come to the studio with clean hair, no makeup, and nude pantyhose. I then made a few calls to my favorite first assistants and was able to hire Grant LeDuc, someone I had worked with many times. Eileen Patskin, my studio assistant, would be on the set as second assistant during the session.

The Shoot. My assistants, Grant and Eileen, arrived at my apartment at 7:45 on the morning of the shoot. We packed the film and lighting equipment in half an hour

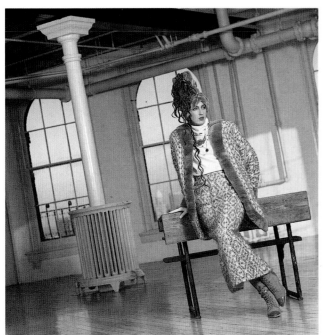

When planning this session, the designer and I agreed that this rental studio would be an ideal location. In this shot, the exposed pipes, the heater, and the old, worn school desk provide an interesting background for the fur ensemble.

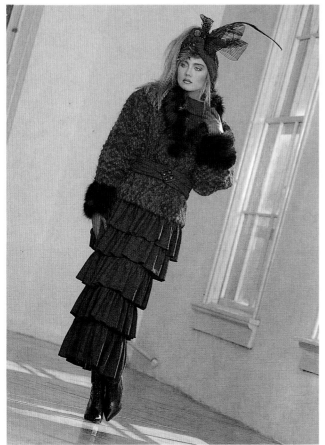

For the second shot of the session, I photographed this model wearing a particularly striking ensemble: a purple tiered outfit with black fur trim. The hat chosen to coordinate with this unusual design works perfectly.

and arrived at the studio at 8:45. Kip and her assistant met us there. Kip brought along several racks of clothing and various accessories: she prefers to do her own styling. She had designed all the hats and made some of the jewelry. Kip also had borrowed a few other pieces of jewelry, as well as some pairs of shoes.

We had scheduled an arrival time of 9 o'clock in the morning for all the other members of the team except the models, who had staggered arrival times. Kip brought a check with her in order to pay the location fee for using the Puck Building. Just as Karen arrived, Kip ordered breakfast for everyone.

In the large dressing room, everything needed for the shoot was laid out and organized, so that everyone could see the order in which the garments would be photographed. This enabled José and Eddie to plan the hairstyle and makeup to complement each garment. Kip, Karen, and I approved their ideas. It is particularly important that the client is in accord with the artists on details, such as the models' hair and makeup. If everyone agrees on these elements from the start, there will be less aggravation and wasted time later in the day.

When Sophia appeared, completely dressed and made up, I took the first Polaroid of the day, checking all details before the actual shoot began. The Polaroid proved that the gray coat she was modeling was much too large for her. To correct this problem, Kip taped the hem and adjusted the way it hung on Sophia. I took another Polaroid to double-check the results.

As the session continued, I photographed Erika in a purple coat, and then Sophia in a brown garment. An old school desk happened to be in the studio, and everyone felt that it worked perfectly with the brown outfit. (Rather than move in tight on a model, I compose my images in a way that gives clients enough space in each photograph to crop it wherever they want to.) For these photographs, I used two electronic flash heads aimed through two shoot-through umbrellas. I took a number of shots at 1/60 sec., and then used various slower exposures to pick up varying degrees of light cast onto the floor.

At the end of the morning, Eileen ordered lunch, to arrive half an hour later: during a shoot, everything is timed. (Although I prefer to have the client pay for meals directly, which Kip did, I always have cash on hand for food, as well as miscellaneous expenses.)

Throughout the day, while each model changed garments, José and Eddie quickly adjusted her hair and makeup, so that her look would blend well with the new outfit she was wearing. When the members of the team on a shoot are working well together, the creative energy flows. I try to maintain an atmosphere in which

the client feels free to suggest alternatives. As a result, I often find myself coming up with new ideas spontaneously during a session.

For example, as this session progressed, I noticed the sun filtering through one of the windows, creating a beautiful rectangle of sunlight on the floor. I suggested that we ask Sophia to lie on her stomach on the floor, so that the detail on the back of the coat—a feature Kip wanted to highlight—would face the camera. One reason we used Sophia for this shot was her thick, lustrous hair. Kip, Karen, and I worked quickly to arrange the model's hair in an interesting pattern above her head. We decided to add another element to the image by placing a hat near her hair. When I began to shoot, I asked Sophia to move her feet to create various angles and positions. I shot in natural light, bracketing up to one stop in both directions. Kip used a shot from this series for her ad.

Next, I photographed Sophia standing up in the same outfit. One of these images was used in black and white for the center spread in Kip's catalog and provided a striking contrast to the color photographs found throughout the rest of it.

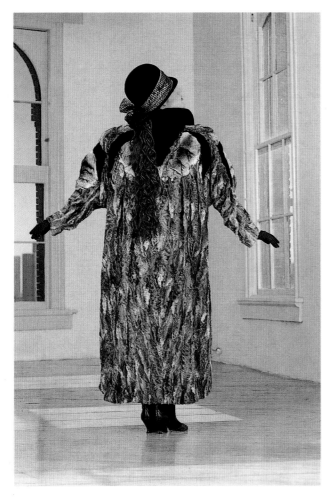

Improvising on the set is often exciting. Here, I directed the model to lie down on the floor. I then asked her to hold her feet in different positions and varied the arrangements of her hair, using it like a prop. Finally, I placed a black, "jewelled" hat on the floor beside her to achieve an even bolder effect. Before I photographed the model this way, I took several straightforward shots of her standing up.

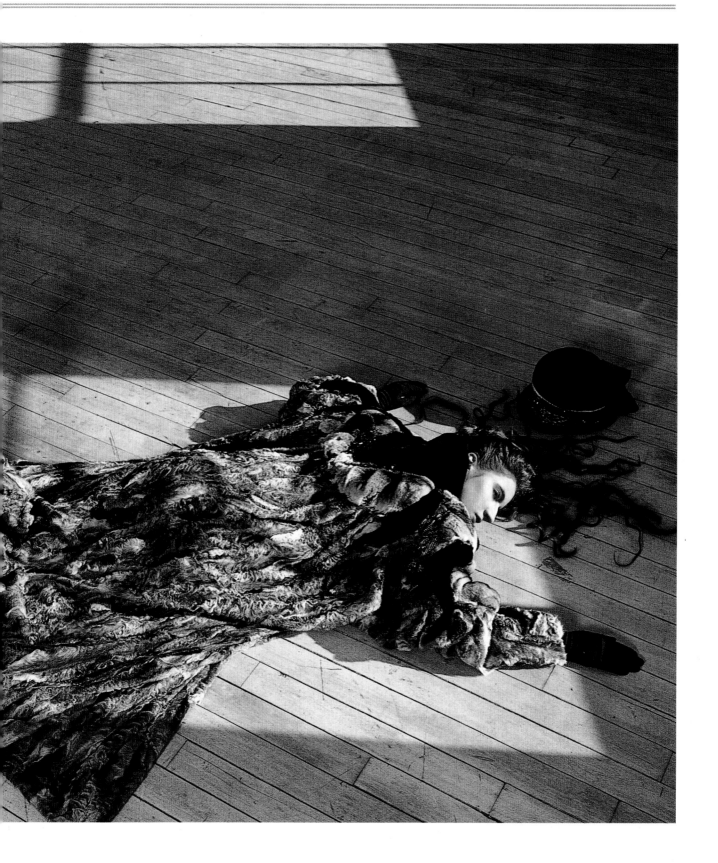

The next scheduled shot called for Erika to pose in a charcoal-colored leather outfit. Because Kip felt that the detail on the back of the jacket was important, I shot from a variety of angles.

A short time later, Shelya, the third model, arrived. To achieve an interesting effect for a photograph of Shelya wearing a jacket made of lamb and gold opossum, I had my assistant hold a 4′ × 8′ silver reflector next to Shelya while I photographed her straight on. The reflector picked up the sunlight shining through the window and threw an unusual pattern of light on the wall.

As the shooting proceeded, Grant recorded each roll of film in numerical order, including *f*-stops, shutter speeds, the models' changes of clothing, and lighting changes. He marked any rolls that had to be *clip-tested* (see Chapter 7, page 133).

Throughout the day, I utilized background props that we had found in the studio for several shots, and the exposed ceiling pipes and radiator column became part of the "backdrop."

Postproduction. It was now 6 o'clock in the evening, and the session was a success. Kip and her assistant packed the clothing; Grant and Eileen packed my equipment. Karen gathered most of the Polaroids in order to get a headstart on laying out the catalog. We cleared and cleaned the studio carefully, making sure we left it as we found it.

The film that was to be clip-tested was sent to the lab. The black-and-white film was sent to another lab that would process it with contact sheets. I viewed the clip tests later that evening to judge whether the exposure was correct or needed adjustment. Everything was on target, and the balance of the film was to be processed "normal."

The next day, the processed film was delivered to my studio. I did a quick edit, eliminating any bad shots. Next, the black-and-white contact sheets arrived, and I sent all of the film to Kip. The catalog had to be produced quickly—the deadline was rapidly approaching—and a fast turnaround time was essential. In just a few short weeks, we had the finished catalog in hand.

To show the detail on the back and the sleeves of this jacket, I asked the model to strike many different poses. This angle provided the best view of the unusual design.

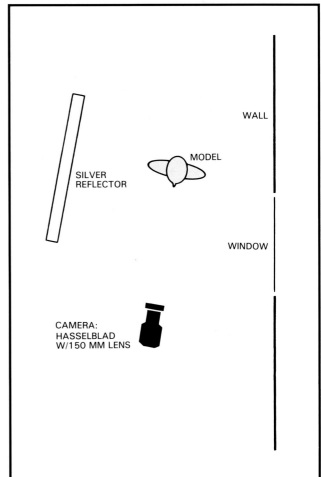

WALL

MODEL

SILVER
REFLECTOR

WINDOW

CAMERA:
HASSELBLAD
W/150 MM LENS

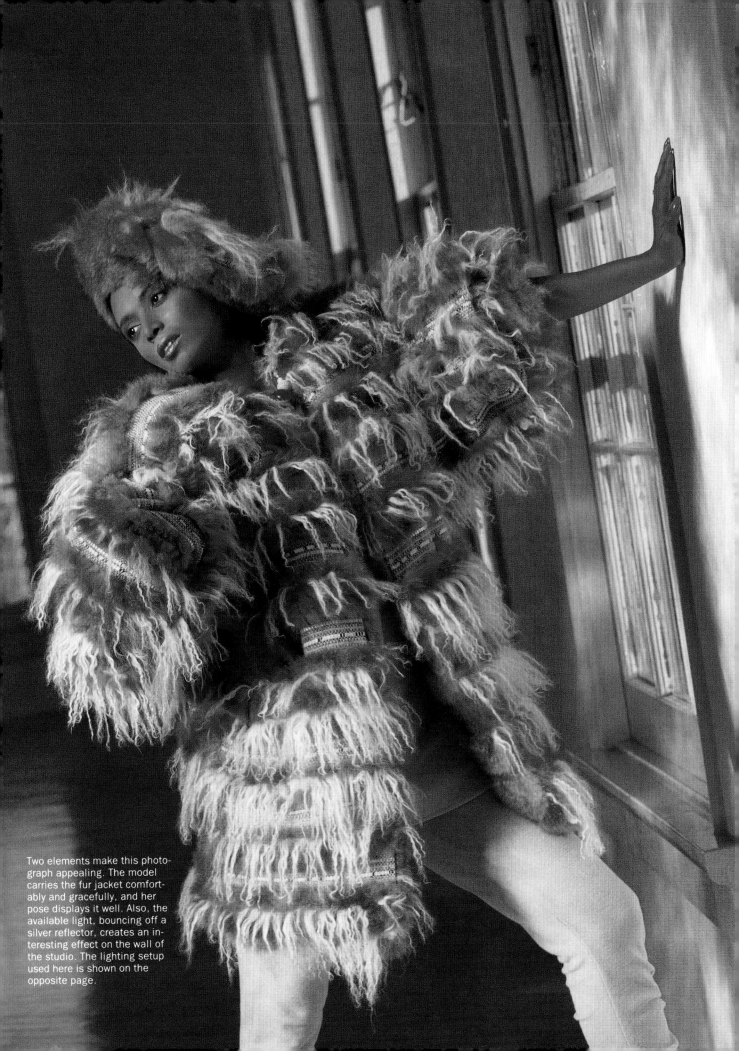

Two elements make this photograph appealing. The model carries the fur jacket comfortably and gracefully, and her pose displays it well. Also, the available light, bouncing off a silver reflector, creates an interesting effect on the wall of the studio. The lighting setup used here is shown on the opposite page.

SAFILO

WORKING WITH A TIGHT SHOOTING SCHEDULE

Sabino Caputo, an art director I have worked with for many years, booked me to produce an image-building brochure for the Safilo eyewear company. The client wanted to promote the idea that today's woman needs an entire wardrobe of eyeglasses to coordinate with the clothes she wears for the various roles she plays. I was to photograph models involved in different activities, such as working at the office, skiing, and shopping for clothes.

Preproduction. During the first meeting about the assignment, Sabino and I concluded that we would be able to complete the job in two days if we planned carefully. After Safilo approved the layouts, we began the preproduction work.

Our first task was to book models. We didn't have to arrange a casting session because the client wanted to hire Stephanie Romanov and Amie Morgan, models who had previously appeared in the company's ads. Using the same models would provide the campaign with a sense of continuity. However, I knew that scheduling them might pose a problem because the Christmas holidays were rapidly approaching. Anticipating this problem, Sabino had started planning the session well in advance. Nevertheless, calls to the modeling agencies confirmed my fears: one of the models was going out of town, and the other was solidly booked. After many additional calls to the client, Sabino, and the agencies, I put the models on a tentative hold for two days in January.

My next step was to rent a studio. (My own studio is small and best suited for beauty assignments.) I decided to go with Tekno/Balcar Studios, which I often do when having abundant daylight isn't a priority. The studios are spacious and laid out well. There is a separate room for dressing and hair and makeup, as well as a kitchenette. Photographic equipment is supplied, so I didn't have to transport my electronic flash units and lights. In addition, the studio's knowledgeable staff can offer advice and information about using new equipment.

I then put a tentative hold on Grant LeDuc, an assistant I book regularly. Patty McGurn, who worked at my studio on a full-time basis, was second assistant on the set. Next, I arranged another meeting with Sabino to discuss the layouts and get copies of them. Studying the layouts reminded me that this was an ambitious, complex project. Numerous elements would have to be pulled together for the brochure to be completed on schedule.

The layouts consisted of five themes: "Career," "Sport," "Shopping," "Evening," and "Weekend Errands." Each theme required a full-length fashion photograph and four shots to be inset. The garments, props, and accessories had to be color-coordinated for each theme.

At this point in the preproduction planning, Sabino and Nancy Wolfson, the stylist he had hired for the job, met with the client to discuss the desired color themes and props. The budget she had to work with and the length of the assignment were addressed. Nancy explained to the client that she required two days to "prop and prepare," two days on the set, and one day for an assistant to return borrowed props and clothing. The client agreed to this schedule.

Next, I needed to book a hairstylist and a makeup artist who were excellent at creating natural looks. I decided to call Zoli Illusions, a division of the Zoli modeling agency. Zoli Illusions represents hairstylists, makeup artists, and photography stylists. I know I can trust the staff's recommendations. I asked about the availability of two artists whose work I particularly like. I then chose Barry Baz; discussed his day rate with Abbey, the booker; and put a tentative hold on Barry. (As Barry's representative, Abbey asked me who the client and advertising agency were and how they planned to use the photographs.)

The layouts also called for a baby, a dog, a sheet of plexiglass, and seamless. Before I cast the baby, Sabino told me that he wanted to use a two-year-old, and, after seeing a snapshot of my secretary's daughter, Jessica, chose her. Despite the risk of working with a child in the throes of the "terrible twos," Sabino wanted an informal atmosphere for the shoot and felt that the inevitable spontaneity would be appropriate. Sabino agreed to book the dog, and I provided him with the names of several animal agencies.

Arranging for the remaining two items on my list was simple. I ordered a standard-size sheet of plexiglass and an extra-long roll of white seamless paper over the phone from a set shop and had the agency send a check. I advised the studio that both the plexiglass and the seamless would be delivered the day before the session.

As the first day of the shoot approached, I continued to review the layouts. Drawing from my experience with catalog shoots, I suggested to Sabino and Alan, Safilo's account executive, that I draw up a shooting schedule (see page 47). For each shot, I would list the props and the time we planned to begin. A timetable prevents both confusion and unnecessary questions. Everyone on the

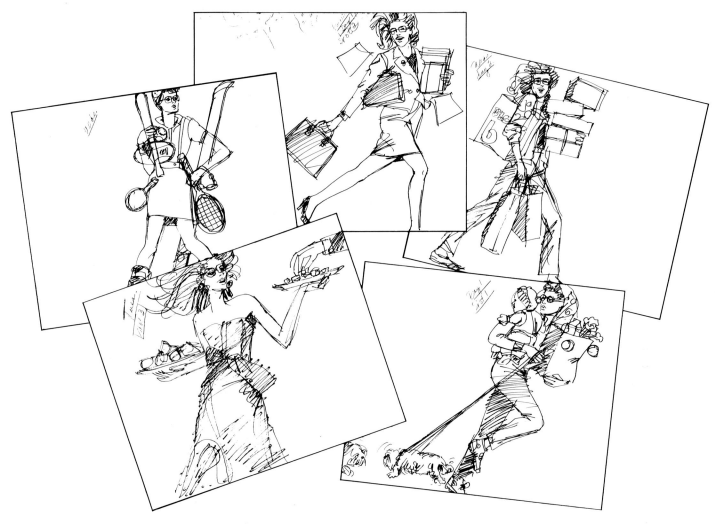

Even though these layouts were just rough sketches, the art director had a fully visualized concept in mind; as a result, the final photographs match them almost exactly.

Before this two-day session started, the art director and I discussed last-minute details about the layouts. As the photographer in charge of the shoot, I have to understand what the art director wants to achieve before shooting.

team would be aware of the plan for the day and whether or not we were on schedule as the session progressed.

Everything was coming together. Shortly before the shoot, Patty, my studio assistant, telephoned the various agencies to confirm Barry and the models. She told the bookers that the models should come with clean hair and no makeup. Patty also confirmed the dates, the starting time, and the studio's name, address, and telephone number with the bookers, who recorded the information and relayed it to the models.

As a final preparation for the shoot, Nancy and I spoke several times, discussing at length details about the schedule, the clothing, and the accessories.

The Shoot. At 7:30 on the first morning of the shoot, my two assistants arrived at my apartment to pack the camera equipment, film, and other miscellaneous items. When we were just about finished, I called the car service I subscribe to. Fifteen minutes later, we were on our way to Tekno Studios.

Everyone else arrived at the studio by 9 o'clock and enjoyed the *de rigueur* continental breakfast Patty had picked up. Having hung up the garment bags as soon as they arrived (to avoid wrinkles), Nancy and her assistant began to sort through the boxes of accessories and props they had brought with them. They included skis, ski boots, tennis rackets, sweatbands, file folders, hatboxes, and groceries. Next, Nancy and the client then started to look through the fifty or so pairs of eyeglass frames on hand, deciding which glasses worked with which garments.

At the same time, Barry set up in the dressing room and started to prepare Stephanie, and I distributed copies of the photography schedule.

The next part of the process involved arranging my equipment. To satisfy Sabino's wishes for a very low camera position in order to make the models appear taller and more imposing, and to suggest light reflecting from the plexiglass the models would stand on, my assistant assembled a makeshift platform. This consisted of two wooden boxes supporting a 6′ × 8′ sheet of plywood. Without the platform, I would have had to position the camera almost level with the floor to achieve the effects the art director requested. The seamless paper was then hung on autopoles; dropped, so that it would sweep down behind the platform; and pulled forward over the plywood and down in front. Finally, we placed the plexiglass on top of the seamless, across the plywood.

Next, I directed Grant in setting up the lights. In the background on either side of the seamless were two

During the shoot, the art director and I discussed many creative ideas and practical concerns.

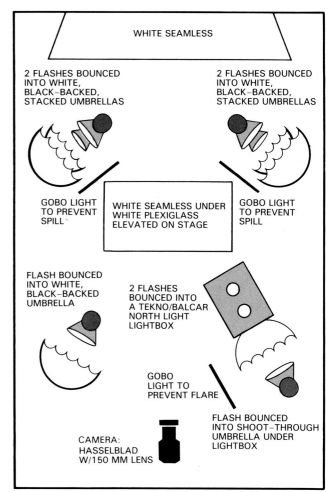

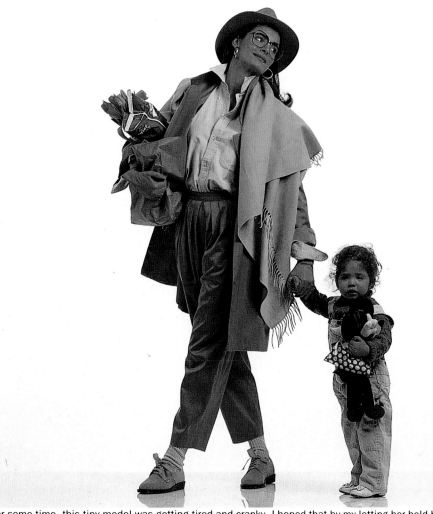

After some time, this tiny model was getting tired and cranky. I hoped that by my letting her hold her favorite stuffed animal, she would get another burst of energy. The toy added the right touch—and was included in the brochure. The lighting arrangement for the shots using this setup is shown on the opposite page.

electronic flash heads with white umbrellas, one higher than the other, and black backing. To prevent spill, I instructed Grant to gobo the background lights with large, black flats clamped to a stand. In the foreground, Grant angled a giant, 3′ × 4′ North Light lightbox with two heads inside toward the model's position, and positioned a separate head through a shoot-through umbrella placed below the lightbox. This light, which was aimed at the spot where the lower part of the garment would be, added extra fill. A white umbrella, black-backed, was placed high and to the left of the set for fill. (The umbrellas are 39 inches wide.) I used a star powerpack 1600w for fast recycling. When I photograph fashion, I tend to shoot quickly, and the star flash unit keeps up with my camera's motor drive.

With everyone ready and every piece of equipment in place, we were able to follow the shooting schedule closely. Barry had completed Stephanie's hair and makeup, and Nancy had assisted her as she got dressed. Nancy had also dressed Jessica in light blue overalls and a navy sweater. And, in spite of her age and the many unfamiliar faces around her, Jessica behaved well. Randee, her mother, had brought her in earlier than necessary to acquaint her with Stephanie. It was soon clear that Jessica was warming up to the model.

As a result, the first shot of the morning, scheduled for 10:40, was taken then. When I continued, I shot a few rolls of Stephanie holding Jessica in her arms and then experimented, having Jessica stand on the floor next to Stephanie. After a while, however, Jessica began to get cranky. But with Randee at my side, I felt secure enough to keep shooting and captured some special moments. After we were satisfied with the shots, Randee signed a model release.

While I was working, Sabino looked through the camera before each shot. Even if the image seems great, the art director may detect the need for an adjustment. For example, if the photograph will be printed as a two-page spread, the art director may suggest moving the model a bit more to one side to avoid the possibility of the gutter (the center of the spread) cutting through her face.

The second shot of the day called for Amy, who was scheduled to pose for all the closeups. While Barry and Nancy helped Amy get ready, Grant and Patty, following my directions, arranged a small beauty set at the other end of the studio. This would prevent us from having to alter the lighting when we switched from full-length shots to closeups. Then, when I photographed Amy, Barry reworked Stephanie's makeup slightly and changed her hairstyle. At the same time, Nancy prepared Stephanie's wardrobe for the "Career" shot, and Patty ordered lunch. We were on schedule. Careful organization was paying off.

Throughout the session, the art director stood directly behind me or as close to me as possible, so his line of vision was similar to mine. This enabled him to suggest any changes immediately, before I continued shooting.

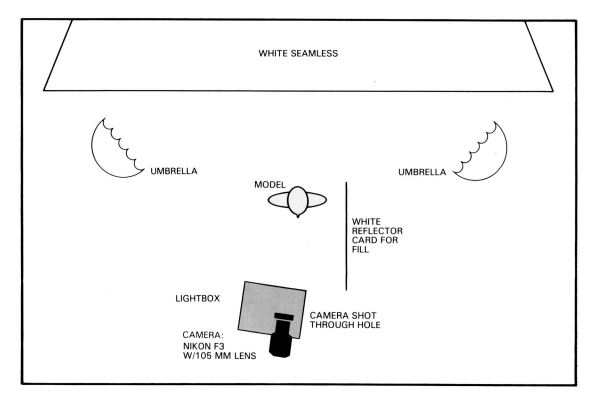

WHITE SEAMLESS

UMBRELLA

UMBRELLA

MODEL

WHITE REFLECTOR CARD FOR FILL

LIGHTBOX

CAMERA SHOT THROUGH HOLE

CAMERA: NIKON F3 W/105 MM LENS

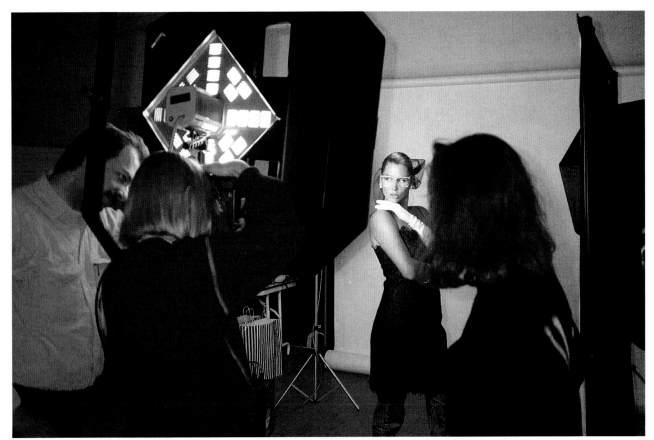

The glamour of fashion photography! Because I was photographing this model from only the shoulders up for a beauty shot, she was able to wear her own pants. The lighting equipment setup is shown below on the opposite page.

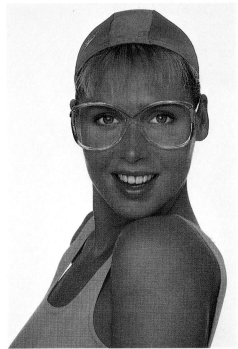

The "Sport" layout for the brochure called for several beauty shots to show the eyeglass frames more clearly. Here, the model poses in a blue bathing cap and yellow bathing suit to create the illusion of wearing glasses at the beach or the pool.

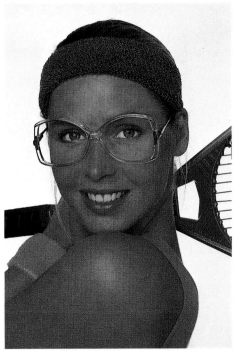

For another "Sport" beauty shot, the model put on a green headband, a yellow wristband, and an orange tee-shirt and held a tennis racket. While their colors are bright, they do not distract from the eyeglass frames.

For this "Career" photograph of a model working in an office, the art director was needed to continually throw computer paper on the set until I got the shot I wanted.

Here, for this "Evening" shot, the account executive was called upon to hold out the serving tray filled with champagne glasses. When a shoot is involved and requires the careful coordination of many elements, extra hands are always needed— and put to use.

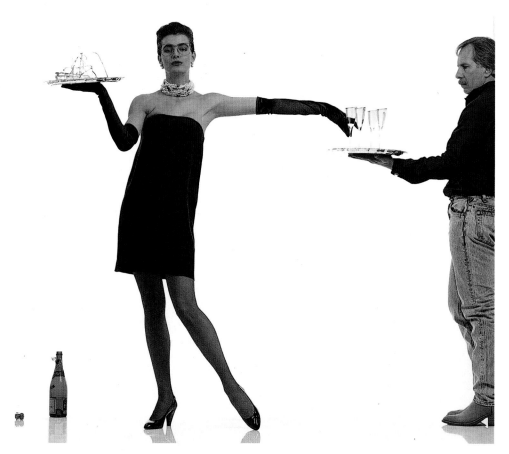

As soon as lunch was over, I photographed the "Career" shot. Standing on Stephanie's right side, Alan tossed sheets of computer paper onto the set. After each click of the shutter, he picked them up and threw them again. The added movement contributed to the sense of deadline pressure and a fast-paced business day. We repeated the paper-throwing for several rolls of film until I felt that I had the shot the client wanted.

The last shot of the first day was the "Evening" theme. Nancy taped champagne glasses to a silver tray and substituted ginger ale for champagne. This series of shots was completed successfully and on schedule. To congratulate ourselves on a job well done, everyone drank real champagne at the end of the day—everyone but Jessica, who had already been taken home.

The second day also went smoothly, with every step proceeding as originally planned.

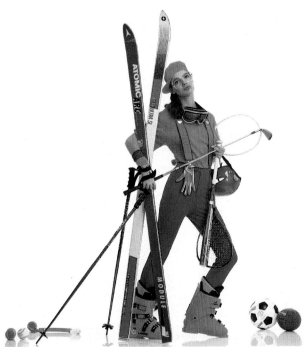

The stylist needed some time to gather all the props for this shot of a model equipped to go skiing and play tennis, baseball, handball, football, soccer, and golf. Some props were purchased, others rented, and still others borrowed.

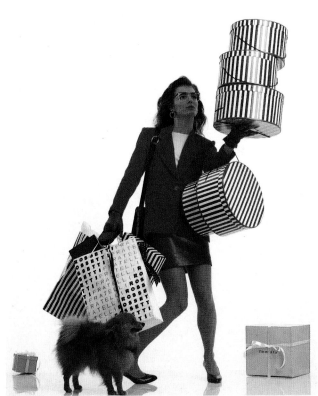

In this shot, taken on the second day of the shoot for the "Shopping" layout, the model begins to have some difficulty managing all the props. The look in her eyes and the position of her right foot reveal that she is about to drop the hatboxes.

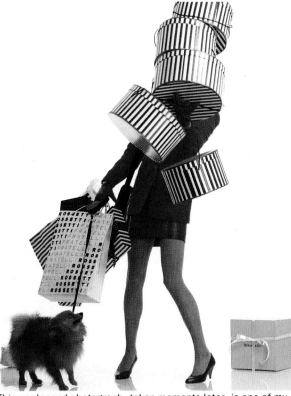

This unplanned photograph, taken moments later, is one of my favorites. Although the boxes were empty and taped together, everything tumbled down when the model lost her balance. Even the dog reacted to the mishap.

The two-page spreads in the brochure give an idea of the large number of photographs taken during this busy, complicated session. The client was pleased that the final brochure followed the layouts closely and presented a variety of the eyeglass frames.

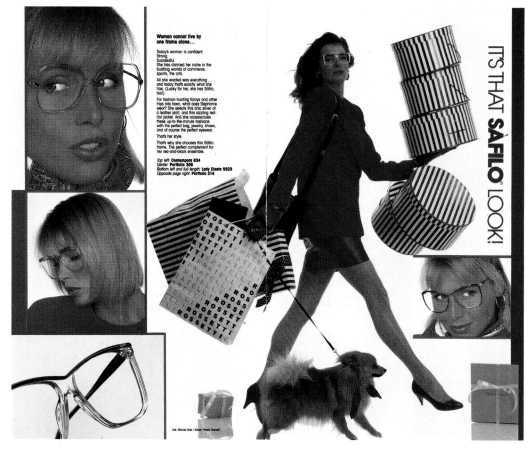

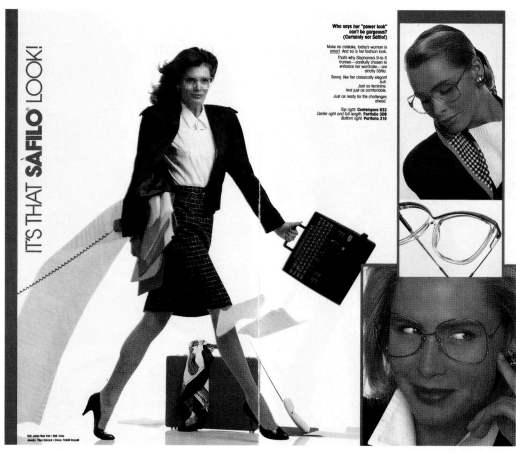

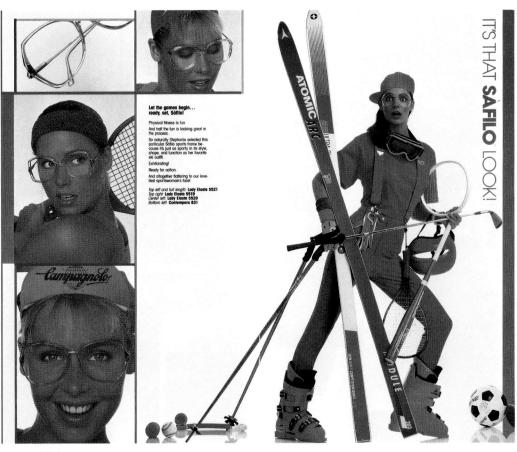

**Let the games begin...
ready, set, Sáfilo!**

Physical fitness is fun.

And half the fun is looking great in the process.

So naturally Stephanie selected this particular Sáfilo sports frame because it's just as sporty in its style, shape, and function as her favorite ski outfit.

Exhilarating!

Ready for action.

And altogether flattering to our loveliest sportswoman's face!

Top left and full length: **Lady Elasta 5521**
Top right: **Lady Elasta 5519**
Center left: **Lady Elasta 5520**
Bottom left: **Contempora 831**

ITS THAT **SÁFILO** LOOK!

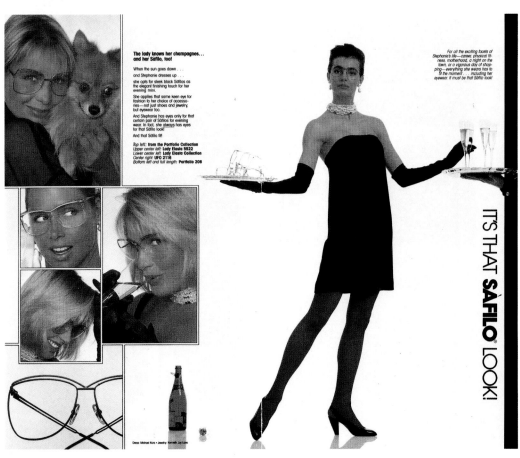

**The lady knows her champagnes...
and her Sáfilo, too!**

When the sun goes down . . .

and Stephanie dresses up . . .

she opts for sleek black Sáfilos as the elegant finishing touch for her evening mini.

She applies that same keen eye for fashion to her choice of accessories—not just shoes and jewelry, but eyewear too.

And Stephanie has eyes only for that certain pair of Sáfilos for evening wear. In fact, she *always* has eyes for that Sáfilo look!

And that Sáfilo fit!

Top left: **from the Portfolio Collection**
Upper center left: **Lady Elasta 5522**
Lower center left: **Lady Elasta Collection**
Center right: **UFO 2116**
Bottom left and full length: **Portfolio 208**

For all the exciting facets of Stephanie's life—career, physical fitness, motherhood, a night on the town, or a vigorous day of shopping—everything she wears has to fit the moment . . . including her eyewear. It must be that Sáfilo look!

Dress: Michael Kors • Jewelry: Kenneth Jay Lane

ITS THAT **SÁFILO** LOOK!

111

Postproduction. The film shot for the job during the day was sent that same night to a lab for *clip tests.* (Grant had marked down on a data sheet which rolls of film needed to be clip-tested. If, for example, a model seems to move a bit closer to the camera accidentally or she changes garments, that roll of film must be clip-tested. Not every roll of film shot during a session is clipped. See Chapter 7, page 133.) After I judged the clips, the film was processed "normal."

I edited the unusable shots and put a red "X" on the photographs I liked. I always hope that my input will influence my clients. I want them to choose what I consider to be a better photograph.

The real editing, however, starts at the advertising agency. Sabino had to base his selection of shots on marketing strategies since the ultimate goal is to sell the product. He made his initial choices according to the placement and fit of the eyeglass frames on the models. After narrowing the field, he looked for a shot with great expression, hair, makeup, and body language. Sabino sent his choices to Safilo, where the advertising director showed them to the company president, vice president, marketing director, and other decision-makers. They made additional comments and sent the shots back to Sabino. A great deal of discussion, negotiation, and compromise probably took place before the "best" photograph was ultimately selected.

The promotional materials and brochure were completed a few months later. The experience was pleasant for everyone involved, and the client satisfied.

Each of these sessions, although composed of the same elements, had a specific, different purpose. And, as you can see, the events that take place during a session can vary dramatically.

During postproduction, I showed the photographs of the session to the art director and the account executive. I had selected the images that I felt were the strongest and marked them with an "X." Although the photographer's opinion is appreciated, respected, and often wanted, the client's choice of images is final.

DEVELOPING YOUR STYLE

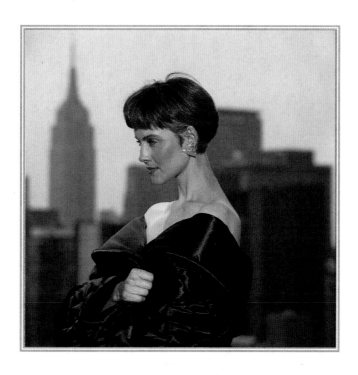

In the fashion world, photographers find it difficult to establish an individual identity because they are called upon to achieve so many different looks in many varied assignments. On the other hand, if you are to succeed in this business, you must establish and protect what distinguishes you and your work. You can accomplish this through the unique way you deal with the variables at your command. ❀ I have discovered—as you will undoubtedly learn—that people bring their experiences to the photograph. I am different from the person I was eleven years ago when I entered this field, and my photography reflects these changes. For my work to be successful and satisfying, it has to incorporate a certain fluidity and sensuality. I "feel" the photograph before I actually shoot it. This is, in part, a result of my years as a fashion model. I can understand what is necessary on both sides of the camera. Also, everything that appeals to my senses—from a trattoria in Milan to the Chrysler Building in New York City—will somehow be externalized on film. ❀ My photographs, for example, reflect my attitudes toward color, form, sensuality, and beauty. I am addicted to color. Whenever I go to Paris, I invariably come back with every shade of Bourjois rouge I can find. I don't wear them, but the colors enrich my palette as an artist, and I must have the latest colors for my collection. Also, while I surround myself at home with soft, quiet colors and limit my wardrobe to neutrals and black, I am usually drawn to vibrant, graphic colors for my photographs. My use of color partly defines my distinctive style as a fashion photographer in the eyes of my clients. ❀

EVALUATING YOUR STRENGTHS

The following are some of the skills that I consider all but indispensable for the successful fashion photographer. He or she should:

- have a strong sense of style
- be able to direct a creative team
- know how to listen carefully
- enjoy a wide variety of personalities
- be able to work well under pressure
- have flexible work habits
- be receptive to new ideas
- have a good eye for detail
- pursue new business aggressively
- be comfortable with an unpredictable income.

LEARNING BY ASSISTING

Perhaps the smartest way to learn the business is to work as a photographer's assistant. A fashion photography studio is an excellent training ground. You see firsthand the techniques of photographers on actual assignments, discovering what is expected of the photographer before being in that situation yourself. You learn—in practice rather than in theory—how to deal with clients and art directors, how to direct models, and how to coordinate the team. No classroom course can offer half as much.

Assistants in a large city, such as New York, have a choice: they can work exclusively with a single photographer, or they can work on a freelance basis. The choice is up to you.

Assisting Full-Time. You may prefer to work for one photographer full-time. There are both advantages and disadvantages to this type of work. A primary benefit is that you will learn your employer's style intimately. You will pick up the photographer's professional tricks and secrets. You will also have the security of a weekly salary and will be working in a less stressful atmosphere, where you can hone your own skills.

An important disadvantage is that you will not have the breadth of experience that a freelancer is exposed to, and you may pick up your employer's weaknesses as well as strengths. As a full-time assistant working from nine to five, you won't have as much free time for your own experimentation.

Many newcomers start by working on a full-time basis with one photographer for a year or two, then switch to freelancing when they gain enough confidence in their technical ability.

Freelancing. Working as a photographer's assistant on a freelance basis has a number of advantages. One is the unlimited variety of the work you will encounter. You will also learn, by necessity, to be flexible in your work habits, which is an asset for any photographer. Another advantage of freelancing is that freelance assistants command a higher day rate than full-time assistants do. And, on the days when you are not booked, you will be free to build your own portfolio; this is an advantage that full-time assistants do not share.

However, as a freelancer you will not be guaranteed the always important, sometimes critical weekly paycheck. Be aware that there may be some lean periods when no work is coming in, and you may experience the panic familiar to everyone who freelances, including actors, writers, and models. Jobs can be quite sporadic. Try to anticipate the slow months that alternate with busy periods.

Your goal as a freelance assistant will be to find desirable work. You can do this by building working relationships with several photographers. First, send out copies of your resumé to a number of photographers, then follow up with telephone calls to schedule appointments for showing your portfolio. After meeting the photographers, decide which ones you want to work with most, and refresh their memory by checking in periodically. An occasional friendly phone call will be welcomed by most photographers, who regard such calls as routine. (It is pointless to hound photographers with frequent, unwarranted—and unappreciated— phone calls.) A good first impression and follow-up phone calls will move you steadily forward on their lists.

Remember that photographers usually have freelance assistants they book regularly, so it will take time for you to get your first break. Be patient, and don't give up. Eventually, if you are persistent, you will find an opening.

As a model, I was exposed to a large number of photographers and situations. Because I was an integral part of the sessions, I had been able to observe how the photographers dealt with clients, handled problems, and chose lighting setups to create different effects. I had the luxury of observing everyone, from assistants to art directors to photographers. I consider this period my apprenticeship.

I built my portfolio by testing with my friends and other models, as well as makeup artists, hairstylists, and set stylists I had worked with. Taking pictures was not new to me: I simply changed places. Instead of looking at the camera, I started to look through it.

EUROPE: THE PERFECT PLACE TO BEGIN

The novice fashion photographer may have more opportunities to break into fashion in Europe. Europeans tend to be more comfortable with innovative, creative approaches and place less emphasis than Americans do on technical bravura. And, unlike Americans, Europeans rely more upon mood and image, and less upon intricately detailed photographs.

Many photographers interested in entering fashion move to Italy or France to build their portfolios and gain experience that is difficult to attain in the United States. European designers, advertising agencies, and other potential employers have an open mind about hiring new photographers. In Europe, photographers are given more creative freedom, as well as a bigger role in incorporating thoughts and concepts into the final photograph. Photographers are allowed to express who they are.

It is also much easier for photographers to put together a book of tearsheets in Europe. They can then return to the United States with experience and a better chance to succeed. Art directors feel more confident about hiring photographers when they have seen commissioned and executed work. Tearsheets prove that someone trusted the photographers' talent enough to work with them. Art directors don't have the perilous responsibility of giving photographers their first job. And, during the past few years, there has been a slight crossover in advertising styles between the United States and Europe.

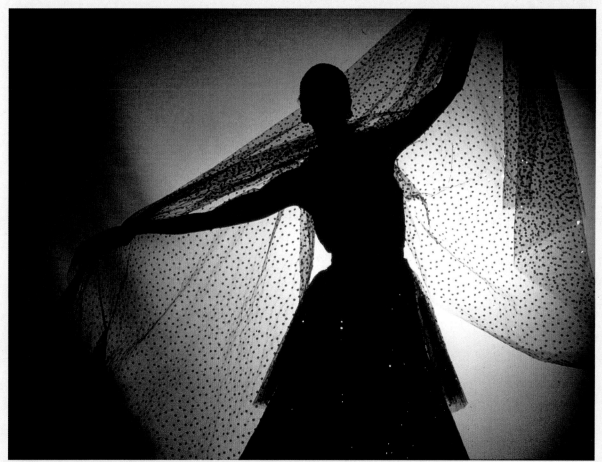

Fashion photographers are allowed more creative freedom in Europe: they can experiment with different lighting techniques, like the one used in this striking silhouette.

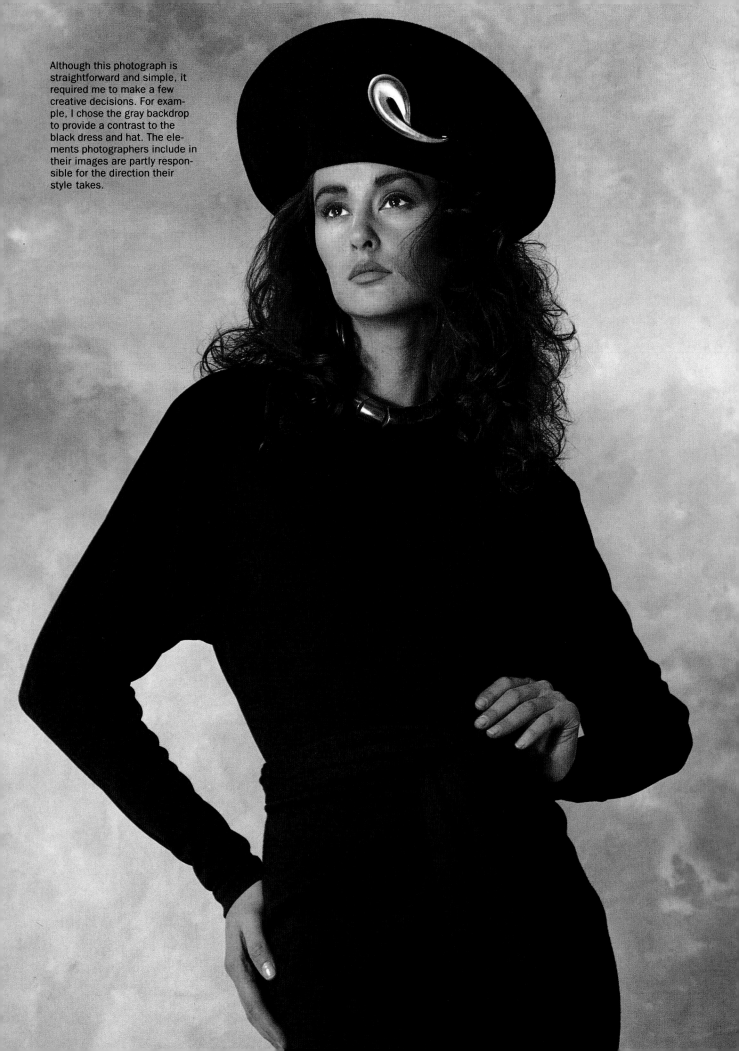

Although this photograph is straightforward and simple, it required me to make a few creative decisions. For example, I chose the gray backdrop to provide a contrast to the black dress and hat. The elements photographers include in their images are partly responsible for the direction their style takes.

FINDING YOUR STYLE

Fashion can take many directions. When I asked dozens of fashion designers the direction they expected fashion to take for my book, *FASHION 2001*, their replies varied tremendously. If I were to have asked five photographers how they would approach shooting a particular garment, I would have received five different answers. Fashion photographers work with an elusive concept. They take a garment or a product, imagine a story about it, and create an impression. Fashion photographers visualize and capture moods.

As a photographer, you will use light to establish moods, to enhance, or to block out. With the camera as your tool, you are free to choose any moment to click the shutter and produce your own creation. By utilizing and exploring your individual point of view, you can relate your own inner vision to the world. You become a creative artist. Over a period of years, you will steadily develop your own unique style through hard work, experience, and even mistakes.

First, get the feel for the many moods and styles of fashion photography; there is a wide range of lighting techniques, equipment, and film to choose from. Try various shooting situations: outdoors, indoors, full-length fashion shots, and beauty shots. Become fully aware of the many effects you can create by shooting at different times of the day.

Photographers starting out in this field find it easiest to copy someone else's style. Although this can be a helpful exercise, developing your own style is the key to becoming successful. If ten photographers show their portfolios to an art director and it's apparent that they have imitated another photographer's style, the art director will want to hire the original photographer.

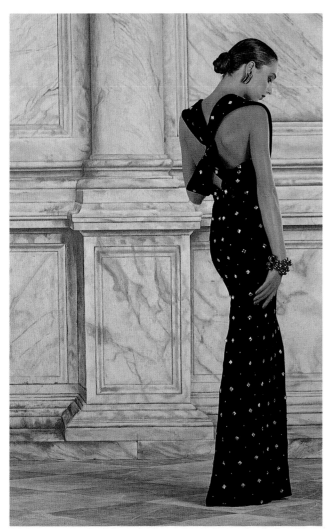

While preparing for this assignment, I selected a simple "marble wall" backdrop and a matching "floor" backdrop to complement the classic, stately line of this design.

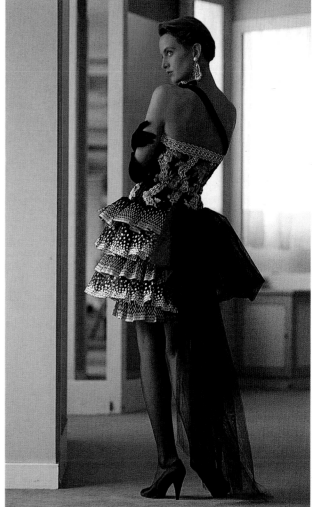

For this shot of a beautiful hand-embroidered and sequined dress, I tried various angles to take advantage of the natural light in the studio. Experimenting is critical to the development of a photographer's style. I try to take unusual images as much as possible when the client gives me some creative freedom—and time allows.

Experimenting. Experimentation is an essential step in discovering and developing your own style. Start by selecting a well-known liquor or cosmetic ad and reshooting it according to your tastes. Cast a completely different type of model, or use another color scheme. Remember: the models, graphics, colors, composition, and form you choose determine your style.

Another exercise is to plan a photograph that will illustrate a specific word, such as "playful," "sensual," or "romantic." This will give you invaluable practice in translating verbal imagery into the visual world of the photograph, which is the essence of the fashion photographer's trade.

As you continue to experiment, you will find that you have certain preferences. If you enjoy directing and capturing movement, think about planning some ses-sions with younger models in jumping and running poses. Do you want to create a sophisticated style? Plan more static, elegant shots. Are you organized enough to plan a real "production"? Try using many models, garments, props, and accessories. Expect to discover both weak areas as well as untapped strengths.

Your style will be the result of experimenting with various techniques and approaches to find your unique look. Give yourself enough time for your style to evolve. By being open to new ideas, you will gradually develop your own preferences in terms of colors, textures, and types of clothing you decide to shoot. Eventually, you will find yourself selecting a certain type of clothing and a particular look in a model. When this starts to happen, you will know that your style has started to take shape and is on its way.

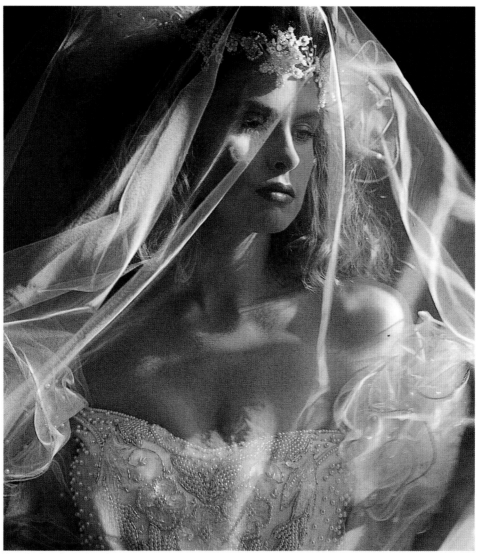

You don't have to feel limited when shooting because you don't have a studio. I used a small area and available light for this shot of a model wearing a wedding dress and veil. As a fashion photographer, you will be called upon to shoot both in the studio and on location. It is important to get experience and to develop flexibility at the beginning of your career.

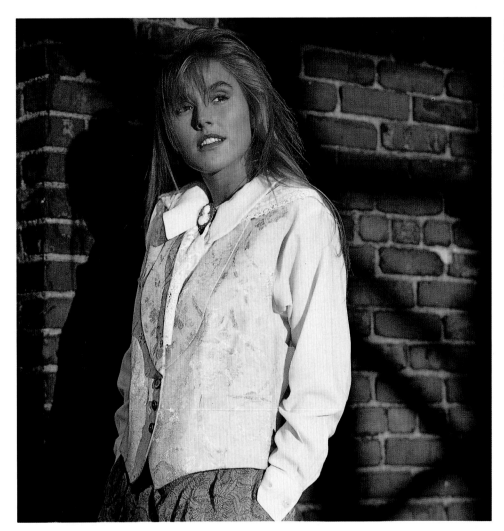

When shooting this photograph, I found the interplay of available light and the graphic shadows intriguing. Even the side of a brick building can be interesting background if you use light to your advantage.

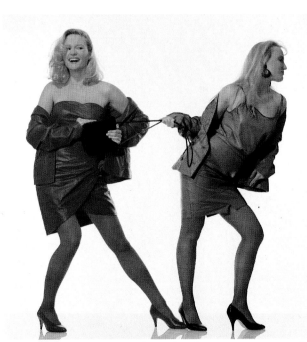

When models interact well during a shot, I try to capture some of these spirited moments. Here, the models played tug-of-war with a leather purse.

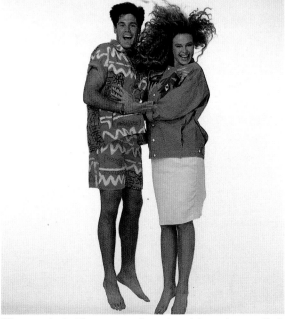

When you test with young, exuberant models, make sure that the garments they wear allow freedom of movement.

Testing. The term *test* applies to photographs for which no one involved—not the photographer, the model, the makeup artist, the hairstylist, or the fashion stylist—receives any payment. Everyone is testing skills as well as the ability to cooperate within a shared framework. In lieu of money, each individual receives a print or transparency from the shoot; this is supplied by the photographer. No one gives anything away: the participants share and exchange talents.

When you first start out in the fashion photography business, most of the work you do will be test shots. You will be able to decide exactly what it is that you want to photograph because you are both the client and the art director. When you are testing, you have the time you need to get the results you want. No one pressures you to get the shot done. If you're not happy with a particular element in the image, you have the power to change it, alter the set and repeat the shot, or cancel the test shots entirely. Enjoy the freedom of testing; rarely will you have this luxury when you're getting paid for an assignment.

Think of each test as if it were a job. Plan your test photographs completely and carefully so that executing them will proceed smoothly. If the shots don't turn out exactly the way you expected them to or if you are not fully satisfied, don't make excuses. Simply throw them away, or file them, referring to them occasionally as examples of what you should not do.

This is also the time to perfect your techniques so that you will be prepared when a job comes along later. For example, learn how to streamline your procedures, so that you won't waste any time during the shoot. You can trim a great deal of time from your shooting schedule by knowing all the idiosyncrasies of your equipment, deciding in advance how you will set up the lighting, and making certain that every single detail of the job has been assigned to the appropriate member of the team. Speed is particularly critical in catalog work. But, of course, time is money in any job.

Setting Up Tests. Gathering the necessary people for a test isn't difficult because everyone involved benefits. Seek out other new artists who are developing their talents. Individuals who are changing direction or attempting to broaden their skills, such as a makeup artist known for "clean" work who wants to move into more sophisticated makeup, will also want to test. Aspiring models need photographs for their composites. People on both sides of the camera in the fashion business have to build a portfolio to show to prospective clients.

The gold highlights in this model's makeup and the gold antique netting she wore enhance the magical quality of this test shot. The antique doll adds an element of interest.

For this shot, makeup artist Peter Brown created "lacy" makeup to match the lace on the doll's veil. I had to photograph the model quickly and carefully because the delicate patterns smudged easily.

Working models, stylists, and hair and makeup artists will not always be eager to test with a new photographer. They already have portfolios filled with tearsheets, so unless they know your work and would like to experiment, they will show no interest. Once you are established and in a position to hire them, they have better reason to test. I prefer to test with hairstylists, makeup artists, and fashion stylists before recommend-ing them for a job, and I regularly schedule tests for that purpose. For now, you must look for others like yourself, interested in building portfolios.

Agencies in major cities that handle stylists and hair and makeup artists will set up tests when their artists are not working. The test is good for both parties. The agencies like their people to work with many photographers and make contacts. Modeling agencies have

BUILDING RELATIONSHIPS WITH SUPPLIERS

An additional benefit of experimenting is that you are building relationships with the labs, messenger services, camera stores, repair houses, rental companies, and other small businesses that you will have to depend on when you start working. Usually, you will have to pay as you go the first few times you place an order. Open charge accounts as soon as you can. Then, make sure that you pay your bills on time. If you are a good customer and easy to work with, you will find that people will go out of their way for you in an emergency.

The adage "You get what you pay for" holds true; a lab featuring unbelievably low prices will not deliver the same quality work you can expect from a more expensive custom lab, and less expensive messenger services may not be reliable. There will be times when you want to economize, but you will have to carefully decide where you want to—and can—cut costs.

testing boards, a division of the agency that handles new models and sets up test sessions with photographers. The people who run them can recommend hair and makeup artists and stylists who are interested.

If you are having a difficult time putting a test together because other artists are reluctant to work with you, try some less obvious alternatives. Artists demonstrating products for customers at makeup counters in department stores are usually paid a small salary and a commission on the makeup they sell. If they are interested in careers as makeup artists, they will need to put together a portfolio and should be anxious to test. I have met many newcomers this way.

You can also contact hairdressers at local salons. They love to document their talents and need pictures to show clients. Salons lend out their people in exchange for photographs they can use in the salon. Always remember to give transparencies or photographs in exchange for their services. (If you shoot several rolls of film, there will be enough transparencies for everyone. You won't have to pay for having duplicate slides made.) Reinforce your reputation as someone who values business relationships and as a professional who carries through what was agreed upon.

Getting Clothes for Tests. Unless you are fortunate and have closets full of model-size clothing, you will have to contact outside sources for your fashions. Start networking. Advertise in trade magazines for a fledgling stylist. You may find someone who has contacts. If you decide to gather the garments yourself, contact local boutiques.

Their owners may be interested in exchanging clothing on loan for some professionally executed photographs to display in their shops. Try calling clothing manufacturers in your area, too.

Choosing Film. When you start testing, estimate how much film you will shoot. See how accurate you were after the test shoot is finished. This comparison will be useful later; with experience you will gain a better idea of how many rolls it takes to capture what you are looking for on film. Although each situation will be different, you will need to supply cost estimates for assignments, so you should always have a rough idea of how much film you tend to shoot. Some photographers shoot very little film, pausing between each click of the camera to think and plan; others shoot more.

Kodachrome 25 offers a clean, almost grainless quality in contrast to Ektachrome 400, which is grainy and gives a completely different effect. Experiment with the various brands and film speeds available, understand the differences among them, and know which types you prefer. (Do the same for black-and-white film.) You might find yourself confronted by unexpected weather and lighting conditions and will be forced to work with another film. Determine what type of film you gravitate to, but be flexible.

Every step of the process of developing your style—analyzing your skills, exploring your imagination, assisting an established photographer, experimenting, testing, and meeting new and unusual people—is an interesting and invaluable experience.

ESTABLISHING YOUR BUSINESS

If you have set your sights on becoming a fashion photographer, you must love fashion as much as I do. If you're like me, you look forward to seeing store window displays change every month. You scour the fashion magazines as soon as they hit the stands. You fantasize about how you would have photographed the garments, and you speculate about how the use of different lighting or another model might have affected the advertisements. ❀ Breaking into the world of fashion photography is no easy task. On the other hand, are worthwhile endeavors ever easy? ❀ Every step of the process of entering the fashion photography business—creating a distinctive style, experimenting, testing, researching potential clients, promoting your work, showing your portfolio, pursuing assignments, directing and completing shoots, establishing a reputation—is a valuable learning experience. You will meet new, interesting people every day. And, if you are talented and dedicated, you will be rewarded financially for having a great deal of fun while you work. ❀ Assuming that you have the determination to begin this exciting process, this chapter should make the rest of the journey somewhat easier for you. ❀

OPENING AND OPERATING A STUDIO

Should you have your own photography studio? This decision depends on many variables, including financial considerations: the initial investment of purchasing a studio, as well as the costs involved in operating and maintaining a studio/office. In large cities, these costs are astronomical. Mortgage payments, rent, phones, staff, equipment, supplies, security, and insurance are some of the expenditures you will have to add to the cost of self-promotion, postage, and updating your portfolio. Besides the monthly maintenance, setting up a studio can be an expensive proposition involving major construction, electrical, and plumbing work.

If you decide to open your own studio, you have several avenues to explore. First, you can look for a studio that has been used for photography before. This studio will probably have a darkroom, and the electrical and plumbing systems will suit your needs. As such, major structural changes will not be needed. Keep in mind, however, that the studio's owner may require you to pay *key money*. This is an additional initial charge—separate from the cost of the rental—that covers the expenses incurred for improvements and alterations previously made in the studio.

Another option available to you is to move into "raw" space. This decision calls for you to think carefully about your needs and to draw up a general floor plan. Adapt your plan to the space, taking into account such requirements as a dressing room with an area for hairstyling and makeup application, a darkroom, a kitchen, a storage room, an office, and, perhaps, a sitting area, but being certain to reserve enough floor space for fashion shoots. Be aware, however, that structural changes will be necessary; these will include plumbing work for the darkroom and an upgrade of the electrical system.

There are other alternatives available to you as well. You can share a studio with one or more photographers. While this allows you to share expenses, scheduling conflicts are inevitable. If you and the other photographer are booked for the same day, you will have to juggle the shootings. Having two shootings—with different art directors, stylists, hair and makeup artists, models, and assistants—happening simultaneously would be awkward unless the studio was spacious enough to be divided. A "spacious" studio would have to be at least 4,000 to 5,000 square feet. Also, keep in mind that a client conflict might arise if an art director you are working with decides to book the photographer you share the studio with.

Another alternative is to rent office space or set up an office in your living quarters, renting a studio only on the days you need one. There are many different types of rental studios available in New York City, and it can be interesting and exciting to experience shooting in new surroundings. If you plan your schedule carefully, you can accomplish quite a bit in a one-day rental. Many rental studios will even supply equipment and an assistant.

Traditionally, European photographers prefer renting studios by the day. Because of climbing costs, this arrangement is becoming quite popular in America. The expenses involved in both renting a studio on a monthly basis and buying a studio are so enormous that even top photographers are giving up their studios. They prefer to reduce their overhead, freeing themselves from a huge financial responsibility.

I believe that it's wise to start out renting studios by the day while you build your portfolio. Why invest a substantial amount of money in a studio when you are not absolutely sure what direction you will take and how your style will evolve? After working for several months, you may find that you prefer the editorial market, in which case most of your photographs will be shot on location.

If finances are a problem but your target is advertising work, use outside locations, friends' houses, and such public places as museums, parks, and beaches. Also, if you can't afford lighting equipment, work with available light. Natural light and electronic flash units produce two different looks and styles, and it is important that you develop skills shooting with both (see page 117).

Furnishing Your Studio/Office. If you are an experienced photographer, you already know which pieces of equipment you will need to buy. If you are a novice, any basic photography textbook can help you plan.

Renting Equipment. You don't have to own much equipment to start working as a fashion photographer. Everything can be rented. Clearly, renting equipment is the easiest and most sensible way to begin without spending thousands of dollars. It may take you quite some time, perhaps even years, to start paying for the essentials with your income as a fashion photographer.

Start with a few basic lenses, such as a 35mm or a 50mm lens, 105mm lens, a 180mm lens, and a 200mm lens. Experiment with other lenses by renting them for a day. You will gravitate to the lenses you prefer.

PROMOTING YOUR WORK

One of the basic concepts you have to grapple with when establishing your business is that you are solely responsible for getting assignments. From the beginning, you must decide how you will approach clients, which photographs you will show them, and how you will present yourself. You can ask everyone you meet in the field for advice about how to contact art buyers, whether or not to advertise your work, how to dress for an interview, and how to structure your fee scale, but you must carefully think about the image you want to project.

Promotional Pieces. For your "calling card," you will need a promotional piece to send out before you schedule a portfolio presentation or to leave behind after such an appointment. Designing your card requires you to utilize taste, judgment, and creativity. With a little imagination, you can design an appealing, eyecatching card and have it printed for a relatively modest sum. Many photographic labs will print an image on photographic paper with your name. Depending on your specialty and how you decide to promote yourself, the image can be black and white or color.

Your promotional piece is just as important as your portfolio. An art director will remember your promotional piece long after the impact of your portfolio has diminished. You must convey your personal statement in a single piece.

Your first promotional piece will probably be a test shot. When deciding on possible photographs, choose those that are representative of your style. Once you are working as a photographer, you will probably want to use your ads as promotional pieces to reflect your experience and to connect your name with known commodities. Most art directors seem to prefer to see a single style in a mailing, but you may want to do a series of mailings that represent your different strengths. Most art directors open their own mail, so your promotional material makes an immediate impression—good or bad. To distinguish your mailing from the dozens of others art directors receive every day, you should consider all the elements involved in the all-important first impression, including size, graphics, and reproduction quality.

Even if you have sent a promotional piece to an art director, leave several cards in your portfolio case. The original mailing may have been misplaced or thrown away. Also, if another art director looks through your book, he or she may want your card as well.

Advertising. Many photographers take out ads displaying their work in trade publications, such as *New York Gold*, *American Showcase*, *The Blackbook*, and *Select* magazine. This avenue of self-promotion is one way of keeping your name visible and showing your work to a vast number of potential clients.

Because taking out an ad is expensive, choose photographs that are of the highest quality and reflect your best work. Potential clients peruse these books, looking intently at each page. You want these individuals to remember your images. As such, it's worth the expense to hire a graphic designer to ensure that your ad is striking and memorable. (One tangible and immediate benefit of taking out an ad is that these publications will supply you with a few thousand reprints of your advertisement printed on a card—an instant mailout. For the price of the ad, you build your name and receive promotional pieces without the need to design them separately.)

Whether or not you will receive many jobs from such ads is unpredictable. I know photographers who get a tremendous amount of work from their ads and others who receive only a few calls. The response from potential clients depends on your style, timing, and the clients' needs.

CREATING AND PRESENTING YOUR PORTFOLIO

Your first portfolio will be composed of your fashion tests. Be selective and critical: don't include everything you have shot. If someone in the business offers constructive criticism, listen carefully rather than defensively. That individual may know more about the field than you do. If shots you love elicit negative reactions, eliminate them. A portfolio should reflect a photographer's strengths, not weaknesses. Remember: less is more. Showing ten great photographs is better than showing twenty mediocre shots.

Because of the cost involved, it is important that you carefully select the slides you will enlarge into prints for your portfolio. With complete freedom to express your creativity, you should put together an outstanding portfolio. You should feel proud when you show it.

At the beginning of your career, buying portfolios with full-page plastic sleeves is advisable: you will be eliminating and adding new prints as your work changes. An alternative is to turn your chromes into large transparencies (4 × 5 or 8 × 10) and mount them within a black border for definition and easy handling.

A more expensive method of presentation is to laminate your photographs. However, you should

Lucille Khornak

425 East 58th Street
New York, New York 10022
(212) 593-0933

Fashion, Beauty & People
Advertising & Editorial
ASMP Member

Published Book: Fashion: 2001

Silver Award—Art Directors Club

Clients include:

Yves St. Laurent
Helena Rubinstein
Ungaro
Pernod Liquor
Coty Cosmetics
Maurice St. Michel
Johnson & Johnson
Lip Quencher
Concord Hotels
Alfa Romeo
Portfolio
Bon Jour
Pierre Cardin
Rive Gauche
Micar Communications
Omni Magazine
Givenchy Jewelry
Private Label
Richelieu
Maidenform.

Conceptual Photographer

Location & Studio

Write or call for your mini
portfolio.

This promotional piece incorporates some of my strongest—and favorite—images. Because promotional pieces are often a potential client's first introduction to you and your photography, they should be done carefully and expertly.

postpone this method until you are sure that the pictures represent your best work. Laminated photographs look beautiful, but they scratch easily and must be handled with care.

You should have an outer case in which to transport the portfolio. Portfolio cases are available in various sizes and qualities at any art supply store. In large cities, some companies specialize in custom portfolios and can make the outer case match the portfolio.

It may seem difficult at first to target your portfolio for a specific market, such as advertising, editorial, or catalog. You will still be experimenting and unsure of what you want to do. Trust your instincts, and show work for the market you feel most comfortable with.

A single portfolio will be sufficient when you start your career. But after you become more established, you will need several to circulate your work to more than one potential client at a time. I find that I get many rush calls for my portfolio, and I could lose business if an extra one were not available.

If you start running ads in the major creative annuals, you will be hoping to get calls from clients around the country. They will ask you to send your portfolio by overnight delivery and will keep it for several days. You must have extra portfolios for such requests.

Setting Up Appointments. You need an appointment whenever you show your portfolio, and you must be aggressive in attempting to schedule each one. Establishing contacts are what the fashion photography business is all about. The more appointments you have, the better your chances of being hired for assignments. In large cities, because the competition is intense and time is limited, it is harder to get appointments. You will spend a great deal of time on the phone, calling and recalling the people you want to see. If they tell you to call back in three months, make a note and be sure to do so. Think of yourself as a salesperson. Above all else, don't get discouraged.

Consider every appointment a job interview. Be prompt. Look presentable. Although some prospective clients may admire the "artsy" look of tattered blue jeans and a sweatshirt, others may expect you to dress more neatly: they may ask you to meet agency personnel. This is your chance to make a favorable first impression. Use each appointment as a learning process. If you are lucky enough to be granted a personal interview (rather than being told to drop off your portfolio—see next section), you can see which photographs receive positive responses. After a number of personal appointments, you will be able to strengthen your portfolio by removing weaker shots. Expect to hear many diverse opinions, and try not to take negative reactions personally.

Drop-Offs. In addition to, and sometimes in lieu of, scheduling appointments, some agencies and magazines have drop-off policies: after dropping off a portfolio, a photographer will be contacted if the agency is interested in seeing more work.

While each drop-off can tie up your book for several days, many companies let you drop off the portfolio one day and pick it up the next. Some companies set aside one day a week for drop-offs; others, one day a month. Ask about each company's policy. Keep in contact with the receptionist or art director you sent your portfolio to, and pick it up as soon as you can. When too much time elapses, portfolios are often misplaced.

I don't favor drop-off policies because you never really know the art director's reaction to your work. Getting feedback from drop-offs is rare. In fact, you can never even be certain that your portfolio was looked at: hectic schedules and emergencies may have prevented the art director from examining your work. Of course, it's always important to keep circulating your book; months later, someone you have never even heard of may contact you because he or she was favorably impressed with your images.

GETTING HIRED

Once you have pulled together a look in your portfolio, you are ready to start thinking about potential clients. Don't expect to hang out the proverbial shingle and have people flock to your door. You will have to seek out clients and convince them that you are the perfect photographer for their next assignment.

Smaller agencies are more receptive to working with new photographers. Your first jobs may be on less important accounts, where, perhaps, less money is at stake. Search for someone who is willing to take a chance because of the strength of the photographer's portfolio.

You should also try to find clients whose style seems to work with yours. Of course, clients may be looking for a fresh approach to their work—but not frequently. Even though fashion is a creative business and you expect people to think creatively, prepare yourself: clients hope to find in portfolios the exact type of work and style they need. For example, a client planning a beauty shot will feel more secure hiring a photographer whose portfolio includes beauty shots. In this situation, your work wouldn't be considered if it were heavily fashion-oriented.

People tend to type your photography. If your promotion card looks like catalog work, they will not think of you when looking for an editorial photographer. With their busy schedules, they simply file you in the appropriate place to keep organized.

It will probably take months of knocking on doors before one will open; this is because existing working relationships are hard to break. Understanding the roles important people play in the process of hiring photographers will help you to understand the decision process.

Editorial Personnel. Your contacts with magazine staff members depend upon whether the assignment you are seeking is in the fashion or beauty area. You will probably deal with one of the following three individuals.

The *fashion editor* is assigned to the fashion section of a magazine. If fashion interests you, this is the person you must see.

The *beauty editor* is assigned to the beauty section of a fashion magazine. Because beauty shots are usually regarded as distinct from fashion shots, you should see this editor if your portfolio favors beauty photography.

The *art director* works with the fashion and beauty editors in laying out the design of the magazine. This individual is always looking for photographers whose style meshes with that of the magazine. Rarely will the art director wish to change the look; however, such a change might take place under a new owner or a new editorial policy.

If you want to work in the editorial market, contact smaller local magazines in your area. They usually have a drop-off policy. Be aware, though, that the editorial field can be difficult to enter. The major magazines seem to rely on the same photographers year after year.

Advertising Agency Personnel. Most advertising agencies, small or large, have the same basic personnel structure. No matter what types of clients they represent, or what part of the United States they are located in, agencies must staff themselves in order to cover the same creative and business skills.

The *client* is the person (or company) who has the product and who commissions the creative team or advertising agency to create the work. Sometimes, a client will not contact an advertising agency and will work directly with the photographer. Most clients, however, prefer to work with an advertising agency. Large agencies, as you would expect, deal with large companies and small agencies with small companies.

The *account executive* acts as a liaison between the client and the creative team. He or she determines with the client what is needed in terms of advertising, taking into account the budget and expenses. The account executive then relays this information to the *creative team*, which usually consists of the *art director* and the *copywriter.* Next, these two individuals begin to work together on a creative concept. When the client approves their rough proposal, the account executive estimates costs for models, printing, production, photography, and other necessities and informs the client. An account executive may deal with one client or several at any given time and oversees the entire process, from concept to execution.

The *art director* is primarily concerned with the visual dimension of the ad. This individual takes information supplied by the account executive and, along with the copywriter, brainstorms ideas in a "creative session." Words supplied by the copywriter can stimulate the art director's imagination. Many advertising campaigns have grown out of the seed of one line of copy. The art director then develops a layout, which is a rough approximation of the idea for the ad, or, more likely, a number of layouts. As soon as an approved layout has been selected, the art director will choose a photographer (or illustrator) to execute it.

The *creative director* is in charge of the creative team. Although he or she may not initiate creative approaches, the creative director enables the copywriter and art director to keep their goal in mind. As an experienced, well-rounded generalist, the creative director helps them devise a production strategy that will remain within the client's stated parameters.

The *art buyer* plays an important role: viewing potential photographers, models, hairstylists, makeup artists, printers, and other suppliers; negotiating prices; issuing purchase orders and contracts; and carefully adhering to the client's budget restrictions. If job costs exceed the prescribed budget, the art buyer must be informed at once.

The art buyer has a "split personality," serving both the financial and creative forces. This person also screens artists who continually pursue the art directors. If art directors took the time to see every portfolio, they would never get their work done. The art buyer sees photographers by appointment and files their cards in an appropriate category. When art directors have a job for a photographer, they ask the art buyer to suggest several whose portfolios they can review. The art directors may also give the art buyer a few names. The art buyer then invites the photographers to drop off their portfolios. Art directors will not meet with the photographers until they narrow down their choices.

Obviously, clear communication from start to finish is critical (see page 36). Art directors choose a photographer who in their eyes is the appropriate person for the job. They are not going to risk their position by selecting a photographer who is unqualified or whose style is unsuitable for a particular assignment.

Catalog Personnel. The personnel associated with catalog assignments varies because some catalogs are produced "in-house," while others are executed by an outside agency specializing in catalog work.

The *in-house art director* is the person who pulls together the entire look and presentation of each catalog. He or she works directly for the catalog house.

The *agency art director* is assigned to produce and direct the look of the catalog. This individual works for an advertising agency.

In small cities, you can be a general photographer and probably succeed by showing a variety of work. In large cities, such as New York and Chicago, you can—and should—show specialized work. In either case, you need a strong portfolio to show to clients, account executives, creative directors, art directors, art buyers, and editors.

DEVELOPING YOUR MAILING LIST

If you want to concentrate on the advertising market, lay the groundwork for a comprehensive mailing list by looking through fashion magazines and noting advertisers that suit your talents and goals. Call and find out if the companies work with a particular advertising agency; if so, ask for the art director's name. Then follow through by calling the agency. This way you will build your own list of art directors.

You can also refer to *The Standard Directory of Advertising Agencies*. This large, expensive source book lists agencies, their accounts, and the amounts of their billing. Unfortunately, agency staffs are continually moving, so the names listed may be incorrect. If, however, you learn that the art director recently moved to another agency, try to get a forwarding address. Accounts leave agencies and take their business elsewhere for a variety of reasons—and sometimes the art director goes with them.

Because large agencies have hundreds of creative people on staff, you must first find out which ones are working on the accounts that you are right for. Don't start with general art directors. You will have a better chance if you know what accounts they work on and if their work is suitable for you. You can also buy mailing lists that supply the names of art directors at the various agencies.

Another option is to turn to fashion magazines themselves as a source of information. Magazines list their personnel on one of the first pages of each issue. There you can easily learn the names of the fashion editors, beauty editors, and art directors. When choosing a magazine, just as when choosing an agency account, select one whose style complements your own.

If you plan to work on catalogs, collect an assortment by asking friends to save those they receive by mail. You can also contact mail-order houses directly. They may hire photographers themselves or may work through a larger agency that handles several catalogs.

As soon as you have a list of names, you can either send out general mailings or mail specific pieces to prospects (see Chapter 8, page 138). If you plan to do a large mailing, investigate the bulk mail rates at the post office. You can save money by organizing your mail according to zip codes.

FOLLOWING UP

Once you start to show your portfolio, you must follow up. Although a company may not need you now, it may need you in the future. Ask how often you should contact the art director. No formulas or definite answers exist; each situation is different. An art director may be happy with the photographer he or she has been using for years, and until something alters that relationship, won't hire you. Should you continue to call? The answer, of course, is up to you. If the feedback you receive sounds positive and you think that you will eventually get the chance to work with the company, then by all means continue to contact the art director.

Occasionally, it's smart to do a general mailing to all the advertising agencies and magazines, if only to let everyone know you exist. They may be working on a car account today, but they may get a fashion account tomorrow. Also, a strong promotional piece can inspire an art director to call you months after receiving the mailing.

GETTING YOUR FIRST ASSIGNMENT

Almost all fashion photographers seek work on their own— at least until their careers are firmly established, at which point they may delegate a representative (a rep, or agent) to handle this chore for them. If, however, you are lucky enough to be represented early in your career, you will not be personally involved in "knocking on doors" in search of work. Most fashion photographers are responsible for finding their own work as they try to establish their name and reputation. Getting hired for those first critical assignments is not as ominous as it sounds once you understand the process.

General Interviews. At a general interview, you are not applying for a specific assignment; rather, you are acquainting the art director or art buyer with your work. Before arriving for the interview, you should gather as much information as possible about the accounts the art director handles. Then, during your conversation, you can emphasize how your skills suit the needs of these clients. Your goal here is to determine whether it will be worthwhile to pursue this particular contact.

Specific Interviews. When you are being considered for a specific assignment, you will meet with the art director, who will discuss the layout and concept. You should listen carefully and closely. Your purpose is to understand as fully as possible the art director's goals and expectations. Is it a national ad or a trade ad? How long will the advertisement run? What kind of model(s) is the client looking for? Feel free to ask as many questions as you like.

If someone asks a specific technical question regarding one of the shots in your portfolio, be prepared to answer. Don't be surprised if your portfolio is needed for a client review before you are hired.

Negotiating Your Fee. All photographers have standard fees for various assignments depending on their current career level. As a beginner, your rates will be on the lower end of the standard assignment rate schedule determined by the American Society of Magazine Photographers (ASMP). This can be found in ASMP's *Professional Business Practices in Photography*, which is revised annually.

Once you build a solid reputation, your fees will escalate. An art director may want an immediate cost estimate; don't be too quick to answer. Study the layout and look for potential problems. Expenses include a great deal more than the costs of film and processing. Will the layout require you to build a set? Will you need a hairstylist and a makeup artist? Will you need a stylist? Will any props be required? It is wiser to overestimate than to underestimate. Tell the art director that you will send a written estimate.

Fees are always negotiable; if your estimate is too high, you can always confer with the agency and decide how costs can be cut. For example, a painted backdrop can replace an expensive custom set.

Submitting Estimates and Bids. It is not my policy to come in with a low estimate (which, when you submit it in competition with those of other photographers, becomes a bid) and then have a large number of hidden expenses on the final invoice. Advise the client in advance of any additional minor charges that you anticipate. Small expenses accumulate, and it's unfair to send a bill full of surprises.

I always try to find out as much specific information as possible before working out costs. If I am responsible for casting, I determine approximately how much time my assistant and I will spend on this task. I also estimate the amount of film I will need, including the cost of clip tests and Polaroid film for the shoot and the casting.

Sometimes an agency may hire you without going through a bidding process; in this situation, you simply submit an estimate. In other cases, you may be bidding competitively for a job. When a major agency receives your bid for an assignment, it may be required to obtain two additional bids before making a decision.

This triple bidding procedure was developed by the accounting and auditing branches within agencies to ensure an equitable selection process. It begins with a selection of three photographers who are given the job specifications, usage, and timetable. Each one submits an independent bid for the job, and the low bid is ordinarily the winner. Occasionally, a higher bid will win, as in the case of a timetable change to a date when the low bidder is not available, or a change of specifications that makes it inappropriate for the low bidder to do the job. Because the three photographers who submit bids are the survivors of an elimination process, be aware that you have already passed through several cuts when you are invited to make a bid.

Assignment Rates. Fees are determined by usage in advertising (for example, national versus regional; billboard versus trade ad; two years versus one-time use only), by the page in editorial (that is, the number of pages on which your work will appear), and by the day or per shot in catalog. For advertising assignments, you may need to include a fee for preparation time, casting, and lighting tests, and any other work that precedes the shooting. There may be several preproduction meetings.

A word of caution: watch for unauthorized uses of your work. I was once hired to photograph a model for the packaging of a particular product. Because the image was to be used in a test market only, I was paid considerably less than I would have been if the packaging were to be used nationally. When I noticed the image displayed as a point-of-purchase card as well as on the nationally distributed packaging of the product, I immediately reminded the agency that my photograph had not been authorized for those purposes. We negotiated a fee for the expanded usage of the photograph. It is your responsibility to keep track of negotiations.

SHOOTING YOUR FIRST ASSIGNMENT

Expect your first assignment to be exciting but nerve-wracking. Whether or not you have been lucky enough to get a job right away, you will probably feel the pressure that comes with someone paying you for your expertise and talent. But you should feel prepared for this moment: you have been working toward it for quite some time by experimenting, testing, and learning from your experiences—and mistakes. Don't let "stage fright" prevent you from utilizing your skills, displaying your talent, and doing your best.

Communicating. In this highly visual industry where we are so intent on how things look, clear communication is critical. I have found that the operative word is "listen." Knowing how to listen is an essential skill for professional photographers.

Sometimes, art directors aren't quite sure about what they're looking for. When this happens, you must listen to them very carefully. If you receive mixed messages from art directors, you have to interpret their thoughts in order to bring their real intentions into focus. If they offer two contradictory ideas, don't risk insulting them by pointing this out. Guide them gently toward a workable solution. Repeat to them what they have proposed; this may just help them crystallize their plans.

Many art directors are reluctant to take chances and would rather be safe than sorry. Understand their position: their jobs may be on the line. If the final ad isn't a success, art directors are usually held responsible. For this reason, cautious art directors may prefer to photograph the ad literally as planned first; then, if time permits, they will be more willing to experiment creatively.

Listen to yourself, too. When you explain your plan to your team—the assistant, hairstylist, makeup artist, and stylist—you have a responsibility to express your intentions lucidly and forcefully. Once you understand the art director's needs, your success in meeting them will largely depend on how well you communicate with your team. Pay careful attention—to the art director, to your team, and to your communication skills.

Getting an Advance. Photographers commonly ask for an advance to meet their expenses before and during the shoot. This keeps them from depending on an incoming cash flow at a critical time.

Photographers must have cash on hand at all times. They also must have film on hand; it needs to be tested before the shoot. Assistants expect to be paid at the end of the working day or week. Other miscellaneous expenses sometimes include renting extra equipment.

In most cases, photographers are expected to pay for lunch on the day of the shoot. While all of these are billable expenses, you will find that you need cash on hand long before you send out your bill (see Chapter 8, pages 140-41 for more information on cash flow and billing). Suppose you have five jobs scheduled in one week, and for each job you spend $600 for film, expenses, and your assistant's time. Obviously, an advance from the agency involved is necessary.

MANAGING THE SHOOT

Anything can happen on a shoot, even when you think every preparation has been made. The product that was scheduled to be delivered on the morning of the shoot via the United Parcel Service does not arrive. It is 10 o'clock in the morning and your team is working away, getting ready for the shoot. Can you think quickly enough to avert a disaster?

Suppose a model shows up two hours late—or never shows up at all. Your automatic reflexes have to take over in an instant: you must book an alternative, and first you may have to schedule an emergency casting call. Everyone with the look you want is booked, so you compromise with another choice. Are you flexible enough to shift gears quickly?

The pressure can be overwhelming. Some people are not able to cope with stress and high-pressured situations. No matter what happens on a shoot, you must be professional about how you handle emergencies. You must still deliver the final photograph.

The shoot is, for all the problems that may arise, the most joyous event in a photographer's life: it is the time when all the preparation you have been working on comes together. Your energy level is at its peak. The moment of creation is at hand.

Responsibilities on the Set. If I have the choice of having the art director and clients on the set, I prefer to have them. Quite often, a last-minute decision or an adjustment to the originally planned layout is required. Rather than having to make the decision on my own, it's great if I have someone else (who has the power to back the decision) with me at the moment. If the final results are not what they expect, they share the responsibility. I also like to have the art directors look through the camera, so that they know precisely what they're getting.

Keep everyone else off the set except for the art director, the client, and the team. When one of your team members is monitoring the model and the set, that person should be positioned directly behind you, not six feet to one side. From that vantage point, he or she

will see everything the same way the camera will.

Sometimes personality conflicts may erupt on the set. Deal with them in a diplomatic way, but make it clear that friction doesn't produce fine results. Keep the peace. The final outcome—the photograph you've all been working hard to produce—is the bottom line.

Safety on the set is an important consideration, and it is your responsibility. Extension cords should be taped down or placed out of the way to avoid accidents. Coffee cups and ashtrays should be emptied often and kept away from clothing, film, and papers.

The models are now on the set and you are ready to go. First, you will take a Polaroid at the position you will be shooting from. The Polaroid is necessary in order for you to check the lighting and to see the overall image. Are the model's hair and makeup right? Is the lighting what the art director was looking for? What about composition? Is there enough area around the image so that the art director will have space for type and will be able to crop? Take a good look at the Polaroid and examine every detail. Check to see if the model's left eye appears to have more eye makeup than her right eye, or if her dress is longer on one side than the other. If any changes are to be made, now is the time to make them. If the background color is not as dark as you would like, you may want to change the angle of the lights or lower the power. Details, details, details—study your Polaroids!

After changes are made, another Polaroid is taken to confirm that everything is right. Several Polaroids may need to be taken before the actual shooting starts.

Concentrate on your model and what she is projecting to the camera. Your team should also be on set watching for minor flaws that can ruin a photograph. Perhaps a strand of hair blew across the model's face; a smudge of lipstick is on her cheek. As the photographer, you must be aware of all the details. But it helps to have your team watching, too, so that you can concentrate on what you are capturing.

It is a good idea to take another Polaroid from time to time when you are shooting for an extended period, just to be safe. Your assistants should also be aware of all the lighting to make sure the head on each electronic flash unit is firing properly.

Once the job has been executed according to what the art director had in mind, you can suggest that you try it the way you want to shoot it. If there is enough time left, the art director will be pleased that you want to take the time to shoot it your way. It often happens that the art director prefers your way, and you will experience a glow of satisfaction when the actual, published ad reflects your own idea.

Clip-Testing and Processing Film. As each roll of film is shot, your assistant should keep a record and number each roll, labeling it with the lens and the *f*-stop you used. I also have my assistant note which garment the model was wearing and if there were any lighting changes. If I feel that a roll is going to need clip-testing, my assistant marks it accordingly. After shooting thirty or forty rolls of film, you might find it difficult to remember what you wanted to clip-test unless good records are kept.

After the shoot, I review the film and the record sheet with my assistant, separating the film we are sending out to be *clip-tested*. Here, two frames from a roll of film are processed, so that the photographer can determine if the exposures on the balance of the roll will need to be adjusted. If I am busy, I will have the lab send the clips back to me by messenger and judge from there. If I can squeeze it into my schedule, I prefer to go to the lab. I have made many late-night visits to pick up film and review clip-tests—sometimes several visits in one night. A clip-test can take two to three hours; the final processing of Ektachrome takes about four hours. However, when labs are inundated with work, it can sometimes take a few more unplanned hours.

If you are shooting Kodachrome, it is advisable to have Kodak process the film because of the company's quality control. In a city like New York, where fashion and advertising are major industries, you can get anything quickly as long as you pay the price. Fleet messengers pick up at your studio and take the film to New Jersey, where the Kodak plant is located. Only hours later, you will have the film delivered at your door. If the messenger service picks up before 10 o'clock in the morning, you will have the film back at about 8 or 9 o'clock in the evening. Kodachrome does take a few more hours than Ektachrome, but the choice is yours.

Editing Film. Once the film is back, I do a quick edit and take out any of the shots in which any obvious flaws show. I mark a red "X" on the ones that are exceptionally good, hoping these marks will steer the art director toward a shot that I consider great. Many art directors are grateful when you mark your preferences. If they are pressured for time, they can glance over all the transparencies and concentrate on the ones with your mark. Editing can take hours depending on how much film was shot. So you may have to squeeze this task into your evenings or wake up earlier than usual to edit before your next shoot.

You will soon find that everyone in this business needs the processed film yesterday. Your agency may

want the film immediately after it is delivered to you, leaving you no time to edit. This is another, all too familiar pressure situation, especially when you are in the middle of shooting another job.

Solving Problems. Reshoots are sometimes necessary when something goes wrong at the initial shoot. Depending on the problem, the agency may or may not pay for the reshoot. If the agency or client changed its mind about what it wanted (such as models, props, location), it pays; if the problem was caused by the photographer (equipment malfunction, processing error, negligence), it is the photographer's duty to reshoot the assignment at no extra charge. Reshoots that are not the fault of the photographer require a new purchase order before the reshoot takes place.

If the agency or client decides to cancel a shoot within four days before the scheduled date, the photographer can expect to be compensated with a cancellation fee, which is a certain percentage of the photographer's fee. This covers time and effort already spent, lost bookings, and any expenses already incurred. This fee depends upon how much notice the photographer is given—from twenty-four to ninety-six hours.

MANAGING YOUR BUSINESS

Fashion photographers used to be considered artists, pure and simple. They were expected to be mercurial, and dramatic—and certainly not adept at bookkeeping, billing, or accounting. Today, however, fashion photographers must have a thorough understanding of business if their creative talent is to surface and thrive. ✿ Because a lackadaisical attitude toward business details contributes to the failure of many fledgling photographers, the point is worth repeating: talent alone is not enough to make you a successful fashion photograher. Staying on top of mountains of paperwork, keeping careful records of all accounts, handling financial and legal matters, and maintaining existing clients and pursuing new ones occupies a large portion of your work week. And, unless you are lucky enough to have a rep (an agent), you must meet with these potential clients and continually promote yourself. You must enter the fashion photography field with soaring energy and enormous self-motivation. ✿ Assistants often tell me that they want to shoot fashion because they can make a great deal of money, meet attractive models and other interesting people, and spend their time in glamorous settings by working in this field. ✿ But fashion photography involves much more than simply picking up your camera and photographing a pretty model wearing a new design. It is a highly competitive business that requires skill, careful attention to detail, enthusiasm, and the willingness to do hard work. If you want to succeed in this demanding field, you must be ready to give it your all. However, you still need something else to break into fashion photography because of the overabundance of photographers. You must have an edge. ✿

GIVING YOURSELF AN EDGE

To develop an edge in the fashion photography business, you must first create your own individual style. As suggested earlier, you can do this by becoming a fashion photographer's assistant, experimenting on your own, and doing test shoots. The promotional pieces that you will eventually send out to potential clients must reveal your photographic "voice." A distinctive look to your photographs and a professionally designed logo will increase your chances of making a lasting impression on prospective clients and art directors and getting assignments. You have to convince the right people that out of the hundreds of photographers who want a particular assignment, you are the one who best meets their needs and can enable them to achieve their goal.

FORMING YOUR BUSINESS

Once you successfully launch your career as a fashion photographer, you will need to know the basics of managing your hard-won business. Then, as your reputation grows and the number of assignments you receive increases, you will need to revise your current methods of operation. Be flexible and open to new ideas. The following setup and systems work well for me and will help you establish your own business practices. Remember: few hard-and-fast rules exist. You have several options to consider when forming your fashion photography business.

Incorporating. A primary reason a photographer incorporates his or her business is to limit personal liability. A corporation is a separate entity from the photographer in private life, and should a catastrophe occur, the photographer's personal assets are protected. (You have to file with state agencies to incorporate your business. An accountant can take you through the necessary paperwork, or you can do most of it yourself with published guidelines.)

S Corporations. This form of business ownership offers a photographer a corporate shield for liability, but profits and losses of the corporation flow to the photographer and must be reflected on his or her individual tax return.

Sole Proprietorship. This is the simplest form of business. The photographer alone is the owner of his or her company and is solely responsible for debts. The photographer can cover personal liability with adequate insurance. You are required to report the income from a sole proprietorship on your personal income tax return using a Federal Income Tax Form Schedule C.

Partnership. With this arrangement, the photographer shares ownership of the business with another person. You may be responsible for your partner's actions and commitments that can be deemed to be within the framework of your business.

HIRING STAFF MEMBERS

The fashion photography business is unique, and each studio operates differently. Photographers often add or subtract personnel and shift responsibilities among staff members.

Office Assistants/Secretaries. In general, I usually have three people working in my studio with me at one time. Randee, my office assistant/secretary, has worked with me for ten years. Her responsibilities include answering much of my personal and business correspondence, as well as the telephone; bookkeeping; scheduling appointments; and working on the special projects I'm involved in, such as books, promotional events, and magazine articles. Randee rarely goes on shoots, but she handles all of the paperwork each job entails; this includes estimates and invoices. Through the years, she has become familiar with most areas of my business.

Studio Managers. In my situation, the position of studio manager is actually a paid apprenticeship. All of my studio managers have been young, energetic individuals whose career goal is to work in the fashion field. Their responsibilities include filing slides, ordering photography equipment and film, making follow-up telephone calls, and acting as my liaison with processing labs. Studio managers are usually competent technically and accompany me to shoots as a second assistant.

Interns. Having an intern on staff can be a rewarding experience for both the photographer and the intern. A photographer can always use an extra pair of hands. And for the intern, helping a professional photographer is an invaluable opportunity. Interns learn that the world of fashion photography is not all glamour. Perhaps completely unaware of the business side of fashion photography, they realize that the daily procedures involved in running a studio are time-consuming, repetitious, and often tedious. They also see firsthand that the hours can be quite long and can decide whether or not this is the right field for them.

SETTING UP YOUR FILING SYSTEM

A meticulously maintained filing system is essential to the smooth operation of any business. When I first

started my photography business, I used one file-card box with individual cards arranged alphabetically according to last name or company name. I was able to fit all the information I needed in that single box; this included listings for advertising agencies, set stylists, hairstylists, makeup artists, models, modeling agencies, processing labs, department stores, and assistants.

As I added cards for new contacts, I realized that I would have to categorize them for efficiency's sake. I organized separate boxes for each of the following groupings:

- Advertising Agencies (eventually, I had to put the large number of cards listing New York City-based advertising agencies in a separate box)
- Advertisers—companies that advertise their products without using advertising agencies
- Personnel—assistants, set stylists, hairstylists, and makeup artists
- Planning a Session—modeling agencies, prop houses, locations, studios, and processing labs
- Styling a Session—sources for clothing, jewelry, and accessories
- Assembling a Promotional Piece—graphic artists, stat houses, and printers

Despite my new system, the amount of information was still unmanageable, and the cards quickly became disorganized. For example, if I planned to style a shoot, I pulled the cards I would need for the day; call the various people and places I wanted for the job; and then leave the cards for my office assistant, so that she could make the follow-up telephone calls. And, because this is a high-pressure business, Randee and I developed the bad habit of not refiling the cards. We never seemed to "have a free minute" to refile the cards, which continued to pile up. I would sometimes try to organize them in groups according to which box they should be returned to, but quickly reached the point where we had to search through the various piles for ten minutes to find the one we needed.

Finally, I made a rule that all cards had to be refiled by the end of the day, and we tried to adhere to it. We also devised a new plan: jotting down the information on a card into notebooks rather than removing the card. And, when we did take the card out of the box, we turned the card behind it on its side in order to replace it easily.

In addition to these file boxes, which held only information I might need at a glance, I had a file cabinet containing hanging folders. Here, I kept correspondence (one folder for incoming correspondence, one for copies of outgoing correspondence), and separate files for model releases, estimates, records of outstanding accounts, and the resumés of potential assistants. I had individual files for receipts for paid bills (one file for those paid by check, and another for those paid for with cash) and three separate folders for miscellaneous expenses (one for messenger receipts, one for car service receipts, and one for taxi receipts—all filed in order by date). The bookkeeping information needed for tax purposes was kept with my ledger.

At long last, I knew exactly where everything was. And, I was lucky enough to have Randee, my office assistant who had been with me from the start—and who knew where to find just about everything.

COMPUTERIZING YOUR OFFICE

With the number of slides and the amount of paperwork photographers must keep track of—including information about assistants, models, stylists, art directors, modeling and advertising agencies, processing labs, and prop houses; assignment records; bills; receipts; and correspondence—many quickly realize that they must invest in a computer. Like many other small business owners, I soon discovered that my manual organizational systems simply were not efficient, adequate, or speedy enough. My index cards filled more than fifteen boxes, and, despite the careful labeling, it often took Randee and I hours to gather slides for a stock photography request. Even just collecting all the information I needed to complete my tax returns was a lengthy and tedious process.

Finally, after giving the idea much thought and investigating the various options available, I decided to buy a computer. I was hesitant because setting up a computer system is quite expensive and time-consuming. You must be willing to spend a large amount of money on the equipment and a great deal of time in finding the computer best suited to your needs and learning how the system works.

Programming the computer, arranging and preparing the files and records to be input, and feeding in all the information took a long time, but was well worth the effort. I feel much more in control of my studio—and better able to manage it. And, while transferring the files and information to the computer, I eliminated many records that were no longer necessary. The process also forced me to call agencies and creative personnel to update my records. My assistant and I are now able to keep this information current on a daily basis and to locate it much more easily.

Once you set up the basic system, you should look into the different software packages on the market. The word processing program I chose allows my assistant to

accomplish more "paperwork" in less time, and I am able to do mass mailings and correspondence that I used to contract out.

A word of caution: don't consider buying a computer system unless you are willing to invest the length of time required to learn how to use it efficiently, to edit and organize your files, and to enter all the information.

SELECTING A REPRESENTATIVE

When you decide to make fashion photography your career, you give up the luxury of depending on anyone else for your livelihood for a time. Once established, you may want to hire a representative. But a good rep—someone who, in addition to being enthusiastic about your photography, is reliable and resourceful—is invaluable and hard to find.

Why are good reps rare? They have to make contacts; do the necessary legwork, taking your portfolio around to every art director in town; follow up; book your jobs; negotiate fees; make sure you receive payment; and act as a buffer between you and your clients, which relieves you of many problems. Reps also provide peace of mind. When you are busy shooting, it's comforting to know that someone you trust is promoting your photography and soliciting new work for you. The percentage you must pay a rep is often worth it.

Finding an individual to represent you is difficult for other reasons as well. Successful reps who have been in the fashion photography business for many years are usually satisfied with their artists. And, if they decide to expand, they take on well-established photographers with substantial billing. Such reps look for portfolios filled with tearsheets, not tests.

Reps also want to work for photographers who have a specific style; they're not interested in someone who claims to be able to do a dozen things well. Their clients usually prefer a particular look, and reps build their reputations by filling these needs.

Having a rep allows you to concentrate on your photography. Remember, however, to choose one carefully: a rep is a representation of you and your work. You and your rep must work together closely and be committed to your joint goals and shared responsibilities. You will want to feel satisfied with your rep's services. You will want to know that your rep is earning his or her commission. Reps receive approximately a 25 percent commission on all advertising assignments, less for editorial jobs, and a negotiable fee for *house accounts*, which are accounts a photographer has before signing a contract with a rep. Percentages vary until the rep brings in a substantial amount of work.

I find that I'm my own best "rep." My work is of paramount importance to me, and I know it better than anyone else does. I enjoy contacting clients and art directors personally, and I think that it makes the shoot go more smoothly. After all, I am the person they have to work with. Also, as my own "rep," I am able to build lasting relationships with clients and art directors. As a result, I don't have to worry about being considered an exchangeable commodity. When your rep builds and sustains a relationship with a client, you risk the possibility that the rep will move on to another photographer and take the client along.

UTILIZING YOUR MAILING LIST

Once you are an established photographer, you will have a comprehensive list of advertising agencies, other potential clients, and creative personnel. In order to use the list efficiently when you send out promotional pieces, you must update it periodically. Make it a habit to call all the advertising agencies from time to time to get current information about their personnel. Also, be sure to note which companies and clients responded favorably to your earlier mailings: they will probably be interested in seeing your latest work.

Keep abreast of personnel changes in the editorial market as well. If you are leaning toward this market, you can keep your portfolio circulating continuously.

Once a year, you may choose to do a mass mailing, sending promotional cards to every name on your mailing list. Keep in mind, however, that while a mass mailing circulates your name, it doesn't necessarily attract new business. You should also target smaller mailings to art directors who work on fashion, beauty, or similar accounts.

Of course, the best advertisement of your abilities is a job well done. Your reputation, good or bad, precedes you and any promotional material you send to potential clients.

MAINTAINING CLIENT INTEREST

Although photographers have a clear advantage with clients who were pleased with their work, they can't allow business relationships to remain static. As a fashion photographer, you can't expect your name to immediately spring into an art director's mind when a new project is being planned simply because you did a great job earlier. You must check in with the art director from time to time by mail and by telephone. Show art directors your new work. Advise them of new projects you're involved in. Also, be sure to keep track of the art directors you know as they move from agency to agency.

PROTECTING YOUR BUSINESS

Setting up a fashion photography business takes a great deal of time, effort, and money. Protecting your investment is critical. Find out what is required of you legally, and learn your rights. Insure your images, your equipment, and your workspace. You must also maintain accurate records of all transactions and keep receipts as written proof of them. For additional information, I suggest that you refer to *The Legal Guide for the Visual Artist* (Madison Square Press).

Getting Insurance. Photographers have specialized insurance needs, so make certain that your policy provides you with adequate coverage for your business. It would be a disaster if an accident occurred in your studio or on location on an assignment, and you did not have proper insurance coverage. You could lose your business, get into serious debt—permanently, and even jeopardize your personal assets. Major insurance carriers have "packages" that usually include the following.

Studio Insurance. This type of coverage includes fire, theft, and water damage for the premises that are insured.

Camera Insurance. This type of insurance covers fire, theft, and water damage worldwide (wherever you take your camera). Make sure that you arrange for this insurance on a replacement cost basis rather than a depreciation cost basis. In case of accident or theft, you want to be covered for the full costs of replacing the equipment, rather than for the dollar amount the damaged or stolen goods were worth at the time.

Valuable Papers Insurance. This coverage includes film and covers expenses to restore film to the condition it was in prior to damage. However, this clause excludes camera malfunction, lab errors, and bad film.

Bailee Insurance. This covers other people's property in your care, custody, or control for fire, theft, or water damage. You can extend this insurance to cover unnamed locations and transit. This is important if you know that you will be shooting in a rental studio, in someone else's home, or on location.

Although most fashion designers have insurance that covers lending their clothing for photography shoots, some insist that you have extensive coverage—especially when you are working on location for a week with a $50,000 fur coat or three $30,000 original designs. The designers will request a copy of your insurance form and a confirmation letter from you for their files. This letter must specify such details as the time of the pickup, the destination, and the date the garments will be returned.

Basic bailee insurance does not cover jewelry, furs, silverware, or coins.

Commercial General Liability Insurance. This type of coverage includes bodily injury or property damage to other people or their property, for which you would be legally liable (up to one million dollars). Basically, this insures you for "trips and falls." For example, if you are on location and a tripod falls over and harms an individual or a piece of property, you are covered. Liability excludes any benefits covered by workman's compensation or disability insurance (see below). This coverage also excludes any injury or damage associated with automobiles, watercraft, aircraft, or pollution, as well as damage to the property of others that is in your care, custody, or control.

Fine Arts Insurance. This type of insurance covers art objects in your custody or owned by you. It includes transit coverage for other people's property for which you may be responsible while traveling.

Portfolio Insurance. This coverage provides for the cost of duplicating your portfolio.

Non-Owned and Hired Automobile Liability Insurance. This covers you on an excess basis for bodily injury or property damage for which you are legally liable and which is the result of the use of a non-owned or hired automobile. This coverage does not include vehicle damage.

Workman's Compensation Insurance. This coverage reimburses an employee hurt on the job for medical expenses and a portion of the employee's income. In New York State, for example, you are required to have workman's compensation coverage whether or not you incorporate.

Disability Insurance. New York State requires you to carry state disability insurance. This covers employees who are injured off the job as a result of accident or sickness and provides them with 50 percent of their income (up to $145 per week) for a maximum of twenty-six weeks.

A final note: *homeowners insurance* does not cover business liabilities. If you live and work in the same

place, you need both homeowners and commercial insurance. Obtaining both policies from the same company will help you to avoid problems when filing a claim.

Handling Financial Matters. In a perfect world, photographers simply would do their work and get paid for their efforts. Unfortunately, a photographer's work does not end when he or she receives payment. Photographers must pay taxes, plan their expenditures, and accurately estimate their overhead. Also, freelance work leads to an inconsistent cash flow.

For these reasons, you should find a good accountant as soon as you are established. Look for a professional. An accountant will handle all of the financial concerns associated with your business wisely and will, in the long run, save you money.

Keeping Daily Records. A careful accounting of expenditures is essential in the fashion photography business. The Internal Revenue Service requires proof of every deduction. You must be able to verify travel and entertainment expenses, so keep and file receipts and cancelled checks. Also, when you entertain a client, note the individual's (or individuals') name and business connection, as well as the date. I use my appointment book as if it were a diary, marking down all of my business meetings, and I retain books from earlier years in case I am audited.

To keep track of day-to-day expenses, I file all my receipts by date in separate folders labeled "Cash," "Checks," "Taxis," "Car Service," and "Messenger Service." My assistant takes care of the bookkeeping, and I leave the more complicated aspects of accounting to a professional accountant. He organized my ledger using the following headings:

Accountant's Fees	Maintenance and Repairs
Advertising	Messengers
Agent's Commissions	New Equipment
Answering Service	Postage
Assistant Fees	Promotion
Donations	Props
Dues and Publications	Sales Tax
Entertainment and Meals	Shareholder
Equipment Rental	Stationery
Film and Processing	Studio Supplies
General (Amount/Reason)	Telephone
Hotel Accommodations	Transportation
Location Fees	Travel

At the end of the year, I tally up my cash receipts and my expenditures, and my accountant prepares my tax

returns shortly thereafter. (You will be expected to file quarterly sales tax returns.)

Establishing Credit. It's a smart idea to get a credit card strictly for business expenditures. You will regularly receive a breakdown of your charges, so keeping track of entertainment and travel expenses is simplified.

It's also much easier to do business on a day-to-day basis if you have professional charge accounts with processing labs, repair shops, and messenger services. This eliminates having to pay each time you use the service. The monthly statements these companies send also help to organize your bookkeeping. You must file your resale certificate number with each vendor whose services you employ, so that you will not be charged sales tax.

Billing Clients. When billing a client, you must include the sales tax percentage applicable in the state in which he or she conducts business. Add that amount to the subtotal for your fees and expenses. Many clients will also have a *resale number.* This is the authorization that companies need in order to collect tax. If they do, you do not have to charge them sales tax, but you do have to keep their resale certificates on file. Always ask your clients to provide you with their certificate. (Having pads of resale certificates on hand is a smart idea. You can purchase them at any stationery supply store. As a professional photographer, you have to both supply these certificates to vendors you patronize and collect them from your own clients.)

If you do collect sales tax from clients, it may be wise to deposit this money in a separate account as soon as you receive payment. This procedure can help curb your urge to spend money that isn't actually yours. Many businesses default because they spend the sales tax money they collect and have difficulty paying the government when it is due. If your payment is late, you quickly incur penalties and interest fees.

When preparing the bill, always include the names of both the client and the advertising agency. Then, if the agency should go out of business unexpectedly, you can contact the client to get the money you earned.

Be sure to mail your invoice as soon as you can once you have completed the assignment. Companies calculate the 30-to-60-day period as starting with the date on your invoice, not the date the work was done. Every day you wait is another day you don't have the money that is rightfully yours.

The billing form recommended by the Advertising Photographers of America (APA) is a standard form that can be altered according to your individual needs. This

gives you an example of what is billed and how it is presented in bill form.

When you have your own forms printed, it will be very helpful to the agencies you work with if you print your tax number or social security number in the address area at the top. Contact the APA for a sample estimate/invoice form, on the reverse side of which there are a number of terms and conditions which your lawyer should review to make certain that they meet the legal requirements of your state of residence.

Determining Cash Flow. Never count your money before it's in your account. Don't purchase $3,000 worth of new equipment on Tuesday because you completed a $5,000 job on Monday. I expect payment thirty days after my client receives an invoice, but some clients routinely pay sixty to ninety days from the receipt of an invoice. Each business has its own payment policy. I routinely send out second notices after thirty days and make follow-up telephone calls.

Paying Bills. Reviewing all your bills yourself is essential. I have found mistakes, such as messenger runs that were not mine and double-billing for film processing. If you don't set aside time for this, you must ask your office assistant to do it. I also suggest that you double-check the bookkeeping of all of your suppliers.

Guarding Copyright Ownership. Who owns a professional photographer's transparencies? According to copyright laws, you are the creator and owner of your photographs from the moment you create them. But you should protect yourself from any possible misunderstandings with clients by including a copyright notice with your estimate and invoice. Even though a client has paid for the film—the unexposed film—the image is your work, and you own the rights to it. You may, however, transfer that right if you wish by express written agreement.

Joining Professional Organizations. Associations for photographers and other professionals can provide you with valuable information to help you safeguard your business and manage it professionally. These organizations sponsor special events and discussion groups for sharing ideas, networking, and solving problems.

APA was formed by a group of photographers in the advertising market who understood the necessity of a forum to exchange information. The association's special bulletins and bimonthly newsletter report on and discuss both new and continuing developments in the photography business. APA also has a hotline that members can call for answers to questions. APA believes that "improving business practices for all photographers will help each photographer."

The American Society of Magazine Photographers (ASMP) was formed in 1944 "to improve the circumstances of working photographers; to safeguard and protect their interests; to maintain and promote the highest standards of performance and ethics; and to cultivate friendship and understanding among professional photographers." ASMP has thirty-one chapters and three subchapters across the United States. These provide support groups and learning centers.

As you can see, the business of fashion photography encompasses more than just glamour. To succeed as a fashion photographer, you must be artistic and business-oriented, and imaginative and practical.

CREDITS

PAGE 63, TOP RIGHT *Model:* Nicole Hood; *Hairstylist:* Ian Malone; *Eyeglasses:* UFO; *Backdrop:* Charles Broderson

PAGE 63, BOTTOM *Model:* Sheila Johnson; *Makeup Artist:* Alister Logue; *Clothing:* Donald Brooks; *Backdrop:* Charles Broderson

PAGE 64, TOP *Model:* Tom Tripodi; *Eyeglasses:* UFO; *Location:* The Puck Building

PAGE 64, BOTTOM *Model:* Saralyn; *Eyeglasses:* UFO; *Clothing:* Laurél; *Location:* The Puck Building

PAGE 65 *Models:* Deborah Kujawa and Pamela Housman; *Clothing:* Sao; *Location:* Palace Belem

PAGES 66–67 *Model:* Jane Fox; *Hair and Makeup Artist:* Bruce Clyde Keller; *Location:* Tekno/Balcar Studio

PAGE 68, LEFT *Models:* Pamela Housman and Deborah Kujawa; *Clothing:* Sao; *Location:* Palace Belem

PAGE 68, RIGHT *Models:* Deborah Kujawa and Pamela Housman; *Clothing:* Sao; *Location:* Palace Belem

PAGE 69 *Model:* Andrew Plucinski; *Stylist:* Katrina; *Location:* The Columns

PAGE 71 *Model:* Tania Koessler; *Clothing:* Chanel; *Location:* Coco Chanel's Residence

PAGE 72 *Model:* Maria Olsson; *Clothing:* Pierre Balmain; *Location:* House of Pierre Balmain

PAGE 73 *Model:* Thereza Ellis

PAGES 74–75 *Models:* Thereza Ellis, Eve Markovics, and Karl Szabo; *Hair and Makeup Artist:* Ron Heck

PAGE 76, TOP *Models:* Karl Szabo and Eve Markovics; *Hair and Makeup Artist:* Ron Heck

PAGE 76, BOTTOM *Model:* Astrid Lamarrs

PAGE 78 *Model:* Thereza Ellis; *Hair and Makeup Artist:* Ron Heck; *Clothing:* Walter Albini

PAGE 79, TOP *Model:* Thereza Ellis; *Hair and Makeup Artist:* Ron Heck

PAGE 79, BOTTOM *Models:* Karl Szabo and Eve Markovics; *Hair and Makeup Artist:* Ron Heck

PAGES 80–81 *Model:* Sophia Tramier; *Clothing:* Ora Feder

CHAPTER 5

PAGE 82 *Model:* Willow Bay; *Hairstylist:* Ron Capozzoli; *Makeup Artist:* Allan Forbes; *Clothing:* Anne Klein

PAGE 84 *Model:* Willow Bay; *Hairstylist:* Ron Capozzoli; *Makeup Artist:* Allan Forbes; *Clothing:* Pamela Dennis

PAGE 85 *Model:* Willow Bay; *Hairstylist:* Ron Capozzoli; *Makeup Artist:* Allan Forbes; *Clothing:* Anthony Muto for Moroci

PAGES 86–87 *Model:* Willow Bay; *Hairstylist:* Ron Capozzoli; *Makeup Artist:* Allan Forbes; *Clothing:* Kip Kirkendall

PAGES 88–89 *Model:* Willow Bay; *Hairstylist:* Ron Capozzoli; *Makeup Artist:* Allan Forbes; *Clothing:* Pamela Dennis

PAGE 91 *Model:* Lynne Paddy; *Hairstylist:* Timothy Downs; *Makeup Artist:* Clorinda; *Jewelry and Clothing:* Givenchy

PAGES 92–93 *Model:* Ely Pouget; *Hairstylist:* Timothy Downs; *Makeup Artist:* Clorinda; *Jewelry and Clothing:* Givenchy

PAGE 94, TOP LEFT *Model:* Joko Zohrer; *Hairstylist:* Ron Capozzoli; *Makeup Artist:* Richard Adams; *Jewelry and Clothing:* Givenchy

PAGE 94, TOP RIGHT AND BOTTOM *Model:* Joanne Russell; *Hairstylist:* Ron Capozzoli; *Makeup Artist:* Richard Adams; *Jewelry and Clothing:* Givenchy

PAGE 95 *Model:* Anne Bezamat; *Hairstylist:* Ron Capozzoli; *Makeup Artist:* Richard Adams; *Jewelry:* Givenchy

PAGE 97, TOP *Model:* Sophia Koustis; *Hair and Makeup Artists:* José Occasio and Eddie Santos; *Clothing:* Kip Kirkendall; *Location:* The Puck Building

PAGE 97, BOTTOM *Model:* Erika Wilson; *Hair and Makeup Artists:* José Occasio and Eddie Santos; *Clothing:* Kip Kirkendall; *Location:* The Puck Building

PAGES 98–99 *Model:* Sophia Koustis; *Hair and Makeup Artists:* José Occasio and Eddie Santos; *Clothing:* Kip Kirkendall; *Location:* The Puck Building

PAGE 100 *Model:* Erika Wilson; *Hair and Makeup Artists:* José Occasio and Eddie Santos; *Clothing:* Kip Kirkendall; *Location:* The Puck Building

PAGE 101 *Model:* Shelya Huff; *Hair and Makeup Artists:* José Occasio and Eddie Santos; *Clothing:* Kip Kirkendall; *Location:* The Puck Building

PAGE 105 *Models:* Stephanie Romanov and Jessica Ginsberg; *Hair and Makeup Artist:* Barry Baz; *Stylist:* Nancy Wolfson; *Eyeglasses:* Safilo

PAGE 107, TOP *Model:* Amie Morgan; *Assistant:* Grant LeDuc; *Photographer:* Lucille Khornak; *Client:* Monica Kosann

PAGE 107, BOTTOM *Model:* Amie Morgan; *Hair and Makeup Artist:* Barry Baz; *Stylist:* Nancy Wolfson; *Eyeglasses:* Safilo

PAGE 108, TOP *Model:* Stephanie Romanov; *Hair and Makeup Artist:* Barry Baz; *Stylist:* Nancy Wolfson; *Eyeglasses:* Safilo

PAGE 108, BOTTOM *Model:* Stephanie Romanov; *Account Executive:* Allan Jarosz; *Hair and Makeup Artist:* Barry Baz; *Stylist:* Nancy Wolfson; *Eyeglasses:* Safilo

PAGE 109 *Model:* Stephanie Romanov; *Hair and Makeup Artist:* Barry Baz; *Stylist:* Nancy Wolfson; *Eyeglasses:* Safilo

PAGES 110, TOP, AND 111 *Models:* Amie Morgan and Stephanie Romanov; *Hair and Makeup Artist:* Barry Baz; *Stylist:* Nancy Wolfson; *Eyeglasses:* Safilo

PAGE 110, BOTTOM *Models:* Stephanie Romanov and Amie Morgan; *Hair and Makeup Artist:* Barry Baz; *Stylist:* Nancy Wolfson; *Eyeglasses:* Safilo

CHAPTER 6

PAGE 113 *Model:* Sophie; *Hair:* Pierre Michel Salon

PAGE 116 *Model:* Joko Zohrer; *Hair and Makeup Artist:* Paddy Crofton; *Clothing and Jewelry:* Donna Karan; *Backdrop:* Charles Broderson

PAGE 117, LEFT *Model:* Pietri Carine; *Hair and Makeup Artist:* Peter Brown; *Clothing:* Givenchy; *Backdrops:* Charles Broderson

PAGE 117, RIGHT *Model:* Julianne Holland; *Clothing:* Christian Dior; *Location:* Christian Dior Showroom

PAGE 118 *Model:* Uta Sander; *Hair and Makeup Artist:* Dennis Gaetano; *Stylist:* Joan Roland; *Clothing:* Paula Varsalona

PAGE 119, TOP *Model:* Donna Barnes; *Hair and Makeup Artist:* Elizabeth Roszkowska; *Stylist:* Katrina

PAGE 119, BOTTOM LEFT *Models:* Rosanna Iversen and Olivia Toscani; *Hair and Makeup Artist:* Dennis Gaetano; *Stylist:* Joan Roland; *Clothing:* Gingette

PAGE 119, BOTTOM RIGHT *Models:* Neil Sundberg and Heather Kewn; *Hair and Makeup Artist:* Peter Brown; *Clothing:* Turbo/Kookai; *Jewelry:* Vogue Straps

PAGES 120–121 *Model:* Katie Easton; *Makeup Artist:* Peter Brown; *Doll:* Sao

PAGE 122 *Model:* Corey Corbin; *Makeup Artist:* Peter Brown; *Doll:* Sao

FRONT COVER *Model:* Pietri Carine; *Hair and Makeup Artist:* Peter Brown; *Clothing:* Givenchy; *Backdrops:* Charles Broderson

BACK COVER *Models:* Amie Morgan and Stephanie Romanov; *Account Executive:* Allan Jarosz; *Hair and Makeup Artist:* Barry Baz; *Stylist:* Nancy Wolfson; *Eyeglasses:* Safilo

INDEX